downTown U.S.A.

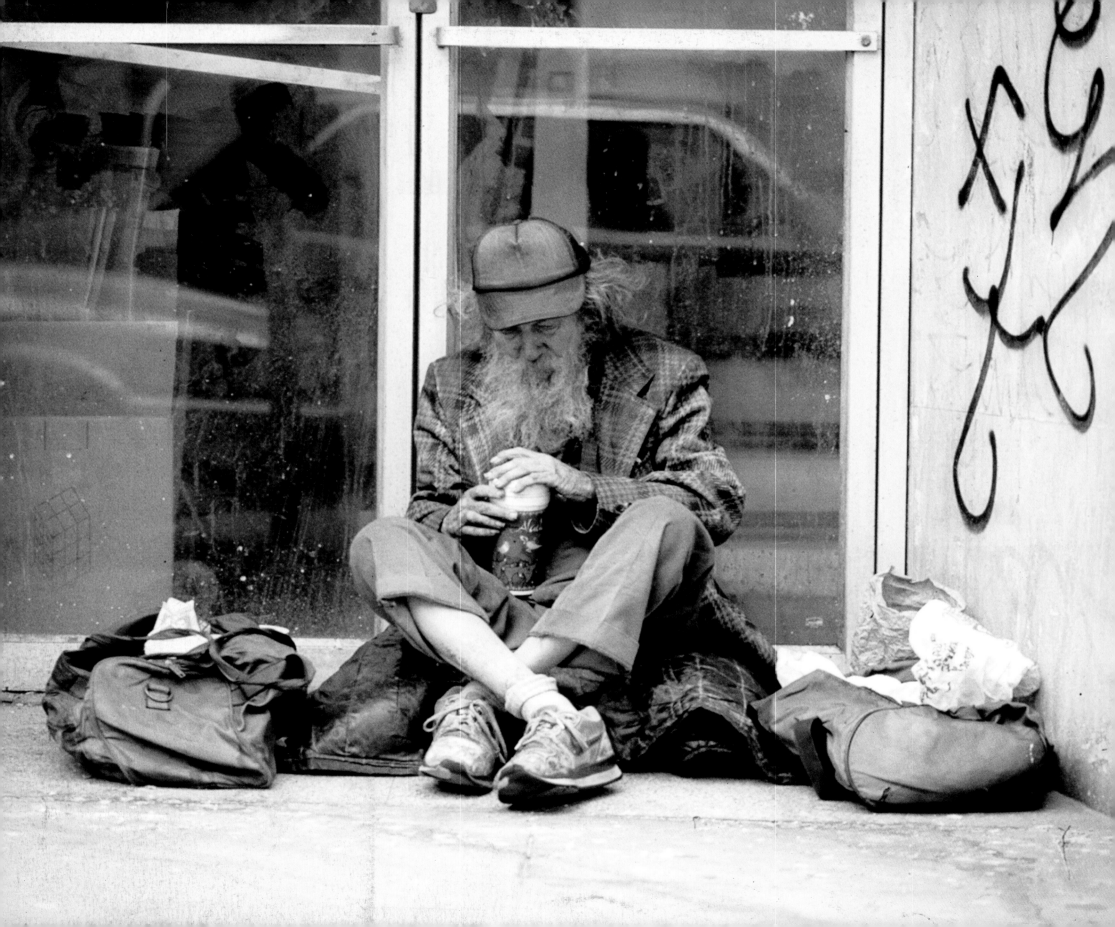

downTown U.S.A.

A Personal Journey with the Homeless

PHOTOGRAPHS AND TEXT BY

SUSAN MADDEN LANKFORD

HUMANE EXPOSURES PUBLISHING, LLC SAN DIEGO, CALIFORNIA

HUMANE EXPOSURES PUBLISHING, LLC

EDITORIAL
Susan Madden Lankford, Lydia Bird

ART BOARD
Susan Madden Lankford, Barbara Jackson

LAYOUT DESIGN
Susan Madden Lankford, Barbara Jackson, Polly Lankford-Smith

GRAPHIC DESIGN
Polly Lankford-Smith, Gene Nocon

PHOTOGRAPHY
Susan Madden Lankford
Polly Lankford-Smith, pages 18,19, 200 and 202

Library of Congress Control Number: 2009929909

Lankford, Susan Madden
downTown U.S.A.: a personal journey with the homeless / Susan Madden Lankford – 1st ed.

ISBN-13: 978-0-9792366-2-4
ISBN-10: 0-9792366-2-2

Photojournalism / Homelessness / Social Justice / San Diego (Calif.)

All the individuals in the pages of this book consented to be photographed and quoted for publication. In most cases, the names of those living on the street and in Balboa Park have been changed to protect their privacy.

Printed in China by Global PSD

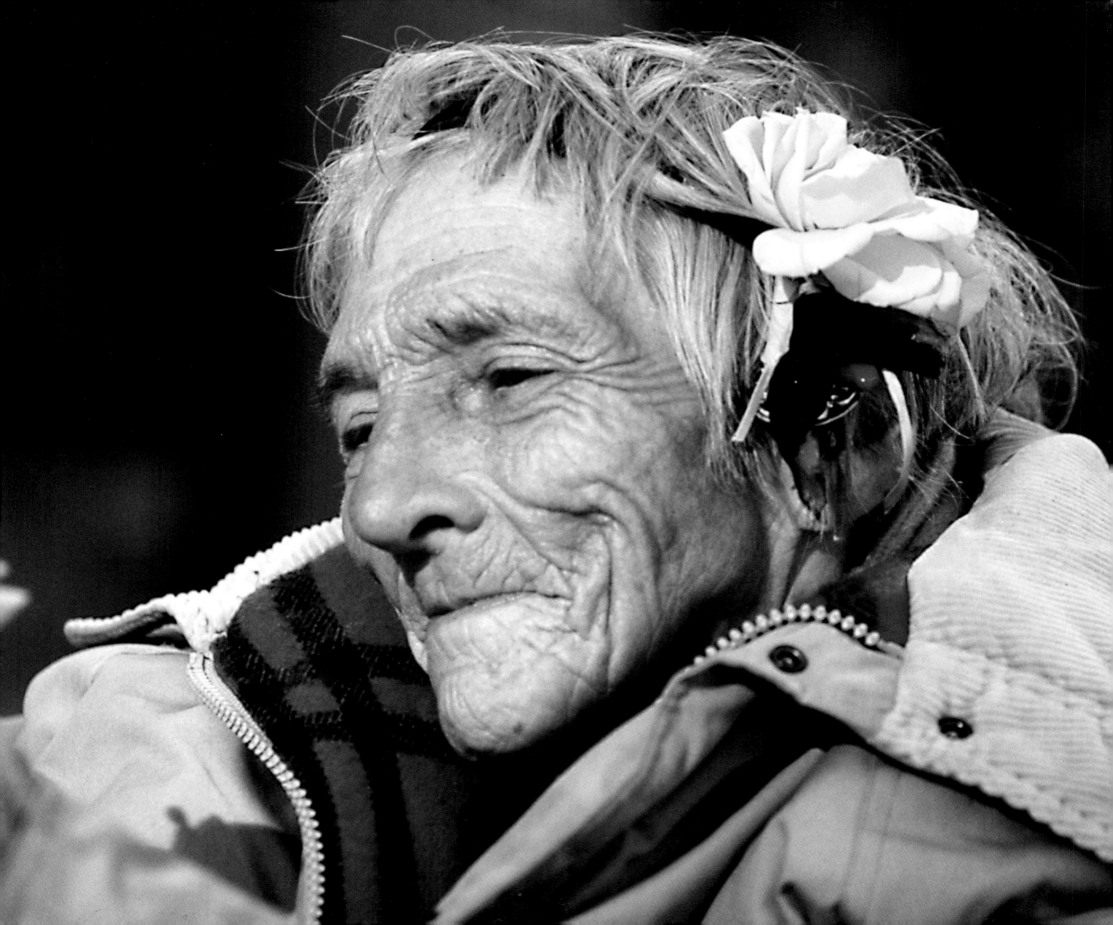

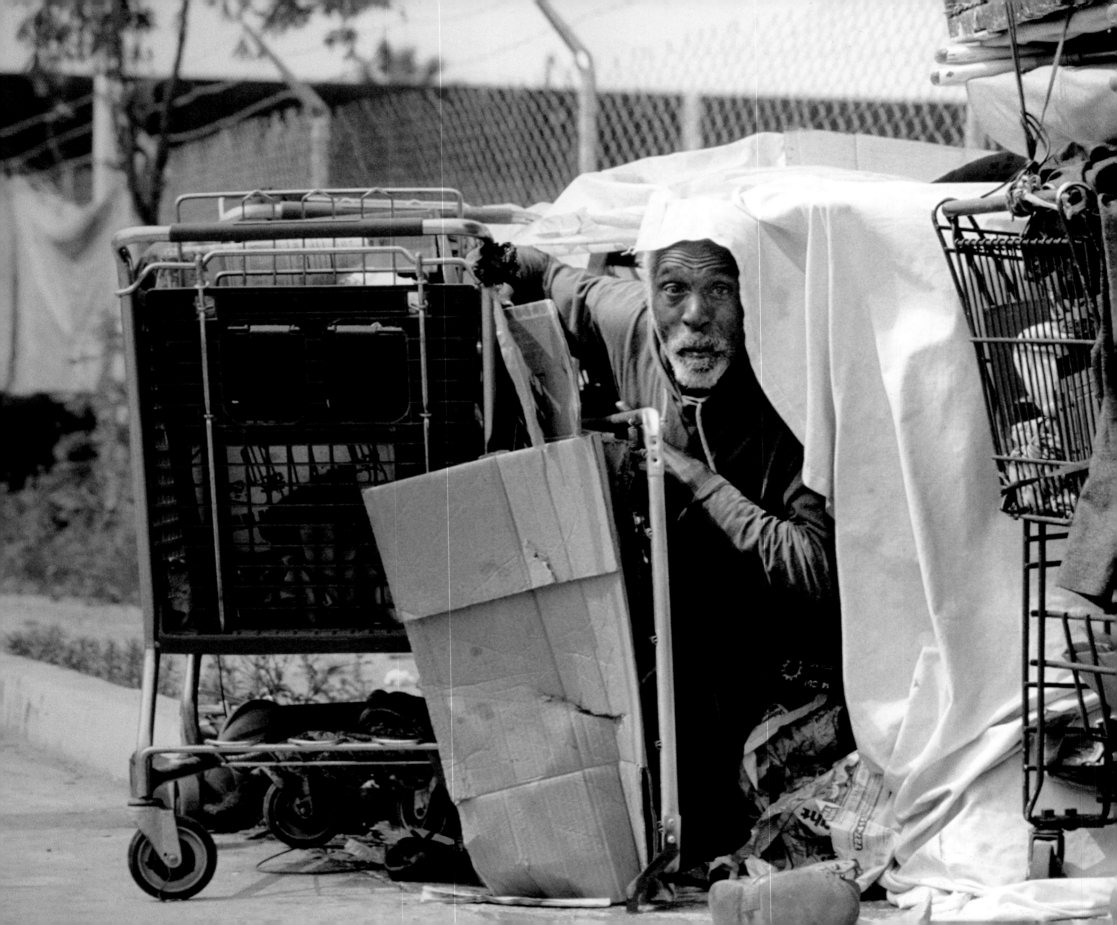

Contents

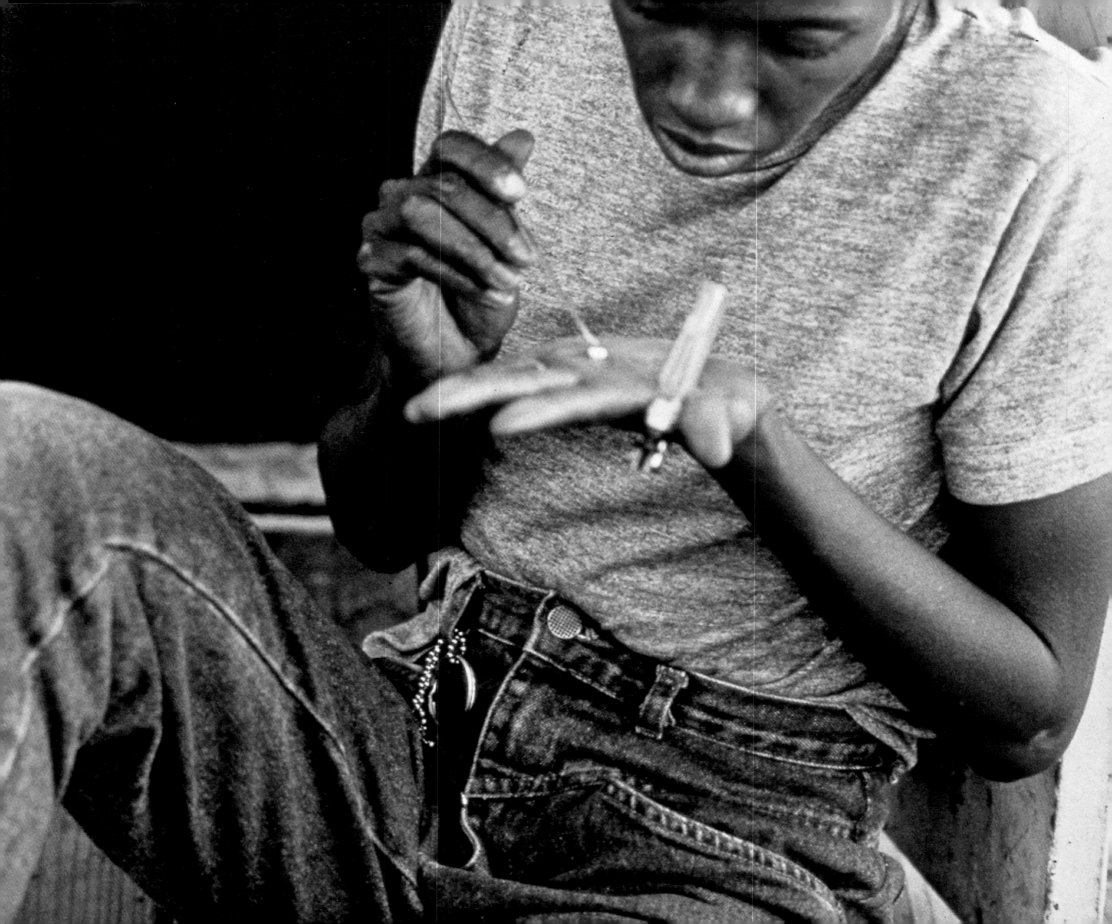

FOREWORD

If we think of homelessness at all, we usually think of its causes as poverty, or mental illness, or a lack of affordable housing. In a less generous mood, we describe the homeless as crazy, as bottomed-out alcoholics, druggies, or bums. Susan Lankford, a fine photojournalist working as an urban anthropologist, leads us into the streets and alleys of downtown San Diego for a more direct and less comfortable understanding of life amongst the homeless. Like Dante guiding us into Hell, she brings us in gently, to experience progressively not only the realities and threats of homeless life, but also its antecedents. By the end of our trip, the usual explanations seem woefully inadequate.

This is the second volume of a trilogy depicting crucial social issues: incarceration, homelessness, and the juvenile justice system. These topics were not chosen randomly; they are all stops on the same journey from abusive childhood to school failure, escape through drugs and alcohol, apprehension, arrest, incarceration, and the endpoint of social failure short of death—homelessness. For most of us, it is easier to be repelled by the disheveled appearance and disturbing odors of the homeless than to ask the question begged by Lankford's volume: "Why would a person choose to be homeless?" Her subjects tell us their stories, and in so doing answer that question by showing us just how poisoned their concept of "home" became, as a result of abuse, neglect, trauma, and chaos in the very families that were meant to nurture them.

The author, wanting to know why things are as they are, and willing to go deep into unsettling territory, shares by photos and recorded interviews what she has learned on the streets. She introduces us to its inhabitants, who bring up a common theme: they have experienced home and family as dangerous, something to be avoided. As we move deeper into the book, becoming less distracted by the superficially more troubling aspects of homelessness, repeated descriptions of destructive early family life support this idea.

As one reads *downTown U.S.A.*, Robert Frost's famous words come to mind: "Home is the place where, when you have to go there, they have to take you in." Before this book, I had never noticed the specified lack of warmth in Frost's phrasing: "…when you *have* to go there, they *have* to take you in." Describing people who have been born but not raised (the theme of the trilogy's final volume, which deals with youth in juvenile hall), Lankford suggests that where there has been no family support, there is no reason to trust the idea of home.

Homelessness thus is not so much the problem as it is a marker, and sometimes a solution, to problems dating back to childhood—events concealed by shame, secrecy, and our tendency to avoid talking and thinking about certain realms of human experience. Perhaps our fear is that if we see the homeless as human, in recognizing them as being like us we will recognize our potential to become like them. If homelessness is a warning flag signaling a problem in our society, rather than the problem itself, we sense that resolving it is a far more difficult task than expected.

downTown U.S.A. provides powerful insight into life on the street, its denizens, and also those of us who covertly support it by purchasing drugs and prostitution from those on the street. The cover photo, a mural of a huge face looking out over a body lying on the sidewalk, accurately depicts the current state of a quandary we try to overlook.

–Vincent J. Felitti, M.D.
Kaiser Permanente Medical Care Program
Clinical Professor of Medicine, University of California, San Diego

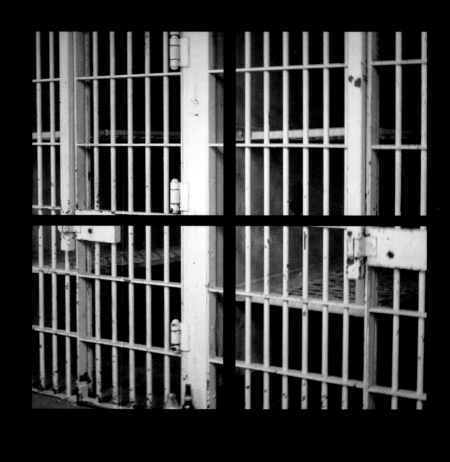

CHAPTER ONE: SEAPORT VILLAGE JAIL

Michael, 2009

My name is Michael. It's spring, 2009 … I live in a studio loft in Golden Hill, an airy unit with hardwood floors and an old claw-foot tub. All my furnishings are secondhand … not only does it give the place "character," it was cheaper that way. The area is pretty nice, and there's a real sense of community.

I work as a truck driver, driving 18-wheelers locally. The truck yard is only five miles from where I live … so it's sweet. Basically, I get up when my dogs Max and Orion stare me down for their morning walk, grab a cup of coffee, go to work … like a bunch of other working-class stiffs … looking for the good in whatever happens. I come home, do some computer stuff, or reading. Most of the time I'm broke, living from paycheck to paycheck, but I enjoy the quiet simplicity of my life.

It's been worse, a lot worse. Back in the early '90s, my home was anything from an unlocked storeroom to a quiet doorway. The only peace, the only calm, the only silence was the moment when I was exhaling the crack smoke.

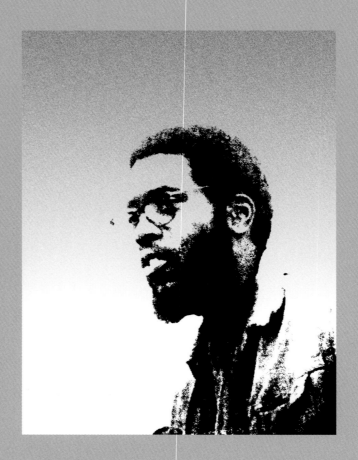

In March of 1991 I rented the old San Diego Seaport Village jail for commercial fashion photography.

Hugh and I drove downtown from my home in North County to meet the city manager at the old jail. The outside of the early 1800s building was classic Spanish stucco. Tiny barred windows were tucked inside thick, old wooden doors. Inside, stale air was as unwelcoming as the cold concrete walls and floors. The city manager opened a blue door marked Block A and led the way inside, asking, "Why would you want to rent this place? The only rental we had was years ago, for a movie."

"I like the light," I said.

The light of the early morning streamed through two high windows like scenes from Birdman of Alcatraz. Two stories of 10' x 7' cells flanked a large open space, still fitted with mattresses on the rusted steel bunks, rust-streaked toilets and sinks. At the end of the block a steel mesh staircase led to the balcony.

I could see a variety of commercial photo possibilities as we toured the building. Hugh couldn't. Hugh was my assistant, a young, sharp guy with lots of opinions.

The city manager warned us as he was leaving, "The renter who made the movie? He accidentally let the door snap shut and locked himself in a cell. He was in there for several hours. So, don't do it."

The place was terrific.

My husband Rob traveled with his development business. When he got back in town that night, I told him what I'd done. "You rented a jail?" he said in shock.

I'd signed a one-month lease.

"This sucks," Hugh said the first time we unpacked the trunk of the old Beemer at the jail. Several homeless wandered in that day as we worked, curious about what we were doing. One older guy with disheveled hair and beard said he slept in the empty jail at night. "You're sort of like...in my house." This irritated Hugh further.

Hugh and I hauled the equipment back and forth each day even though we locked the door before we left. It seemed the old guy wasn't the only one entering the facility at night. We prowled through the far side of the jail, a nasty-smelling, moldy, carpeted space the sheriff still used for training dogs. We found a couple of busted-out windows and figured that's where the homeless entered. I found myself wondering what their lives were like.

Hugh and I were crossing Fifth and Market when a skinny black female, clutching a book, approached us in front of the Aztec Theater.

"Excuse me, would you like to take my picture?" she said, striking a pose.

"What's the book you're reading?" I asked, taking a photo.

"Oh, I'm not reading it. It's camouflage. Works like this, you take my picture, talk to me, and I say, 'Gee, I could sure use a half a chicken at Ferris and Ferris, the best chicken and I can't eat a whole one.' Got the picture?"

"Yeah, you panhandle," Hugh said.

"Call it what you want, I call it work."

I asked what her name was, how old she was, whether she lived on the street. Thirty-one-year-old Chelsea Townsend said she lived inside and outside.

"Let's get going," Hugh said to me.

I told Chelsea we'd buy her some lunch.

"I can just tell. You need to loosen up," she said to Hugh, swinging her hips and checking herself out in the dirty street windows. She waved at men as she passed, calling out, "Hi darlin'." She led us to the Half Moon café, a Chinese hole-in-the-wall. She seemed to have forgotten about Ferris and Ferris.

The owner knew her. We watched her pack away Chinese-style chicken and dumplings, three cups of coffee with six teaspoons of sugar, no bread, no greens.

Hugh was angry and quiet.

"Cat got your tongue or are you paid to be quiet?" Chelsea asked him, picking the chicken apart with her long fingers. She moved her head to the music and said, "You don't want a bite of this? It's divine."

I explained we didn't have a lot of time.

"You goin' to that jail?" she asked without lifting her head.

"How'd you know where we were going?" he asked.

"I wasn't born yesterday, honey. What you two need is an education."

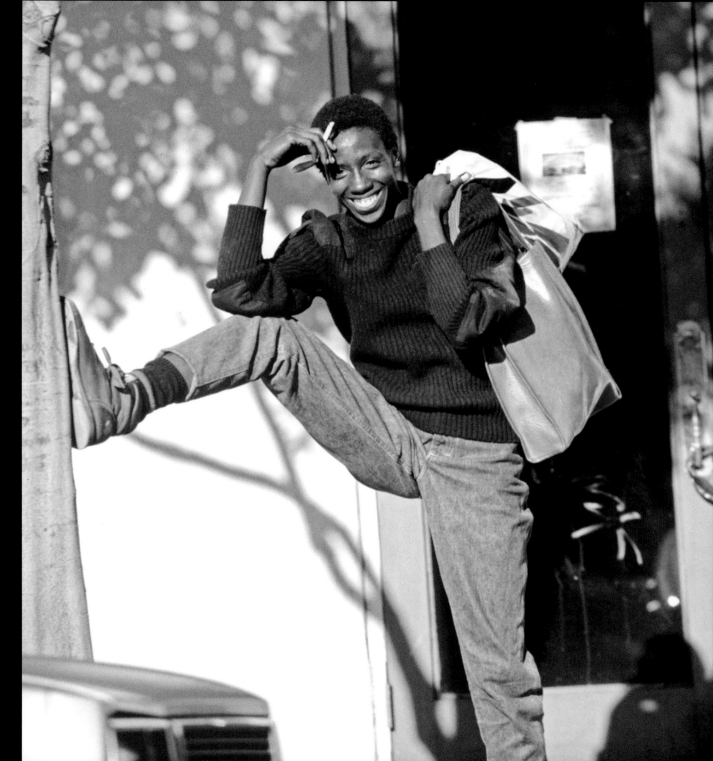

"Call it what you want, call it work."
–Chelsea

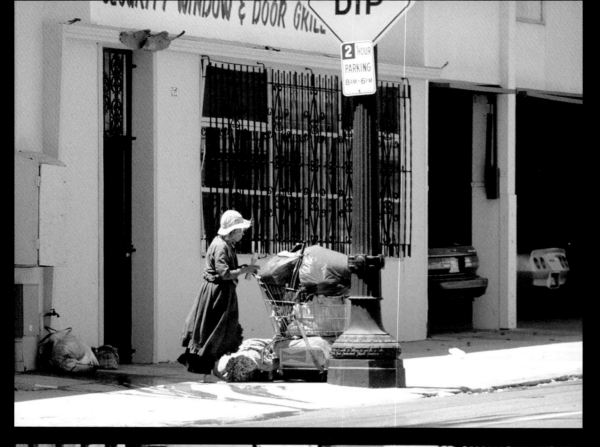

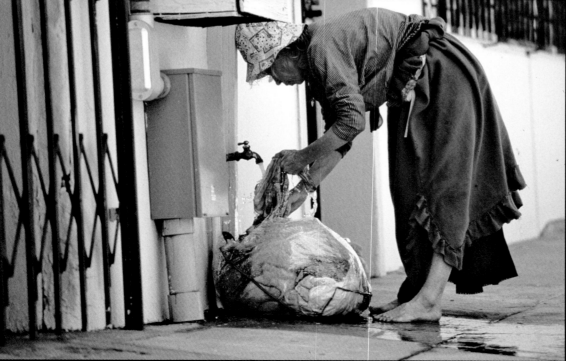

Sunday morning I went downtown without Hugh. I spotted a woman pushing a cart across Sixth Avenue. She looked up at me and said, "I used to be with the police force. I'm a meter maid. I'm in charge of all these meters."

She pointed across the street. "I own that block over there. I'm very wealthy and my mind is in Mexico. I know your mother…"

I turned away to reload my camera.

"I'm not homeless. I just like to push a cart."

The woman moved to a spigot across the street and knuckle-scrubbed her clothes, a container of Downy at her side.

A young, large, black man came up to me. His eyes were bloodshot. "Pardon me, are you a spy or something?"

I explained that I was taking photos of street scenes.

"Not of her!" he said. "She's a mental case. Her name's Bonnie. You have any questions about downtown San Diego, just ask me. I'm Jed."

He looked like a big, dirty kid, 25 at the most, with a sweetly forceful presence. His smell was forceful, too. We talked for a while, and decided to meet the next day at Fifth and Market so he could show Hugh and me around downtown San Diego.

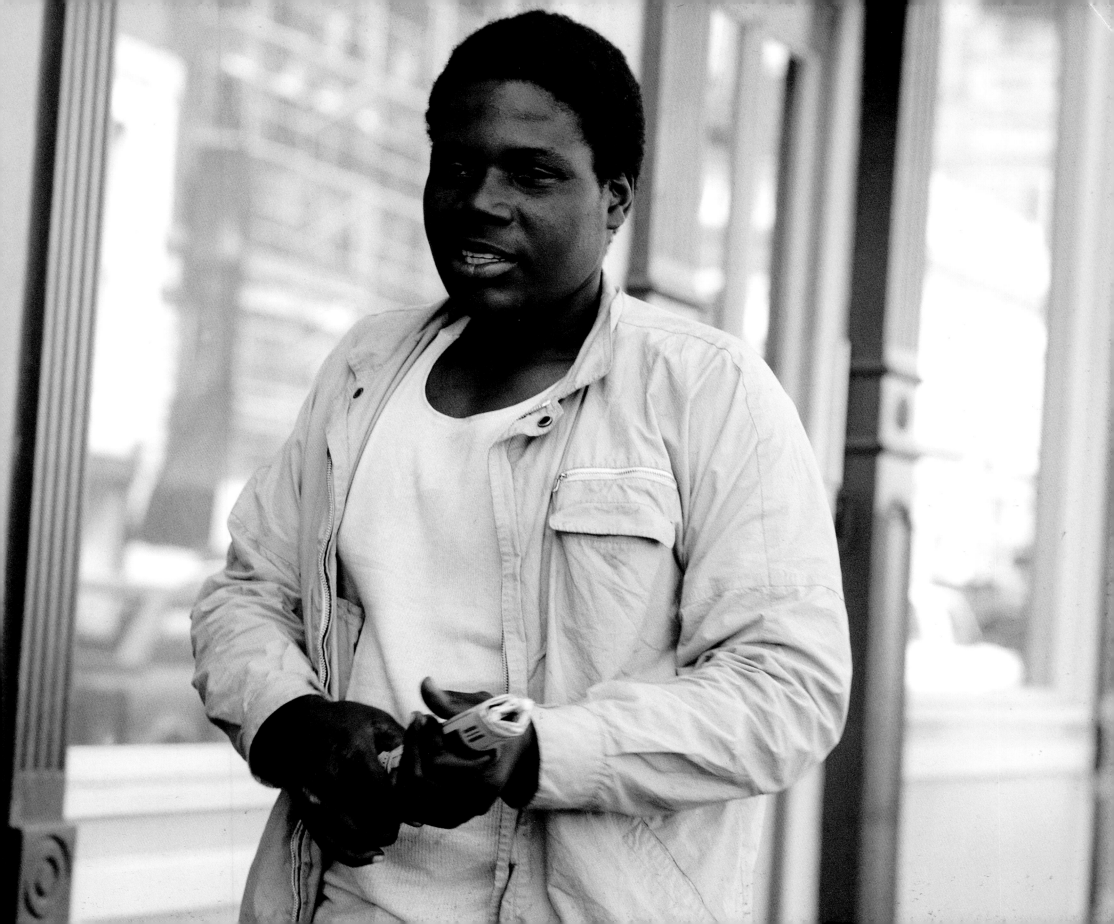

"Hey, Susan, over here!" someone shouted.

Jed was on time, dressed in the same filthy khakis. He wore a great smile and smelled as bad as the day before.

He climbed in the back seat of the Beemer. I opened all the windows. He directed us to the old Coombs Electrical building, where a number of homeless people had set up camp high on the concrete loading dock. Jed pointed to a wardrobe container. "That's where I live," he said.

"Where?" I asked.

He laughed. "In that box! And that's my old homie, Lonnie." He nodded toward a man lying on his stomach in a partially opened sleeping bag.

Lonnie looked up and smiled. His upper left incisor was gold-capped and his smile was huge. Next to his bedding was a bottle of Windex and a roll of paper towels.

"What's that?" Hugh asked.

"That's my job, young fella. I'll get myself up here pretty darn quick and wash windows up and down the streets until dark."

"Yeah, Lonnie, he works hard," Jed said. "Him and me, we been up here the longest."

The dock was friendly. In fact, it was real friendly. A campsite.

The dock was friendly. In fact, it was real friendly. A campsite.

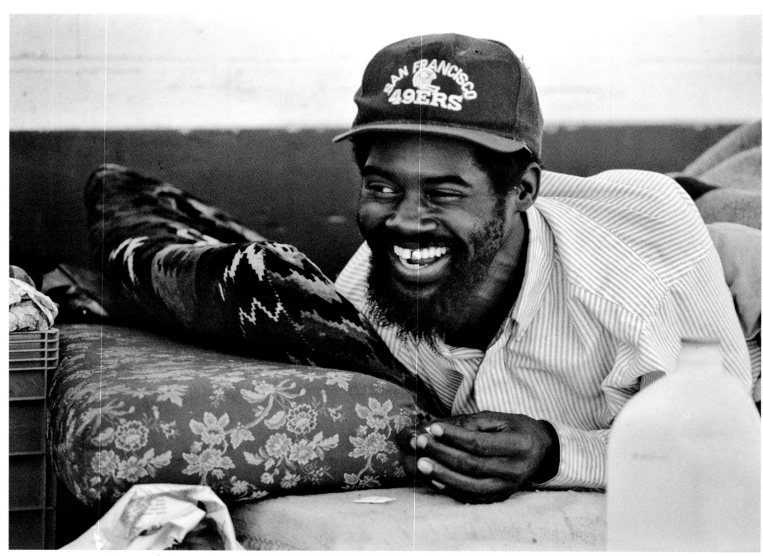

8

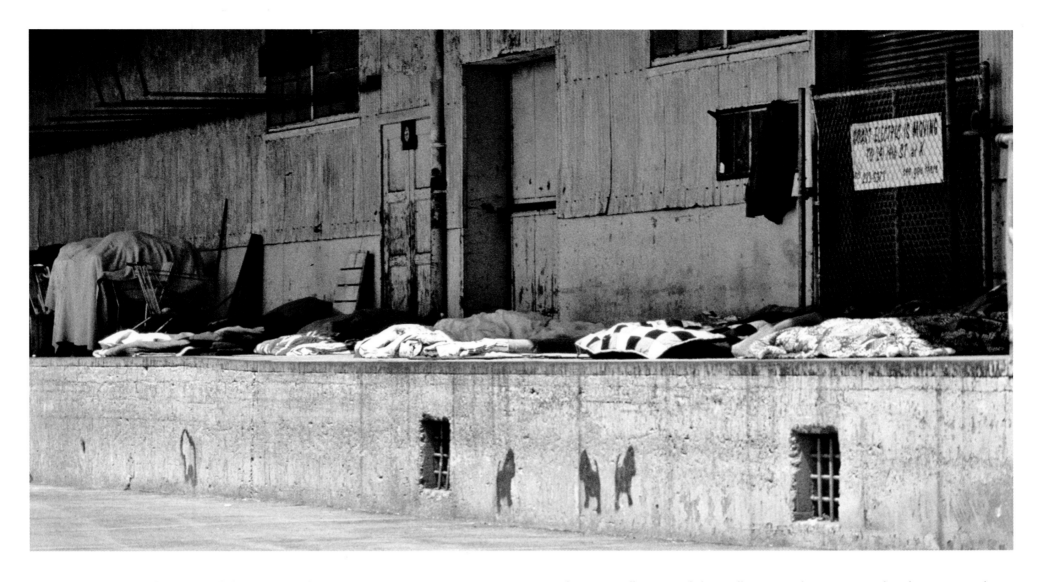

We got back in the car and drove around.

"See, over there. They're smokin'."

"Smoking what?" asked Hugh.

"Oh man, smokin', you know, crack…with a pipe. Ain't you never seen that before?"

"No. What kind of pipe?"

"Wait and I'll point another out to ya. Have to be careful, though. It isn't like pot or nothin'. They don't want to be seen. I'll tell you. Let's park and walk around a little. Pull over to that meter and give it two hours. That'll be plenty."

We parked and walked. Jed pointed out locations along Broadway.

"You probably think it's just business folks going to work who come along here. But see, that's what all these corners is about. This here's the pot corner. Over there's the heroin corner." Turning down Sixth Avenue he said, "And down there, and just about every corner east of Ninth, is crack. Especially around the trolley. You don't want to be down on 12th alone with those cameras, Susan."

I told Jed I'd buy him a sandwich for his time and trouble. He talked about his experiences as he ate, his speech free and easy.

"You got a lot of interesting things to discover, Susan. I think it's cool to be about street folks and what goes on in downtown San Diego. This is my home. I been born and raised in San Diego. No place better."

"Being homeless?" Hugh said.

"Well, the homeless part, that ain't so great. No. But, San Diego, I loves San Diego. My whole family is in San Diego. I goes fishing here, fix my own meals, sleep where I want. Inside or out, it's home."

We made another date for Sunday morning. "Be at the dock at seven-thirty," Jed said. "We have to be down at 11th and E before the old man arrive with the breakfasts. He does it every Sunday. You guys will be surprised how many turn up for free sandwiches and juice."

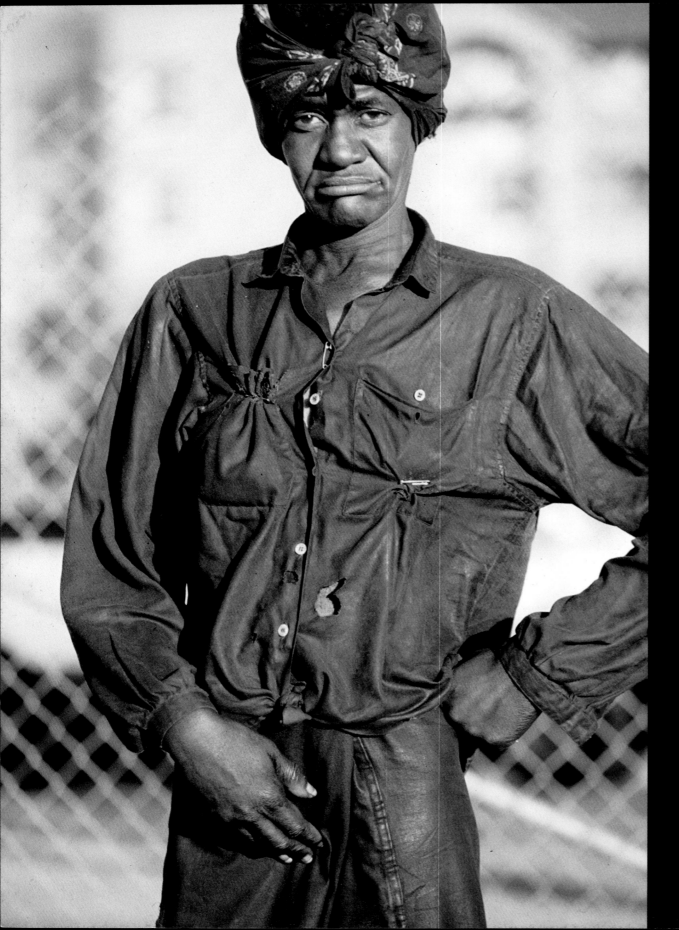

When we came out of the deli, an old black homeless woman looked at us, talking to herself. I asked if I could take her picture. She stopped and struck a pose.

"I ain't no professional model or nothin'," she exclaimed.

I'd begun a new relationship with the streets of downtown San Diego. As I told my family about some of the experiences, I realized it was going to take another level of exposure for them to understand.

"I ain't no professional model or nothin'."

–Momma

Michael, 2009

I was on the street from '89 to '91, and again for a number of months in '93. I was like this urban survival dude … I stayed out of the way, kept a low profile, and no matter how drunk or high I was I tried not to do anything too stupid. Personally, I didn't feel safe in a group setting … although some do, that's why you see homeless folk all bunched up together … that wasn't me.

Downtown was crack infested, my kind o' town. I'd stroll through Gaslamp … it had fruit stands, abandoned warehouses and bodegas … nothing like it is now, with all the shops and cafés. I'd get food from the hotel dumpsters … the Embassy Suites was a regular stop … the Hyatt and the Marriot weren't even there yet. Along the way, I might have to fight over a bad drug deal … fight people off after I bought some dope. Sometimes I'd jump in a pool to wash up … that always felt good … sneak into the pool at the Embassy Suites, dive in, then shower, and bolt out before I got caught.

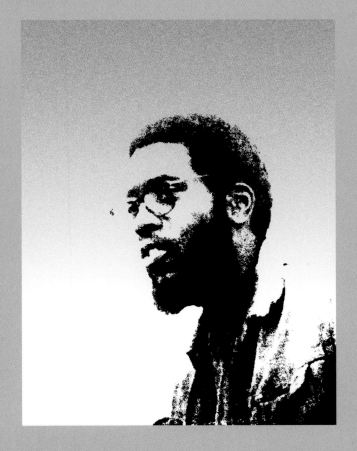

I did think I was immortal, as if time had no effect on me. The days, weeks, months … hell, years passed and I was still stuck, like a hamster on a wheel … running and running, and getting nowhere.

 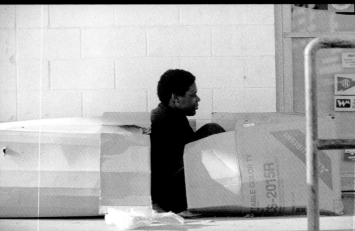 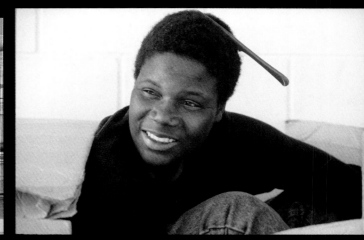

We arrived at Jed's dock on Sunday at seven-thirty sharp. A seagull was perched on a dumpster at the west end of the dock, working on a frankfurter. We cautiously got out of the car. Several bodies, including Lonnie, were lined up, dead to the world. I looked for any movement. Not even the bird cared. The top of a TV box was tucked in the bottom of Jed's wardrobe box. How could there be any oxygen in there? A cardboard coffin.

"Knock on the box?" Hugh asked, standing next to it. "You really think he's in there?"

Hugh tapped on the box. The mid section pulled apart a little. Hugh jumped down next to me. It opened a little more. A large black right hand came out of the opening and then Jed's head.

He squinted at us. "Oh man, is it Sunday? What time is it? I'm late? I had a rough night."

He crawled out of the boxes, a chain wrapped around his left hand. "Oh, that… I been stabbed so many times I keep this close."

He wasn't completely awake when he got in the car.

"Turn left on 16th, Susan. Go to Market. It'll be on your right."

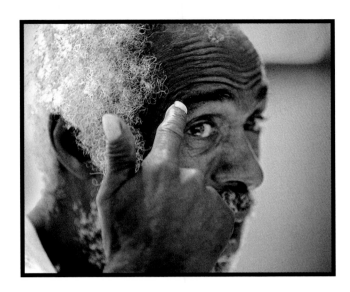

"You mother fuckers get those camera out of here!"

—Papa Smurf

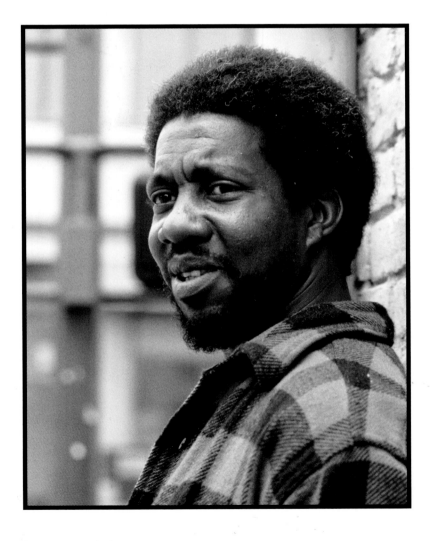

We pulled into the Shell station. A small crowd was gathering across the street, including a tall guy in a lumberjack shirt and a small guy with white hair and beard.

"That be where the old man will pull up, with the breakfasts," Jed said. "And that old guy standing over there now? That's Papa Smurf. He's scandalous."

I started setting up cameras, three of them on sandbags on the hood and roof of the car. The little old man saw me and walked into the street, arms flailing. "What you think you're doing over there!" he shouted. "You got cameras? Don't you go taking no pictures!"

Jed laughed. "What I tell yous? Oh man, he's really worked up, and you haven't even done nothin' yet."

The old man stomped past us, heading to the gas-station pay phone. "I call the po-lice!" he yelled. "You mother fuckers get those cameras out of here."

"Let's talk to him," I said.

I explained to Papa Smurf what I was trying to do, and that I wouldn't take his picture if he didn't want me to. He nodded and quieted down. He and Hugh walked off toward a 7-Eleven.

The tall guy in the lumberjack shirt wandered over from across the street. He stood about six-foot-three, with a trim shape. It was a warm day and he was dressed for winter. He said, "Hey, you use nice equipment. I used to shoot a Hasselblad. I drove a truck and did some photo work on the side. They call me Big Man around here. My real name is Roger Wilmington."

Hugh and Papa returned. Papa held a chicken sandwich and a pack of Camels. He walked right up to me, eyes dancing and looking right into mine. "You can't just act like a bunch of mother fuckers, 'cause I'm Papa and I is a Mother Fucker. I know how bad that is. You're a lady. You got to act like one. Don't you go taking no pictures out here without permission. You hear?"

"Would you like to give me permission?" I asked.

He agreed and signed my waiver. "May I call you Papa?" I asked.

"That be my name, baby. You sure can. And I'll call you Baby. They call me Papa 'cause Papa's been out here a long time. I am just a Mother Fuckin' Nigger. This is my home. I been in all the wars. I been in Viet Nam and watched women and children get killed. I been a smoker, a drinker, a bastard. And look at me, I'm 62, I still do pushups."

Papa dropped to the ground and started doing pushups.

Big Man said, "I have a wife and family in Pismo. All of that. I guess you could say I'm on vacation. You know, boom, boom, boom, taking a little break."

Papa stood up. "Let me tell you something. Papa has seen a lot. You know, in one month, my wife died, my mother died, and my daughter died. I never smoked crack up 'til then. I drank, oh yeah, I drank, but that's when I came out on the street. I didn't have anything to live for and I'm too tough to die."

Big Man said if I needed any photo assistance he'd be interested. He and Papa headed back across the street. The crowd was thick and glaring at us until a brown hatchback pulled up. Behind the wheel was an old man with a gray mustache and tense arms. He got out and was swarmed by homeless. Papa strutted back and forth. Wordlessly, the man handed out juice and tidy brown-paper packages of homemade baloney sandwiches. He was gone in 12 minutes, leaving fed homeless, their trash, and a bunch of birds picking from the remains.

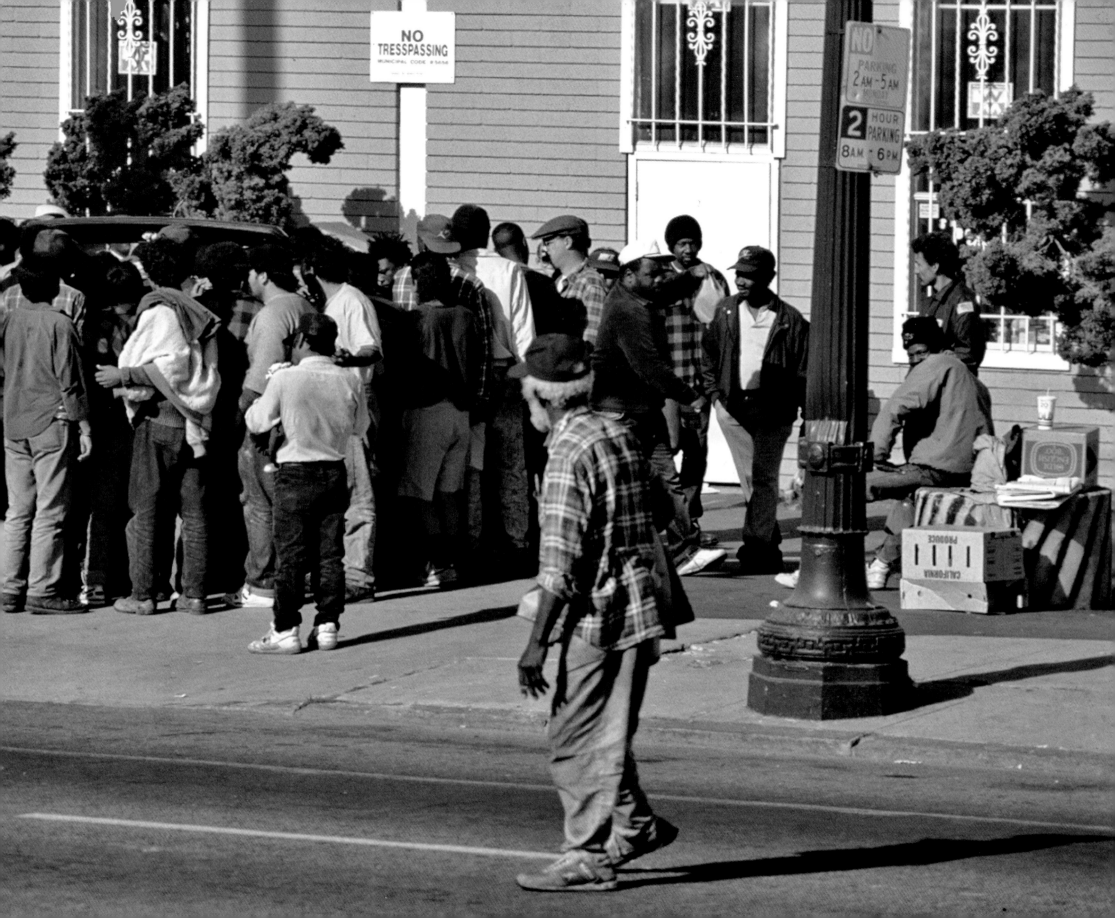

We saw Chelsea once a week or so. She'd come by the jail, or we'd set up a time and place to meet. She was a chameleon. One day she'd be dressed in ragged jeans, another in high heels and a hip-looking jumpsuit.

She insisted on taking us to meet Randall Henry, a man she'd done office work for a while back. He owned a produce business and had a suite in a handsome old historical office building. Chelsea called him "Dad," which clearly made him uncomfortable, but he was polite to me and Hugh during our brief meeting.

I talked to him later, on the phone.

"Susie, she was real sharp looking. I mean, she could dress up and present herself and accept responsibility."

"So what happened to her?" I asked.

"She fell back on drugs again," he said. "It's that simple."

Chelsea could get into rambling monologues. At McDonald's one day she told us about meeting Phil Collins, how he'd offered her a job in L.A. She seemed to be telling the truth. Another time, she told us about a security aide for the governor of Virginia who wanted to give her an airline ticket to Georgia and buy her expensive clothes.

She talked about getting high. "You have to analyze coke, like a person would analyze a pissed-off leopard," she said. "I may never stop getting high. I have control over the drug. It doesn't control me. I'm addicted. People are addicted to eating and drinking. They're addicted to different things."

Her agenda was to get money from us. If she took us somewhere or told us a story, she expected to get paid. I didn't get the same feeling from Jed.

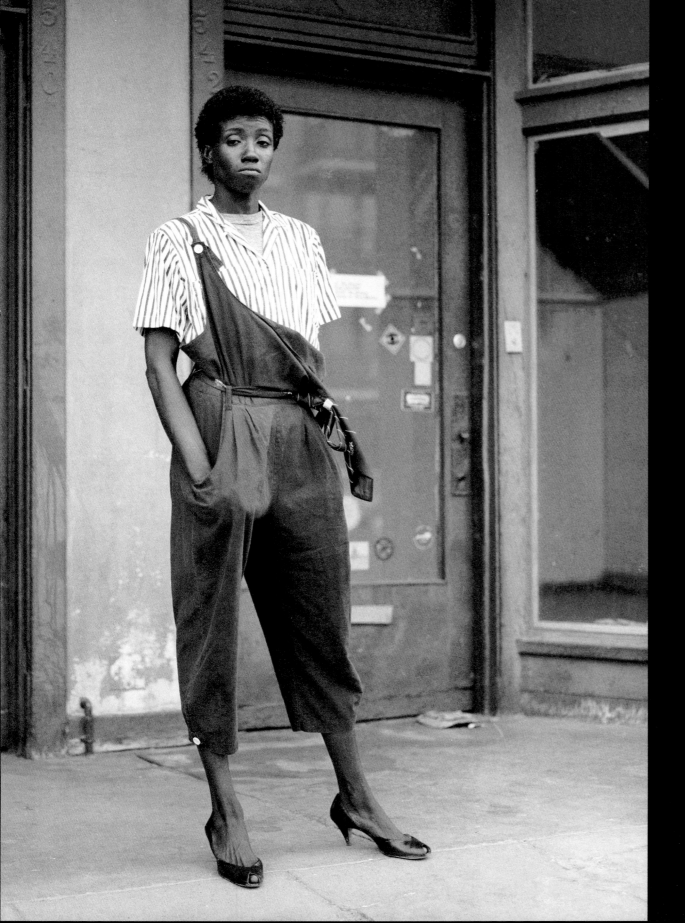

One day she'd be dressed in ragged jeans, another in high heels and a hip-looking jumpsuit.

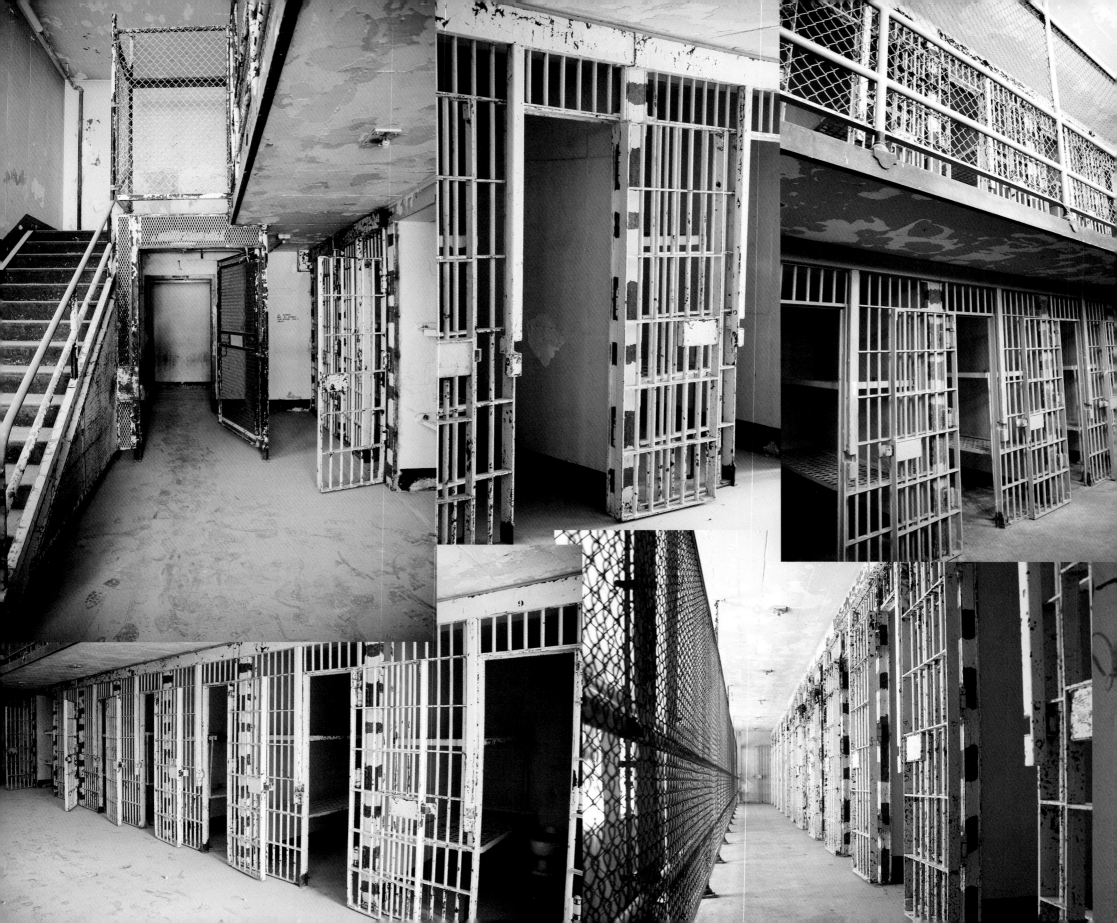

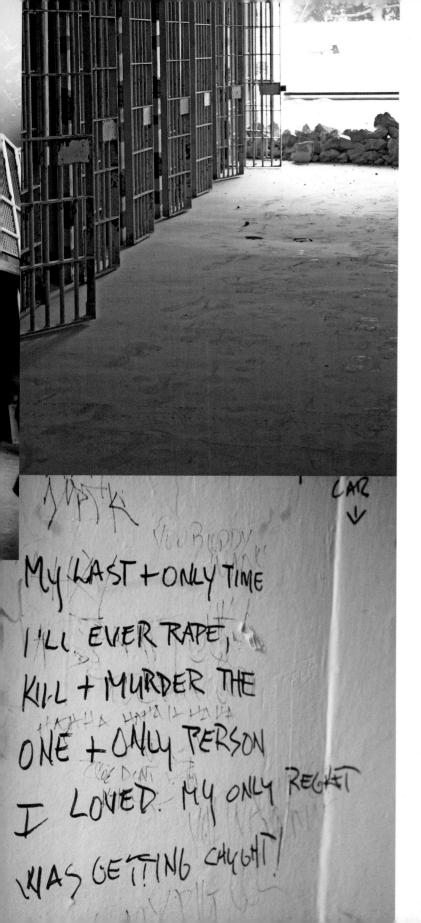

I had told Jed he could come by the jail and help with the equipment. He showed up the morning I suggested at 9:00 a.m. I looked up from a tripod and saw him, shocked. I'll never forget the feeling. He was wearing new jeans, black Nikes strung with green laces, a good-looking blue-textured pullover. I was proud of him!

Hugh was speechless.

"What you want me to do?" Jed asked

We were shooting a fashion layout for a local boutique, with my 17-year-old daughter Polly modeling. I introduced her to Jed. Before long they were joking together; he had a way of fitting in.

I asked Jed to read the light meter, telling him how to hold it and what to press.

We shot several rolls of film with Polly wearing a red-knit designer gown and holding leashes to two gorgeous Russian wolfhounds. The courtyard of the jail was majestic but the lighting was very harsh and contrasty. We worked with diffusion and really too much equipment to carefully instruct Jed but he stayed focused and asked good questions.

Rob, Stacey, and Samantha drove down with a picnic the afternoon Polly was modeling. Before I knew it, Jed was laughing with my two younger daughters as they unloaded the food from the car. Hugh passed out the sandwiches and we sat in the sunny courtyard of the old mission jail. Jed opened a beer with his teeth. He talked politics and sports with Rob, easily and comfortably. He impressed Rob with his broad knowledge of current events, his street truths, and he plugged into being a kid, with the girls.

After everybody else had left, Jed said, "Hey Susan, this was real nice. I have to talk to you about something. It's hard for me. I have to tell you… You see, I'm running from the law."

"For what?"

"It's pretty complicated. I need to take some time and explain it. Not now. I just wanted you to know, I have a past."

"Jed, did you kill anyone?"

"Oh man, hell no!"

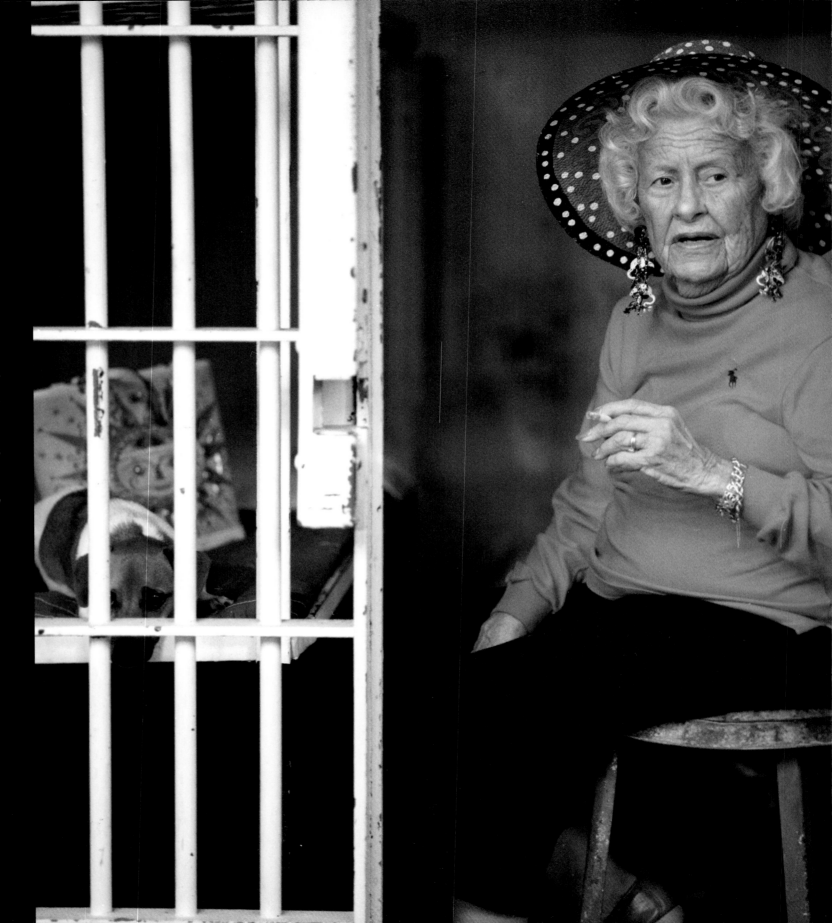

"Why?" Mother asked. "Why would you do anything to get locked up in a place like this?"

San Diego's mild climate drew a variety of homeless to its streets, and the shelters and welfare offices kept most of them downtown or close to downtown.

Many of the street folk were well known by the police, who issued them with multiple citations for vagrancy, sleeping on docks, urinating in public, or jay-walking. The tickets were rarely processed; many of the homeless laughed it off, thinking it was funny to have a pocketful of citations, though this worked against them if they got pulled in for possession or more serious offenses. Some of them, it seemed, didn't mind going to jail occasionally, for the chance to clean up.

On Veterans Day the courts would dismiss many of the tickets from the prior year. I was starting to see the cycles—citations issued and dismissed, bodies recycled in and out of local institutions.

One night, my 87-year-old mother said, "Why would you want to do a thing like that, rent a jail?" Polly had told her about the photo shoot. Hugh made up stories of politicians who wanted to be photographed at the jail. The tenacious Phi Beta Kappa next asked, "When can I go with you?"

Hugh said, "Dorie, we'll take you down on Monday!"

Eight a.m. sharp, Mother stood outside her cottage-sized house. Hugh, laughing, loaded her up in the old Beemer and Oliver, our Jack Russell terrier, jumped on her lap.

I pulled up to the inside courtyard of the jail and parked close to the entrance. Jed turned up as we unloaded the car. Mother looked up at him and said she used to teach black boys at Boys Town U.S.A.

"That right?" Jed said, smiling sweetly, as if he respected an older woman.

He took her to cells and told her about inmates in jail.

"You mean to tell me that you've been in this jail?" she asked.

"I have not been in this particular jail. But I've been in many jails."

Hugh set up a tripod. I screwed a Hasselblad on the tripod. Oliver chased after Mother as she entered the cell and, surprisingly, jumped in her purse. Jed chuckled, then lighted Mother's cigarette. She wasn't supposed to smoke.

"Wait, Jed," Mother said. "Stay here and tell me more about places like this. You mean you slept in a cell this size and continued to commit crimes?"

"Yes, ma'am. I did."

"Why?" Mother asked. "Why would you do anything to get locked up in a place like this and jeopardize your freedom?"

"I wish I could answer that like you want me to, real fast and easy. It's not simple like that, ma'am. I grew up in an area that bred the sort of things that put you in a place like this. I guess you could say this was like going to camp."

Mother smoked nonstop.

"Let me tell you about this place," Jed went on, sitting on a metal stool. "Sitting here and talking about it brings up so many memories."

I thought about asking Jed to write about some of his memories.

Mother smoked and enjoyed the experience.

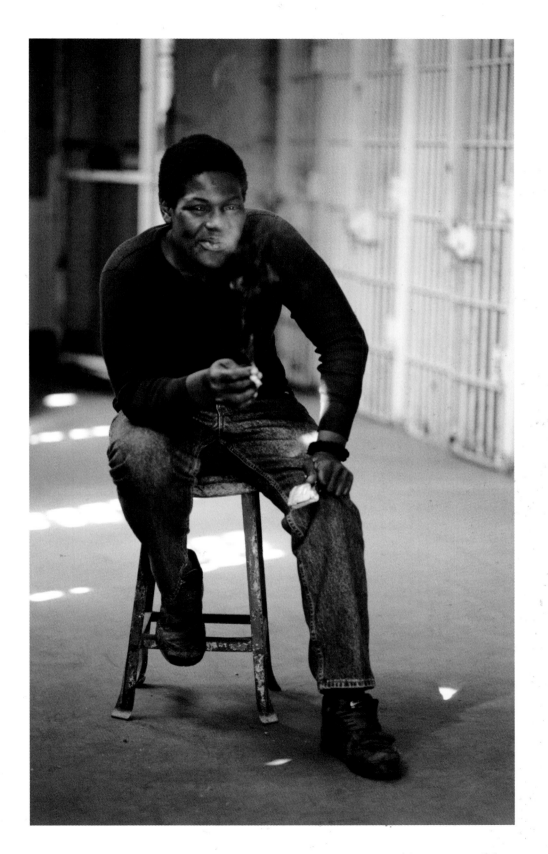

I renewed my lease for another month. Jed helped us on a few more assignments. We saw Papa and Big Man often around the old jail. Big Man introduced me to Walter, another tall and lean black fella. I learned he had sickle-cell anemia, and earned pocket money by selling blood. Chelsea disappeared completely. By the end of the month, I was ready to leave the jail, but wanted to keep working downtown. Driving off, the last week of our lease, we passed a renovated six-story 1930s red-brick building with a white banner saying, "Pioneer Warehouse Lofts, Live-Work Lofts for Rent." I asked Hugh to stop. He stayed with Ranger, my oversized black Lab, as I hopped out of the car and ran into the sales office. I ended up renting the northeast corner unit overlooking the Fifth Avenue Gaslamp district while Hugh waited. Hugh thought this was another bad idea.

The day we were packing up to leave the old jail, Hugh lifted his head from the trunk of the Beemer and pointed across the street.

"Look who's turned up," he said.

Chelsea staggered across the street. "I gotta have me some coffee, something to eat. Take me to Horton Plaza."

We took her to the shopping center. She ate three deep-fried donuts and drank her coffee, talking as she ate, slurring her words. "Susan, I just have to see Jenny, my daughter. It's her birthday today, she's 11. She wants a Cabbage Patch doll. That's why I wanted to come over here. You can find me one and take it to her. She lives with my grandmother Bertoom. Bert hates me. I guess I haven't been…"

Her speech halted. Her chin dropped to her bony chest. She was asleep.

It was 10:30 a.m. I poked her; no response. Hugh stared at his spoon.

Ninety degrees out. We were having coffee with a homeless person who had just passed out at the table.

"She's probably high on drugs," Hugh said finally.

We stood her up and strapped our arms together against her back, pushing and steering her through a busy crowd of shoppers, her head bobbing with each step.

At the car, I held her up while Hugh unlocked the door. She fell into the back seat.

"Where to, boss?" Sweat streamed down his full cheeks.

The car was 20 degrees hotter. Chelsea wasn't even perspiring. We decided on a small motel on 12th, cheap and clean.

"Is this for you, ma'am?" asked the woman at the counter.

"It's for another gal. She'll be quiet."

The woman took a look through the office window and saw Chelsea in the back seat.

"Don't worry, we get a lot of this around here. One night?"

Hugh and I hauled Chelsea into the room and pulled the drapes. I was closing the door when she sat up in bed and yelled, "Get me a hamburger!"

I moved most of the studio from my home to the new downtown loft. Rob was concerned. For the first time I was spending money for a studio and not earning much. He didn't complain; he was just quiet.

Big Man came by the loft not long after I moved in, checking out our sixth-floor view of Fifth Avenue. He'd offered several times to take pictures, and wanted to use one of my cameras. Instead, I bought him a cheap Olympus.

"I've never had a present," he said as he opened the package.

"It's yours. Take some shots."

I met Big Man several times to collect his film and contact sheets after introducing him to the lab owner on the corner of India and Grape. His shots were average. No indication that he'd been a professional, but I wanted to give him the opportunity to show me his view of the streets.

By now, Jed had quit coming by. Hugh and I looked for him in his usual haunts, and drove by his dock several times. The final time, the box had been destroyed.

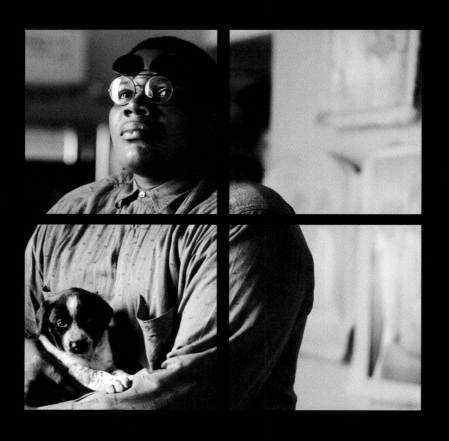

CHAPTER TWO: JED AKA DALTON

THE NIGHT BEFORE MOTHER'S DAY, Rob and I decided go to dinner at Dobson's then spend the night at the loft. The kids were on their own, taking care of the animals.

Heading down Fifth Avenue toward the restaurant, I noticed a guy tweaking behind a hedge. The guy was picking and plucking at the foliage. When he lifted his head, I saw it was Jed, but he quickly turned and walked off.

As we walked back from Dobson's, Jed came out of nowhere and stepped in front of Rob and me.

"Where've you been?" I asked.

"Had me some troubles. Didn't want you to see me. But, seeing as yous is out here now, thought I'd tell Rob not to show that gold watch around too much this time a night."

Rob ignored the comment. "Jed, what's happened to you?" he asked.

"Hey man, you got five bucks?"

Surprised, Rob dug into his pocket and pulled out his wallet. "Sure, here."

Jed left, head down.

At the entrance to the loft, he reappeared and pulled his right hand out from behind his back.

"Here Susie, happy Mother's Day," he said, handing me a single red rose.

The day after Mother's Day, I got a collect call from a jail.

"Hello, Susan? It's me. Jed. I got myself in a little trouble again. How are the kids? My old homegirl Samantha answered the phone, didn't she? I could hear her voice but they wouldn't let us talk 'cause it's collect. It's bad this time. I don't know what's gonna happen to me, and over just a piece of fruit and a package of meat."

"Jed, start over."

"I'm sorry. I was tired, see, and I fell asleep on the trolley and the next thing I knew, I was in Lemon Grove. There's an Alpha Beta market. I go in and walk back to the meats, then I get me a piece of fruit, a peach. They got me. They dragged me out of the store and handcuffed me. It looks like I be in for six years, this time."

"For stealing fruit?"

"I had priors. I have a record. There's someone you could talk to about me, my parole officer, Larry Barnard. Call him in the San Diego parole office. He knows just about all there is to know about me."

He told me his real name was Dalton Carroll. Jed was his street name. "I'll always be Jed to you," he said.

I called Lieutenant Larry Barnard the next day from the loft. He was abrupt.

"I'm calling about Dalton Carroll," I said. "He's been doing a little part-time work for me and I just found out he's in jail."

"So, what's new?"

"I don't know. I hoped you could tell me."

"Ma'am, I don't know what you want, but I can tell you I've known Dalton for 16 years and he's bad. They don't come much worse. If I were you, I'd forget I knew him."

"You're his parole officer?" I asked.

"Was. Dalton violated all his parole meetings. Hasn't shown up in a year. He's a repeat offender. Types like him never change—in and out of jail for as long as they live. He's bad, ma'am."

"What did he say?" Hugh asked.

"According to this guy, Jed ought to be sitting next to the worst on death row."

"Jed can't be that bad." Hugh was weakening.

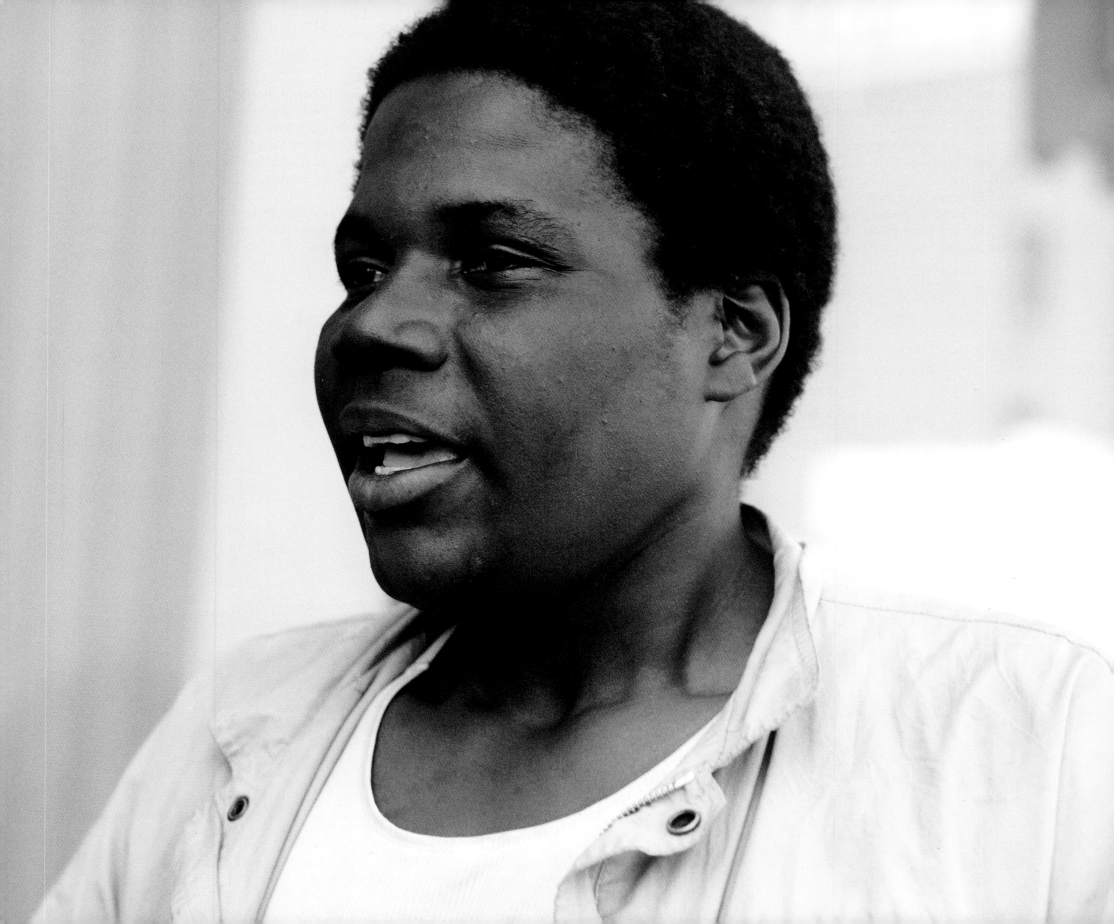

Big Man had been taking photos for me for a couple of weeks now. He would drop off film at the lab on India Street and I'd swing by for the contact sheets and to pay the bill.

He'd told me about God's Extended Hand Ministries, at the corner of 16th and Island, where he and Papa and others went for a free lunch. "Sister Winnie is Jewish and doing this Pentecostal thing," he told me. "She lives in some big house in La Jolla. You have to listen to a sermon to get lunch."

He offered to show us the place.

"Morning, lady, Hugh," he said as he crawled in the car. "How ya'll be. It's like beautiful out, huh? Got the film?"

I handed him the most recent contact sheets.

"Oh, they look pretty good. Yeah, see here, this is a guy was out cold. He didn't even wake up when the flash went off like boom, boom, boom."

We drove to God's Extended Hand Ministries. It was a blocky two-story building with a cross on the side and a lot of homeless people milling around on the sidewalk. Next to it was a cottage, painted bright, strong green. "That's where Sister Winnie has her office," Big Man told us.

He showed us the meeting hall, the kitchen. He told us the cook had recently lost his wife and lived upstairs. He clearly liked the cook staff better than the preachers and missionaries.

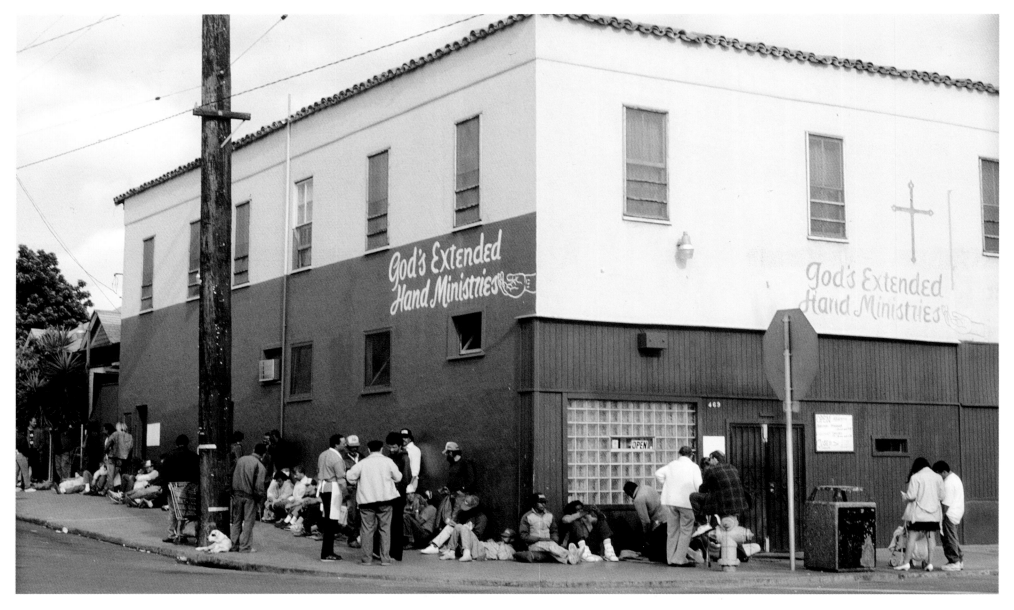

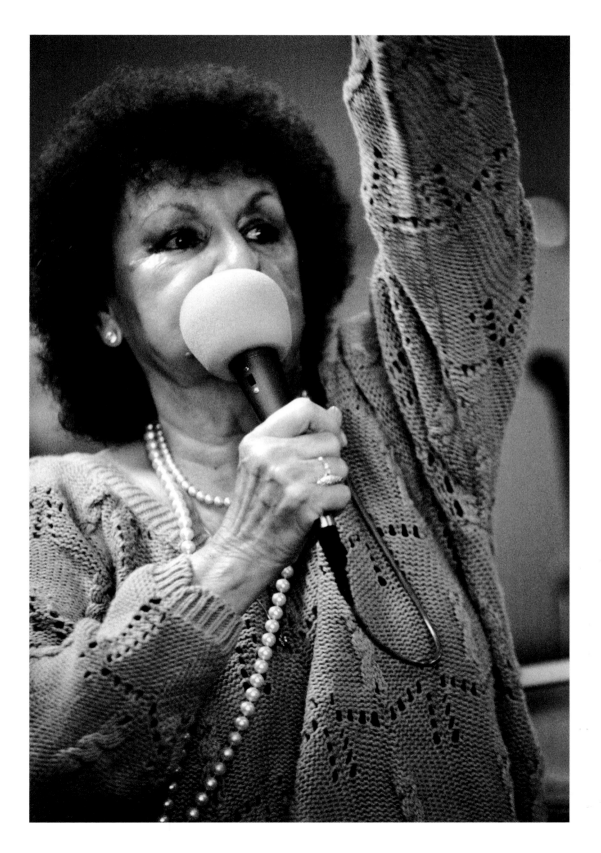

He joined his friends on the sidewalk and left us alone to meet Sister Winnie. We entered the cottage into a tiny living room, the adjacent dining room converted into a reception area. A large, elderly woman greeted us then disappeared. Hugh retreated to a couch in the living room. I hadn't seen doilies on furniture since my grandmother's house.

I glanced into an office that was totally pink, with white lace drapes on the windows. A stern-looking older woman, talking on the phone behind a cluttered desk, looked up at me without any interest. I joined Hugh in the living room. Fifteen minutes later Winnie clicked into the room on five-inch hot-pink spiked heels.

"Who are you?" she asked, her abruptness a contrast to the feminine surroundings. She swished behind me to readjust the doilies, not missing a thing. "What do you want?"

She softened a little when I asked her about her ministry.

"I was an alcoholic, headed for devastation. God saved me, and I want to help others to follow the Lord and let a spiritual life overcome their addictions."

"Can we come to one of your lessons?" I asked.

"You can come to my birthday party. I'm not going to tell you which one." She laughed. "It's next Friday, the 14th of June. You have to wear a party hat. Everyone wears a party hat. Plus, I want a picture!"

Hugh and I attended the birthday party. A roomful of homeless people wearing party hats left me wondering how much good Sister Winnie was doing. Lunch and a sermon wouldn't keep people like Jed off drugs, or out of jail.

Later that day, I got a call from Stacy Gulley, Esq. He asked me to write a letter about Jed for Judge McGrath. "Frankly, I have little defense for Dalton," he told me. "His priors are serious. With his parole violations, he could get six years. I don't know if your letter can help, but might as well give it a try."

I wrote the letter.

On June 19th, Stacey and Polly joined Hugh and me at the courthouse for Jed's trial.

Jed smiled at us, wringing his hands at the same time. The courtroom was crowded. The viewers were there for the trial following Jed's. A sailor was accused of killing a member of his girl's family.

Mr. Gulley began, "The state will try to prove Mr. Carroll guilty of stealing one orange, one banana, and a container of prepared meat from the Alpha Beta in Lemon Grove."

We sat through 30 minutes of legal proceedings. Before reading the sentence, the judge picked up some papers.

"The court will take a few minutes' break while I read this rather lengthy letter from Mrs. Lankford," said Judge McGrath.

My heart was pounding. I realized I'd been very outspoken about Jed as I knew him, with little knowledge of his priors.

We milled around in the corridor during the recess.

"The court is out of recess and will come to order," said the bailiff.

"Mrs. Lankford, where are you?"

I raised my hand. The judge took a moment to locate me and ran his eyes over Hugh and my girls. "I take it this is the family you refer to in your letter?"

"Yes."

"I find this letter very interesting. I spoke with Mr. Carroll at great length, and I too was impressed with his honesty. I'm going to reduce his sentence to eight months. I feel it's necessary to sentence him, due to his parole violations and prior offenses. I hope, Mr. Carroll, you learn from this. I also hope you appreciate the value of Mrs. Lankford. If ever there has been a case of hands across the water, this is it. If you're smart, you'll contact Mrs. Lankford when you get out."

Two men escorted Jed from the courtroom.

"How about some lemonade," said Hugh once we were outside. "It's hotter than a witch's tit out here."

"I can't wait to tell my friends what can happen if you take an orange from the farmers' market," Stacey said.

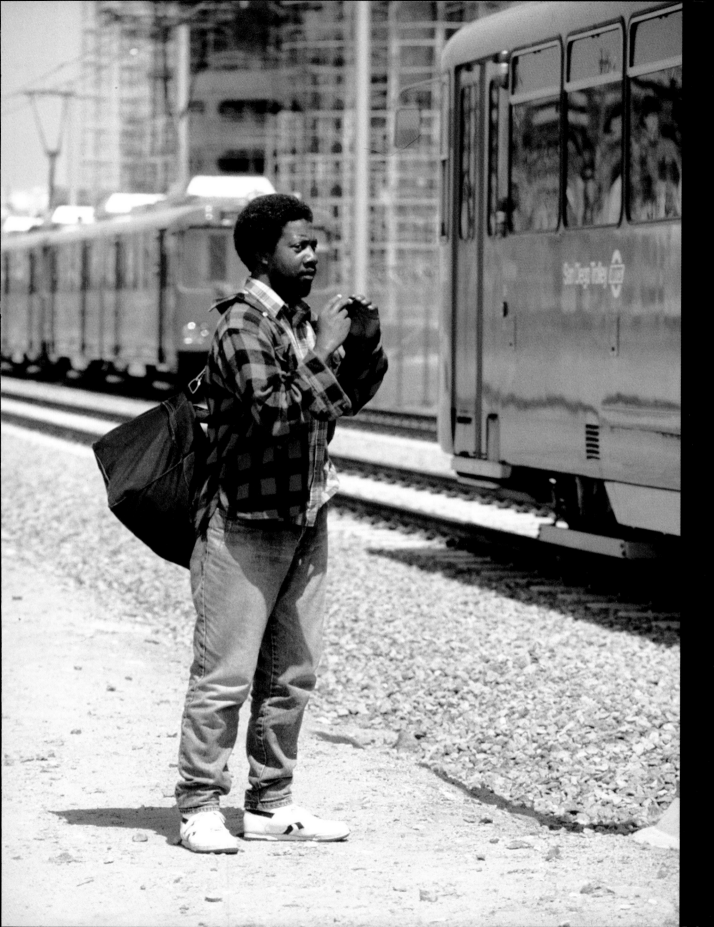

The guy at the film lab showed me inconsistencies in the exposures of Big Man's photos. "It almost looks like he's opening the camera back in real dim light. Do you have another one he could borrow just for the night, to see if it's something he does or the camera he's using?"

I decided to loan Big Man the old R-3 Leica. I handed it to him outside the loft.

"Yeah, I'll try it," he said. "I want to figure out what happened to that film."

"Bring it back tomorrow," I said. "I'll meet you at the lab. After the film drop."

"Okay, I hear ya."

The next day, he didn't show. The lab had not received any film from Big Man.

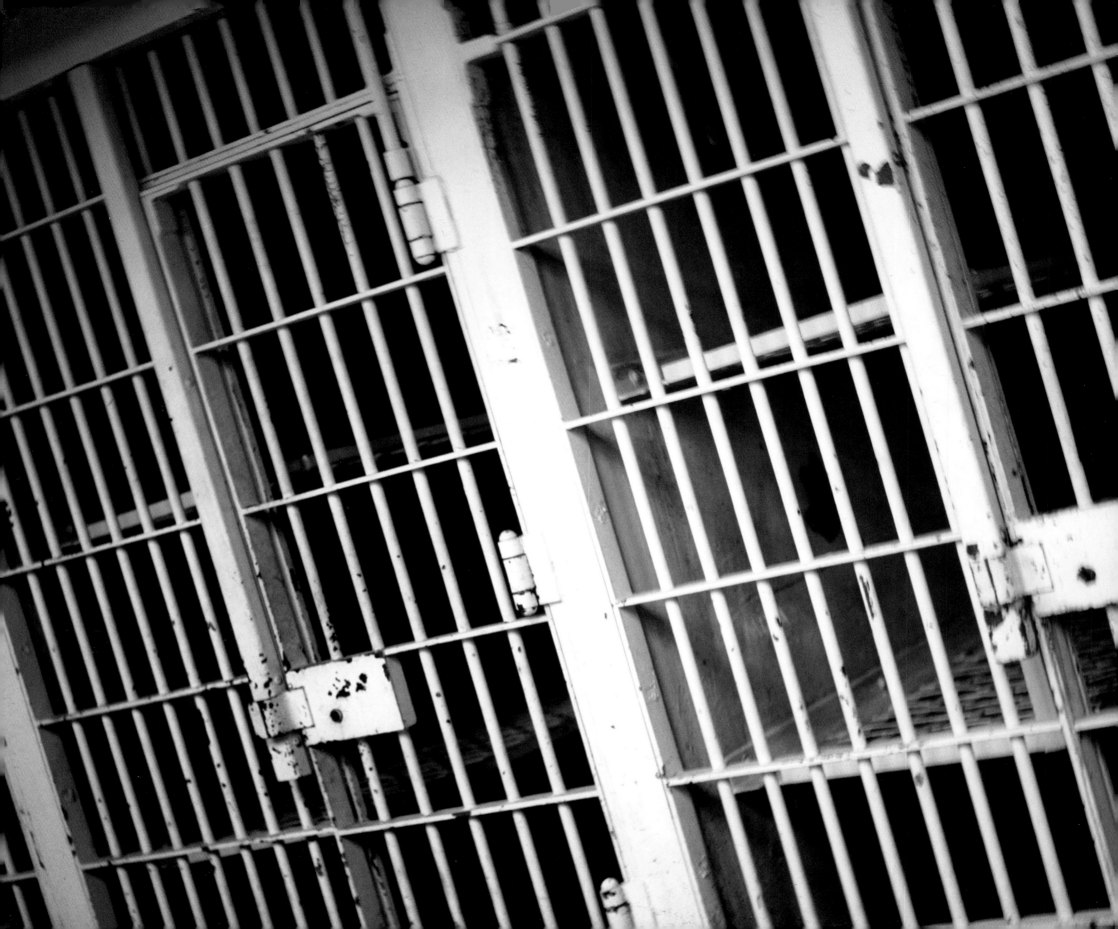

Jed sent me some writings from jail.

I was taken to the La Mesa police department where I
received my rights, but I pretty much tried to lie
due to the fact I was on the run for parole for using
cocaine and change of residence without permission. I
gave a false name but they gave me fingerprinting. Since
I am a parolee and ex-con, they transported me to the
county jail in downtown San Diego. You get a wrist band
with your name and number stamped on it like an animal.
You can make three calls, usually to your mom, lawyers,
and bail bondsmen.

You are packed in with many small-time felonies,
misdemeanors, and drunk driving, foul smelling, three
long benches and crowded. They strip you naked and
check you over including all orifices for hidden weapons
and drugs.

In jailhouse clothes you're put in a larger holding
cell with people relapsing, kicking drugs. They piss on
the floor, they throw up all over. There are gnats flying
around. It's very filthy.

This was Jed's seventh time in jail. I was learning a lot about the American penal
system. Jail was where you went when you were awaiting trial, or for short sen-
tences. For long sentences, you went to prison.
 Jed was transferred to Donovan Prison.
 "Oh man, I wish you could see this place," he said, calling from the prison.
"There ain't no sky!"

Hugh and I went to visit Jed on Saturday. We waited in line. Most of the visitors were girlfriends, plus a distraught couple there to see their son.

They let Hugh and me go together into the room with phones and booths for conversation. Our side of the barricade was about three feet wide and 20 feet long. A voice from a gray speaker strung up in the corner repeated, over and over, "Please limit your conversation…"

Jed picked up his phone. "Man, you never been in one of these places, have you? I can see by your faces." He laughed.

"Got a lot more to write you. This is good in a way, see, makes me think over things I never did think about. Like stuff with my mother."

He asked about the girls, about downtown, Papa, Big Man and Chelsea. "I don't never want to go back to the street, but I sure is homesick to be out of here."

The guard gave him an extra two minutes. Hugh and I walked out of the two sets of doors to the long hallway. The couple was standing at the elevator, and the four of us rode up together to the exit.

"Third time for our son," the husband said, depressed and stunned. "It doesn't get better. Our boy is a heroin addict. We've put him in one institution after another. He just keeps falling off."

We were now outside the building, headed for the parking lot. The man stared down at the concrete.

"How old was he when he first went to jail?" I asked.

"Twenty-one, a young man. Should be his best years. He's 28 now. Once an addict, always an addict. There's no place for them to go after jail, no transition. Society expects a lost child to magically turn into someone else." He was almost angry by now.

"We must have done wrong along the road," his wife said, "but we aren't able to fix it, now."

"No, dear. I won't hear that anymore! We were there. Hell, we still are, aren't we?"

Hugh and I walked them to their car. I felt as though their son were ready for the gas chamber. He was in for stealing.

"He'd steal anything from you if he needed a hit," the man said, then nodded toward his wife. "She won't be able to talk the rest of the day."

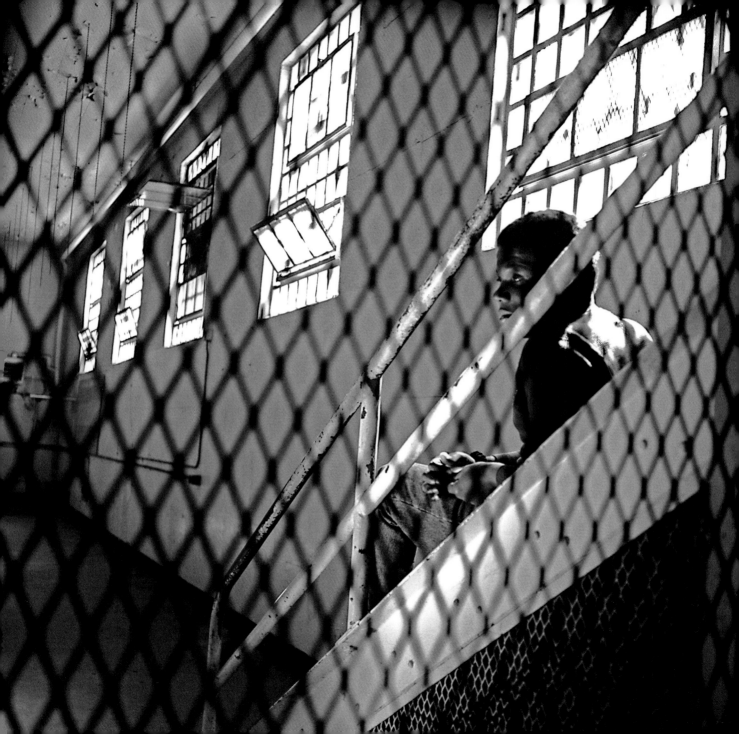

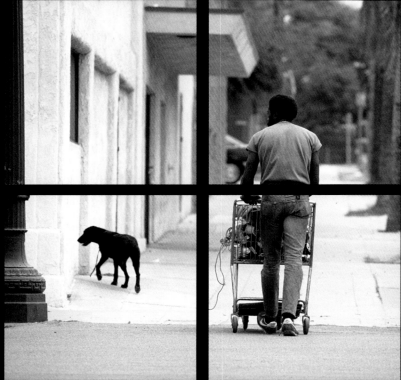

CHAPTER THREE: MICHAEL AND PEP

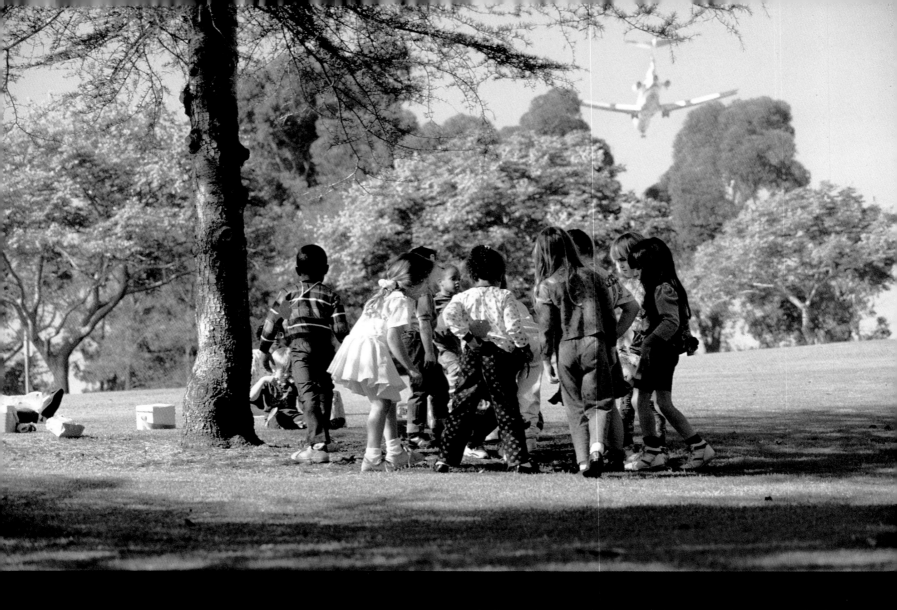

"Teachers bring kids to the park to play, all the time. They don't realize there are used needles by the trees, in the grass."

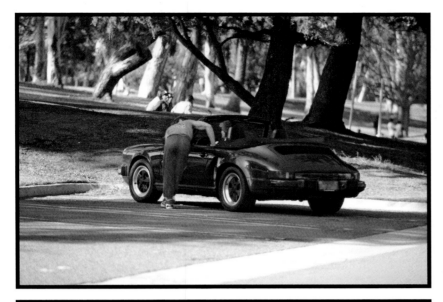

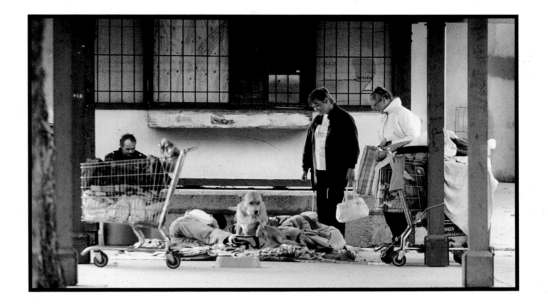

HUGH AND I WENT TO BALBOA PARK one hot summer day with salads from the Cheese Shop for lunch. The park was more like two parks connected by a block-long stone bridge. The side we were on was long and narrow, with swings, teeter-totters, slides, that scene; people grazing and playing. Across the intersecting bridge were clumps of museums, restaurants, and the amphitheater; I'd served on the Museum of Photographic Arts board and attended other museum events, but I'd never driven to the park to sit and eat lunch.

We sat in the old Beemer with the windows open under a huge oak tree, a lovely breeze drifting in and out.

Hugh put down his salad fork and pointed to a brown Porsche convertible parked across from us and down a half block. "Been watching that dude," Hugh said. "I've seen him around, downtown."

"So?"

"See…look at the guy coming out of the can. See him?"

I nodded. The guy could pass for a Calvin Klein model. Shirtless, tanned, long golden locks bouncing with his youthful prance up the grass hillside.

"Watch this. He's headed for that Porsche."

Hugh was right. The guy approached the convertible and leaned on the driver's door, pissed. He shook his fist then stood back only to rush the back of the Porsche and yank out the driver's sport coat. The good-looking silver-haired owner jumped out, grabbed his coat by the sleeve, and tugged until the lining split away. He tossed what was left of his jacket into the convertible, got in, and sped off.

Hugh and I followed him to a major downtown law firm, surprised as he parked in one of the spots reserved for partners.

When I drove around, I looked for Big Man, outside the mission, Sister Winnie's, the Greyhound. No Big Man.

From the north-facing windows of the studio I could see what was happening on the street. We saw Chelsea two or three times a week, Papa showed up occasionally, and Lonnie found a spot to work washing car windows across from our building.

From the loft, I'd noticed a homeless guy with an obedient dog. He always seemed to be on his way somewhere, pushing his full shopping cart quickly and with purpose. His sweet black dog with white markings either trotted alongside the cart or rode in the lower rack. I kept hoping for a chance to talk to the guy, but he moved too quickly.

His sweet black dog trotted alongside the cart.

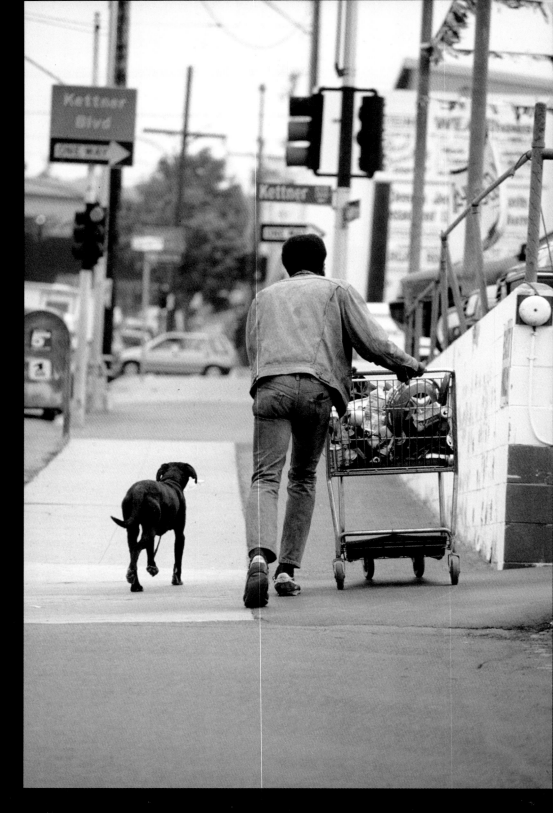

Michael, 2009

It's been so many years since that first day I met Susie … but I'll never forget it. I was drinking my tequila … I had some rock on me, too … and heading on up to the recycling place, the junk yard, when I heard someone calling, a voice I didn't recognize. I didn't usually stop for people … I wasn't into taking food from people I didn't know. When Hugh came running after me … oh man, it could've been anything, an odd job, or a weirdo. But it was this attractive lady, wanting to take pictures of me.

There was something special about her from the very start. I felt I knew Susie from somewhere before … there was a spiritual connection, a sense we'd already met. And Pepper loved her … I was so in tune with Pepper, and Pepper just melted.

Yes, I capitalized on the situation, and charged her for the pictures … that's what dope fiends do. Yes, I took every dime she gave me and got high … that's what dope fiends, crackheads do.

But I was open … for discussion, advice. I let my guard down. For the first time in a long time, someone was interested …

Stacey came to the loft one day in late June. At age 14, she would focus on a photograph she was filing and question me about the subject. Her inquisitiveness was refreshing. I moved onto the small wrought-iron balcony and saw the tall guy with the dog tearing along K Street, flinging his shopping cart, the dog riding underneath.

I begged Hugh to go after the guy. Hugh took off down the hall calling out, "He's moving so fast, I'll never get down there in time."

By the time Stacey and I got to the street we could see Hugh was running full speed up K Street.

It was 97 degrees out at noon. We caught up with Hugh and the dirty black guy at Sixth Avenue. He looked at us, startled.

"Are you homeless?" I asked.

"Yeah. You could say that." He looked at me suspiciously. "Why me?"

"I guess because every time I see you, you're headed for something, and your dog is obedient. I figure you're pretty good with animals."

"Yeah. She's a good dog." He went over to his cart and got the dog. "Come on, Pep."

"What's her name?" Stacey asked.

"Salt and Pepper Sally. I'm Michael."

He rolled the dog over, lovingly. He let her lick his mouth. Then he picked her up with one hand and held her close to his chest.

I told him I was photographing people on the street and asked if I could take his picture.

"Sure. You gonna pay me for it?"

"As long as you sign a waiver. Would you like to do some writing for me? I'll pay you for that, too." Somehow I knew Michael would have things to write about.

After I took some photos he walked over to the camera, jokingly trying to see how many shots I'd taken. "That'll be ten bucks."

He stepped back again and smiled. "Why don't you all meet me on the 12th of July at the train station. You know where the Santa Fe train station is, don't you? Yeah. My mom'll be coming in there at 1:00 p.m."

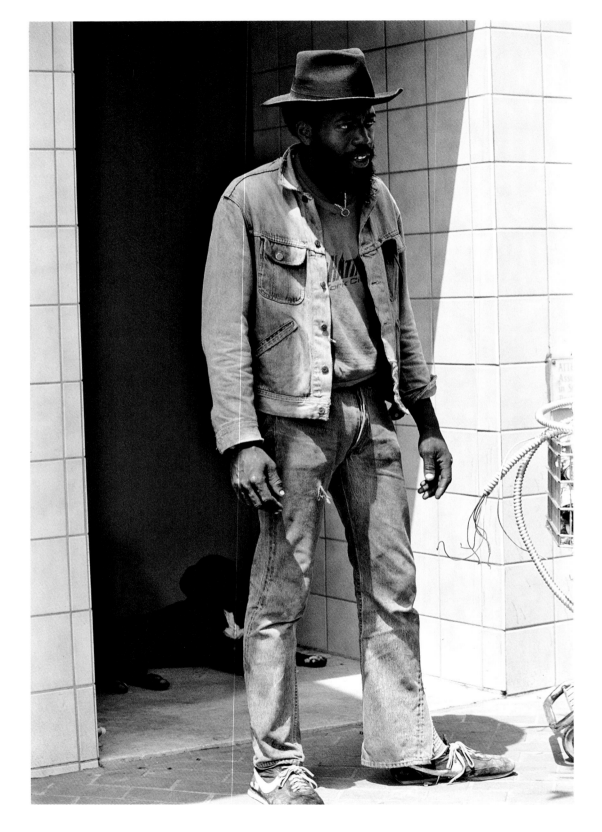

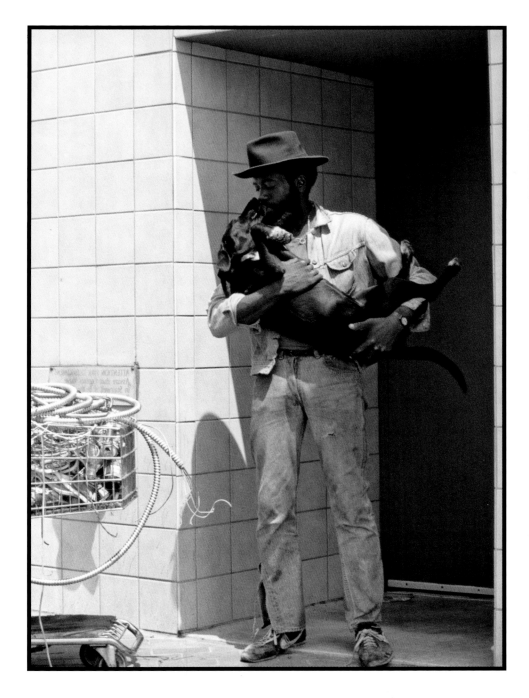

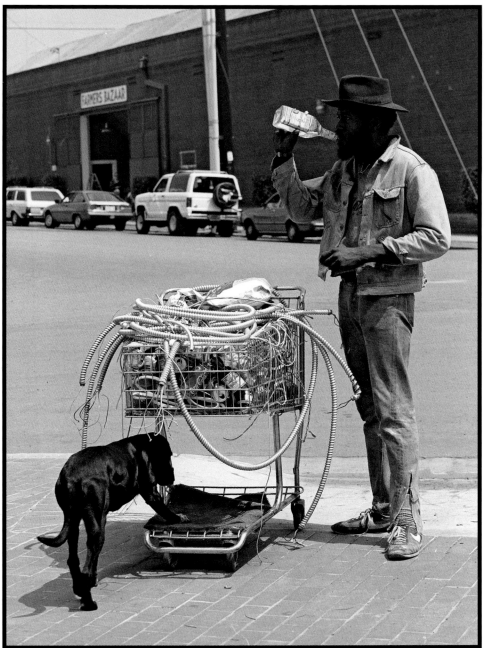

The jail photos were processed and cropped. I had transparencies of Chelsea, Jed, Big Man, the breakfast, Papa, the jail and many from the street. This project was feeling more important to me than commercial work.

Jed sent letters and writings twice a week from prison. The loft had an intercom at the street level, and Chelsea and Papa frequently called up from the intercom. Big Man had slipped away.

Papa usually called up with a warning of some type.

"Hey Baby, where are you? Come down here. It's your Papa and I'm tired of being out here, honey. I mean it. Papa can still do pushups and still smoke my crack, but it's getting tough. Niggers are stealing from a nigger. It's black-on-black crime now."

"Papa, have you seen Big Man?"

"Baby, you stay away from him. That nigger, he took you! I told him, 'There are blacks and there are niggers, and you are a nigger.' I said, 'How could you take Susan like that?' Your camera, Baby. He sat at the mission and told me he sold it to get high. He said he wasn't going to do any pictures. I said, 'You are a real mother fucker and deserve to be treated like one. She trusted you. You are a fool.'"

I didn't want to believe him.

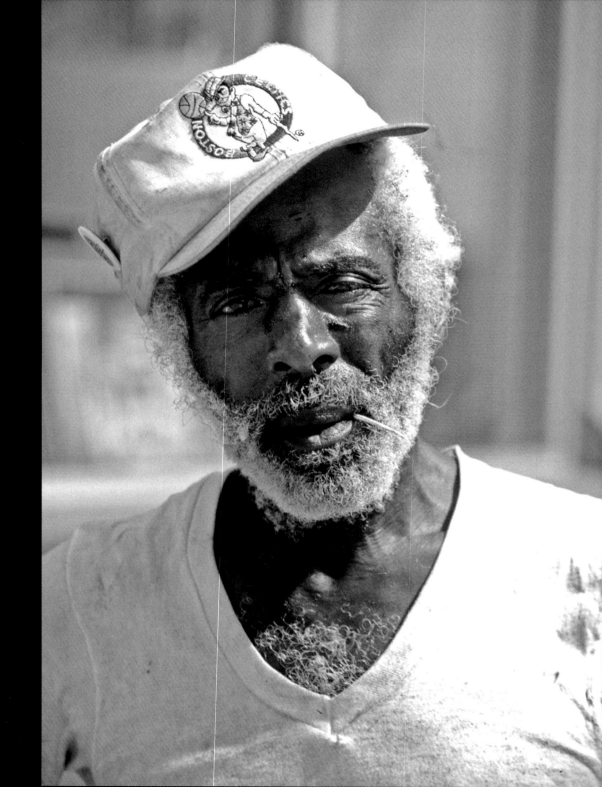

Two letters were waiting for me at home, from Jed.

These people who got me on drugs were my family mother sisters aunts and uncles my only hope for life was my grandmother my grandmother's sister (my great aunt)! She use to tell me all the time to stay away and keep your nose clean she was doing my mother's job!

My cousins were the first to give me my first free-base hit of coke, but my aunt was the first to give me my first big hit of coke a hit so big it knocked me out for a good second. I could have died that day after that it was on. I was sick from coke I was sparked… I started buying half ounces and sell some and smoke some I will sell enough to where I can get me another half ounce of coke, it was not for the money it was for me to smoke! At this time everyone was smoking even the dealers now it is different! They have smokers and they have dealers! I went to prison for the first time and had so much problems from gangs, for the simple reason that I was a Blood.

I'm straight locked down in a 6 x 12 cell with two beds and a toilet plus two lockers and one cellmate. The only good thing is I have a good view of the hills and county view of Otay Mesa. I have already passed one real test for cocaine addiction, I have plenty of chances to smoke coke and other things but I refuse like a real champ. I really don't need the stuff at all, this shows me that I have hope.

Prison life is not a joking matter when it comes to you, yourself and I! I have made up my mind of my life, it's a dream that will come true. First I will attend the drug rehab here at Donovan and upon my parole from prison, I will then attend school for to become a cook and chef and also go to night school for my high-school diploma.

I had a friend name Rob Tom Dillion. He was my best friend. Where I went he was sure to follow and I was the same way. We had trust in one of another. I remember the times when me and him used to get high off of PCP or Sherman sticks and go do us some robberies and break into houses high off PCP to bring our courage up. I had a .22 that shot eleven times plus a nine-shot 12-gauge shotgun. We were two bad-ass teenagers. I will see my old homie sooner or later. I just hope he has woke up and smelled the coffee and stop gang banging because it can be very fatal and life can be taken away from you fast.

"Mom, the phone's for you. I don't know who it is!" Stacey yelled downstairs. I was preparing our Fourth of July dinner.

"Hey lady, where you been? Know who this is?"

"Big Man," I said.

"Hey, thanks for shining me that way, lady. Nice way to let somebody down. Real class."

"What are you talking about?" I asked.

"You just sat up there in that loft and didn't answer your calls. You're no different than the rest."

"I was where I said I'd be the day after loaning you the Leica. Where were you?"

"Like right, sure you were. I had a little trouble, like you know, boom, the camera is there and boom someone puts it to me and carries off with the merchandise. Like where were you to help me out? You are a typical, manipulating white female who wants something for nothing."

"I am fresh out of cameras," I said.

"Just forget it, you bitch!" He hung up.

Papa was right—Big Man sold the camera for drugs! I was shaking.

We had perfect weather for the Fourth of July, homemade strawberry and peach ice cream, a few friends and the kids participating in the town parade.

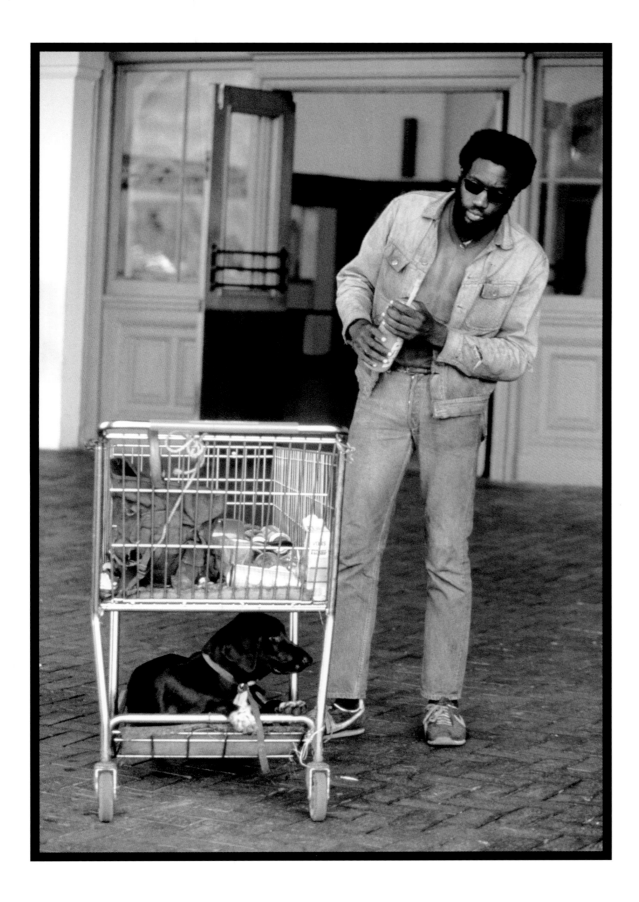

On July 12th, Hugh and I arrived on time at the Santa Fe train station. There was no train. There were no people, just a janitor sweeping the south end of the brick court. Hugh trailed me around the corner to the back entrance where people exit the station to board the train. There, proudly posed at the handle of his grocery cart, was Michael with Pep.

"Hey, where's the train?" I asked.

He looked at me with a surprised expression.

"You know…your mom? Arriving at one o'clock?"

"Oh, that… Well…looks like she didn't make it," he said, casually.

Hugh growled at me and turned away. Michael tilted his head with that look of surprise. I took some photos of him tossing a plastic soda bottle for Pep to catch. We walked several blocks. Michael showed us where he picked up Pep as a pup at a little fenced-in house on Hawthorne, along his daily route. He seemed like he was play-acting.

I suggested we meet again, the following week. I told him to be himself next time. He looked at me as if I was crazy.

"You know...your mom? Arriving at one o'clock?"

Papa, Michael, and even Chelsea seemed to look down on people who went to St. Vincent de Paul and other shelters. They had a macho attitude about the rough-and-ready homeless lifestyle, saying they'd rather live outside than inside.

I decided to set up some meetings with Father Joe Carroll at St. Vincent de Paul Village, a Catholic charity, and also Jonathan Hunter, with Episcopal Community Services. Father Joe graciously told me I could get clearance to photograph and interview willing residents once I checked in with Mary Case, the chief administrator. Jonathan Hunter suggested that I visit ECS residential housing for ex-cons and see the difference between St. Vincent's and ECS.

At St. Vincent's, Mary Case informed me that I could only photograph individuals with a green dot on their ID badges. I entered a central courtyard, surrounded by two stories of small rooms with windows, opened and no screens. Women and children shared rooms while men were placed in dorms. The playground was large and active—kids tossed the tetherball, played hopscotch and seemed relatively happy.

A strawberry-blonde 15-year-old popped in front of the camera with her one-year-old baby. I asked her why she was in the shelter.

"I'm homeless," Mandy said. "My mom and dad can't afford us. This is my daughter, Amber. Amber gets so much attention in here. I'm lucky. See, my parents don't like me being here but fact is, I just got out of a drug survival program on Market and 31st. My mom and stepdad are in a group home. They don't have a home. But my dad is going out today and looking for a job."

A handsome black counselor, Michelle, approached them and picked up the baby. "Oh, I see you met my godchild." She smiled. "Mandy's mom couldn't keep her and then Mandy got pregnant. She has a place to stay in this extension program, for a while. She's so young. The extension program is only 28 days long."

We got stopped by levels of security, following rules for photographers and news reporters. The mixture of folks living there was overwhelming. As beautiful and professional as the shelter was, the kids were heartbreakers.

Kids of all descents lived, learned, and broke bread together at St. Vincent's. An education in itself. The parents? Well, singles mostly and female at that. Out of work or just out of husband, they didn't have the means to support their families.

I heard from shelter operators that there's no such thing as The American Dream. "The middle class—we're two paychecks away from being homeless," said Father Joe.

"We have lost a generation of young people to lead our country," said Jonathan Hunter, Episcopalian Community Services contact. "We have no-fault divorce, buying on the installment plan, drugs, loads of credos to make gratification easier.

"We take what St. Vincent's rejects. We get the hard core; the drug addicted and the mentally ill. It isn't pretty. The success ratio isn't high like Father Joe's, but then I feel that many of his clients would get jobs without the shelter. Try the Palms. ECS works there too."

"My mom and dad can't afford us," said Mandy, a 15-year-old with a one-year-old baby.

Hugh and I went to meet Michael in front of Lubock's restaurant, as arranged. He was late so Hugh and I walked the boardwalk. The plan was to walk the streets with Michael and Pepper and check out some of his habits for survival. We passed the corner a fourth time, headed for the car when we saw Michael sitting at the bus stop, dry brushing his teeth.

He yelled, "Hey, you're late." He looked at us strangely, as if he believed we were the ones who were late. He was wearing glasses without any glass in them.

I handed him a McDonald's breakfast. He stuck the toothbrush in his back pocket. "I don't eat eggs," he said.

Michael fed Pep the eggs, then poured some milk into her tin and drank the rest.

"Here, you're so interested in homeless…"
He handed me some scraps of paper.

After all, this is America, the land of the free. Correct? What is to become of the homeless? Life seems to be a wasteland, just surviving at one of the lowest levels of jungle existence. No luxury. No groovies, no second chances. Just existing, living to drink, smoke and dope ourselves into a state of numbness. To the point of not feeling pain.

There are all types of people on the streets. We all run into each other. Street life constantly makes you want to run, to go somewhere else. However, it seems to be the same old story no matter where we street people end up. There is a mark placed on us, a glow, an aura, placed on us even if I were to put on a three-piece suit. "This is a street person, treat him as such" the sign would say. There's a cloud of doubt that overshadows him/her. Is this person violent? Does this person steal? Will this person try to harm my loved ones? Who is this individual, Why is he/she here? What is this person looking for?

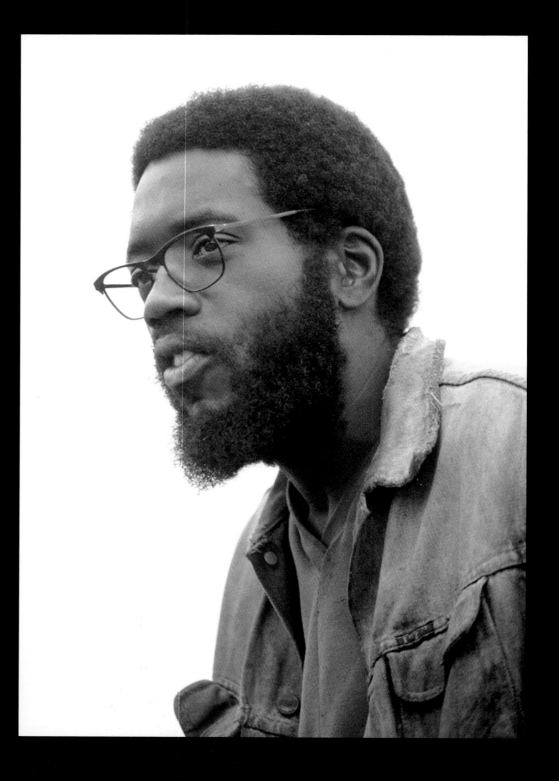

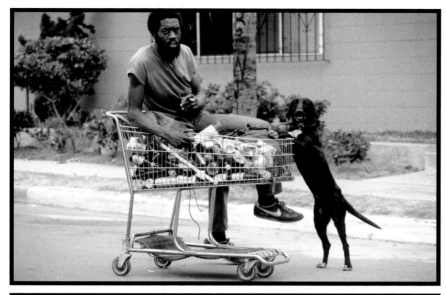

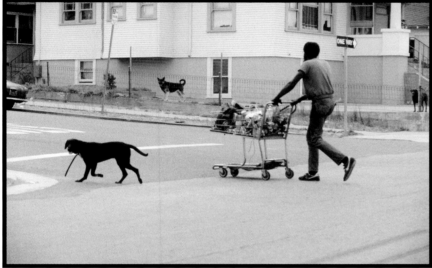

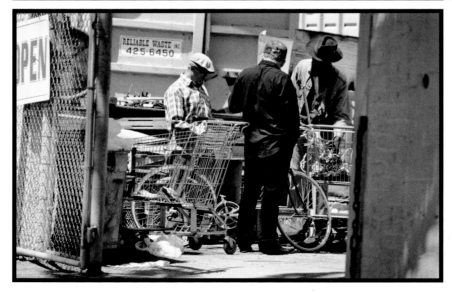

I asked Michael to continue writing. I'd keep paying him, if the writing made any sense.

He met me a couple times a week outside the loft. He never used the intercom. He had definitive times set to meet. Shy but curious, he'd ask, "What do you want me to write about, huh?"

"You could write about your family," I suggested

"Yeah, I guess I could try that out."

Michael continued to intrigue me. He didn't seem to have a real reason to be on the streets, other than the drugs. He wasn't lazy. He wasn't stupid. He was actually pretty damn smart. I'd always feel surprised when I got back to the loft and opened up the crumpled pieces of paper he'd shoved in my direction.

```
I'll start with my brother. I never did like him.
He was a sissy. I recollect getting a beating
for calling him one. Plus he was a tattletale.
When I smoked my first square behind the garage he
snitched and I got a beating. I was looking for a
big brother who was real cool. But he was a wimp.

When I was a kid, my mother always called me "My
Michael." I was the one always getting into shit,
"wandering." We used to jog together ... my sister
and brother away in college and me a junior or
senior in high school, alone with the folks at
home, no siblings.

I also have two half sisters ... my dad's first
marriage.

All my sisters and brother finished college.
All sisters majored in business management. My
brother went to Harvard at 16 and got his Ph.D. in
engineering. My dad is 12 years my mother's senior.
So he had no problem proving who was the "boss."

There seems to be more that just a physical
distance between me and my family, a mental
distance, a spiritual distance, it's like I am so
far removed from them almost to the point that it
never existed. That my marriage never happened and
the kids were never born.
```

Jed sent more letters and notes.

As a youngster, I don't remember things by the age I was. I remember them by the grade of school I was in. It was not until the second grade I started going the wrong way in school. And then, I started doing the same thing at home.

It was a very strict family. We all had dinner at the same time. We went to church and went on a lot of family outings, mostly fishing. It was a good family until the shit hit the fan and my stepfather left.

It all started when my parents started fighting over some woman. But this particular fight, my mother was fed up with it all. She shot my stepfather seven times. She went to jail for a couple of weeks. I stayed with my grandmother and my stepfather until my mother came home from jail. My stepfather ended up leaving for good which was a bad mistake. I think they could have worked things out.

I started to miss my stepfather because there was no man in the house and I started to do my own thing. And this is when my mother came home with this other man who said he will be around for awhile. And this is when we moved from the low class to the middle class.

So at this new school that we moved to for this new man, I was behind my class. Everyone was ahead of me in learning and reading. This was a different kind of teaching and learning and a different kind of people. This was a mostly white school and neighborhood. By the time I got to the sixth grade, I had more white friends than black.

My mother was a smoker and a dope head for heroin. I could not handle no more so I decided to go and get lost from everyone. So I went downtown San Diego as a homeless person where no one knew of me or cared about me. I just needed to get away for a little while but I began to smoke too much cocaine.

As I write this letter, I can look back and see myself running from something. That's what a lot of people are doing. Running. You can run but not hide from your problems.

"My mother shot my stepfather seven times."
—Jed

My mother had surgery in mid July, and we moved her to a retirement community after she recovered. She enjoyed her new surroundings and swam in the pool, daily. I'd receive phone calls. "Darling, I love my new home. I had the most interesting conversation last night with Judge John Phillips. He was valedictorian of his high-school class and graduated summa cum laude from Brown in '32. He's years younger than I." With that, she hung up. I knew she was happy.

I was learning about Michael, both from his writings and from our talks. He'd grown up in New York. He'd gotten a scholarship to Alabama, but went to Morehouse, which he called "the Harvard of the South." He'd been married, and had four-year-old twins.

He almost seemed proud to be the first person in his family to be homeless. "On the street I can do my own thing and I can do a good job at it," he told me. "It may be stealing copper, but I'm damn good."

Sometimes I'd walk a couple miles with Michael and Pep. She was a good dog, always checking with her master to make sure she was headed the right direction. He'd give her a nod at the same time as talking to me, pointing to his hangouts.

He had a routine. Most mornings, he'd go through the hotel dumpsters, looking for food and things to recycle. Or alcohol, half-full bottles. Then he'd make his rounds, the train depot, the Greyhound station, north to Embarcadero, over to Barrio Logan to sell scrap metal at the junk yard. He'd buy drugs with the money he made recycling.

I challenged him about his drug habit. Wouldn't drugs interfere with his thoughts?

I asked Michael to write about bliss.

What is bliss? It's a feeling of ultimate or close
to ultimate pleasure, enjoyment, ecstasy. An
orgasmic feeling, a climax, pure joy. In my life
I've experienced several types of bliss. Like when
eating a piece of my grandmother's bread pudding,
piping hot, just out of the oven. Or when my mother
used to lay my head on her lap and clean my ears
out with a bobby pin. Sounds almost primal, but her
touch at times was so special.

There's also bliss in getting high on drugs,
the euphoric state when the drug finally hits the
pleasure zone in the gray area.

Another bliss is being good company and having a
good conversation, the time of interacting and
conversing before realizing that the good times
won't last forever.

There's the moment of peace, happy, silly, sort of
relaxed to the point of almost being asleep that's
blissful.

I have noticed that most blissful situations only
last a little while.

Back in New York after Morehouse, cruising on the
street, I was making a lot of money, stealing
anything that wasn't nailed down, selling weed,
picking up prostitutes and using drugs. Money
was power. I was looking good. I fucked a lot of
people, like a vulture. I'd prey upon the weak,
using my wits to outsmart them. I know when they're
scared and how to use manipulation like most dope
fiends do.

Seems like lately I've been chilling out with
this writing. It's making me take another look
at myself. I'm not stupid. I've read many books,
attended some of the finest schools in the nation
and have met many interesting people. I'd get
high just going to the library and doing intensive
research on various subjects, just for the hell of
it. Growing up in New York, I was introduced to the
most cultured environment on the planet.

I also remember sitting around during family
functions, picnics, barbecues or whatever, and
listening to all the good and positive things each
family member had done. It made me sick to my
stomach and I would have to get up and leave.

By August, Michael had given my address to his mother in Florida so she could write him. He asked me to read a couple of the letters in front of him. She wrote as though he were still a teenager, calling him "My Michael" and lecturing him about "marching to a different drummer." She told him she'd always love him. He tossed the letters in the cart, disgusted. I suggested Michael write more about his family, in hopes he'd loosen up and find some humor. He mumbled that there was too much to write.

I gave Michael my father's battery-operated Silver Reed typewriter, which sat on Mother's desk, never in use. I knew Michael would use it, and his handwriting was hard to read. I had no idea if he'd respect it or pitch it for crack, but I was willing to take the risk. It had little monetary value and no sentimental value, unlike the Leica R-3 that had been my uncle's.

The next batch of writing I got from Michael, he'd adopted the pen name "Silver Reed," and signed off at the bottom of the contribution.

"Seems like I get along with the typewriter," he told me, waiting on the warehouse dock across from my work loft. "It's cool. Yeah, here. Do I get anything for this?"

I handed him a 20-dollar bill. He said, "That's cool. Come on Pep, take it on down," his cue for her to pick up her leash and follow.

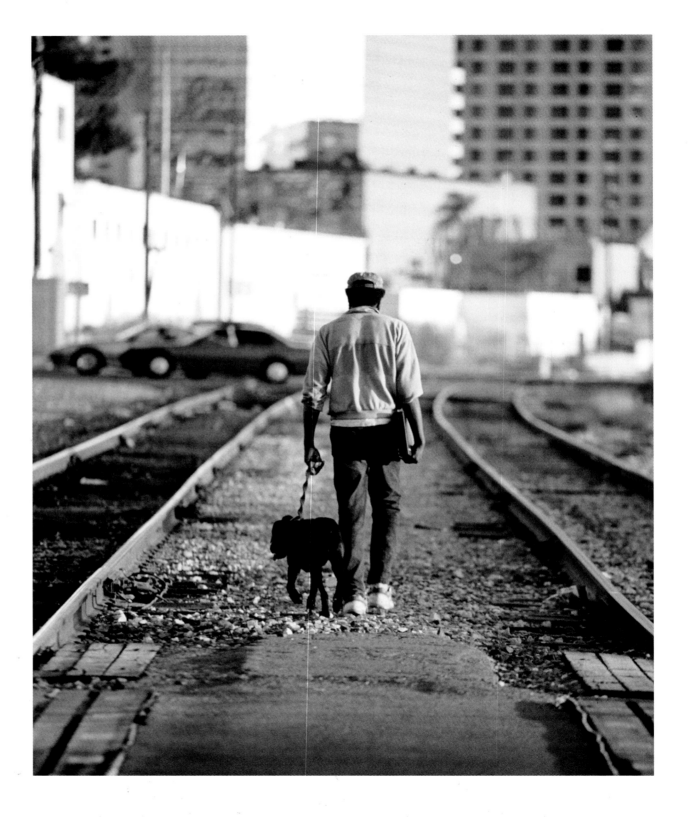

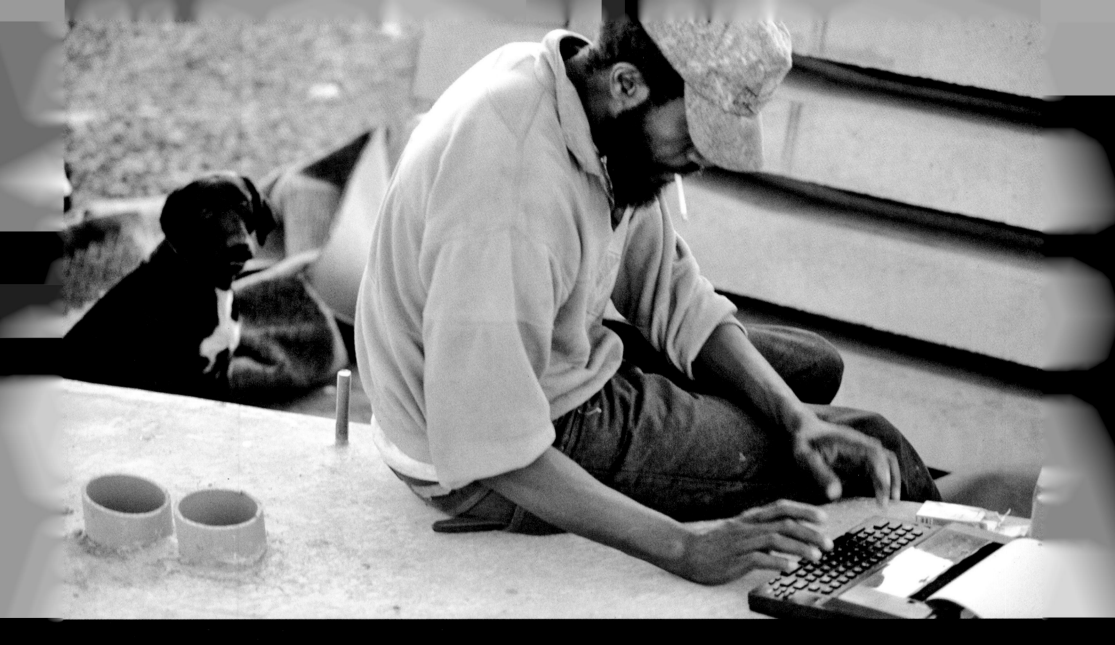

Not every day do I sleep. I may stay up 48 hours.
When I do get a decent nights' sleep, the first
thing I do is check on Pep. Next, put on my shoes,
hat, do stretches, urinate. Anywhere except where I
sleep. During the night, say three a.m., I may go
to certain dumpsters to look for wine or perhaps
something for Pep and me to eat. Then I return and
go back to sleep.

There's one feeling I was immediately forced to face
after my separation from my wife-loneliness. It was
a trip that first night. No one in the bed. Sometimes
at night, I wake up and look around for people,
and suddenly think everyone else is gone. I might

be all alone on this planet, crazy, just one of
my mind trips. Or everyone else is stuck in place,
motionless. Perhaps I watched too many Twilight Zone
episodes at an early age.

I recall this intense dream I had a couple of times.
I dreamed I could fly-like a bird, like Superman-I
could just run and jump and up and away I'd go,
flying over the houses in my neighborhood. When I
descended, it would be graceful, like a feather.
I'd just run out of gas and slowly land on another
side of town and run and jump and fly again. When I'd
think about how great it felt to fly, and questioned
how I was doing it, right, I began to descend

Michael and I argued daily over whether Pep should have her vaccinations. I told him I'd pay. She could then get her license to wear on the leather collar he'd carefully selected for her.

"No way. Dogs don't need shots. They need to develop their own immunity to those things," he declared. Daily.

But he knew if the cops saw she didn't have a license, they could take her from him. That was the deciding factor.

I took them to the North Park vet on University. I'd never been to this vet but it was a friendly looking little hospital and one Michael could get to if he needed to in the future.

Outside, Michael acted as though he didn't plan to go in.

"You have to sign the paperwork," I told him.

Chagrinned, he entered behind me. He looked pretty bad and the girl behind the counter didn't want to talk to him. She directed all comments to me and I passed them on to Michael.

Quickly, we were taken into the examining room where Michael put Pep on the stainless table. This was the fastest vet service I'd ever experienced. It was clear they wanted Michael out of the offices.

The vet looked at Michael, then over at me, curiously. He next instructed Michael to be careful what he fed Pep. "No chicken bones. Ever!" Michael nodded, not really caring what the guy had to say. Then the vet told Michael it was terrific Pep was getting her shots as there was a lot of parvo running around the parks.

We left. I hoped Michael would give more thought to caring for something living. He was able to escape a lot of his past, but he needed to be responsible for Pep.

He refused to get her spayed.

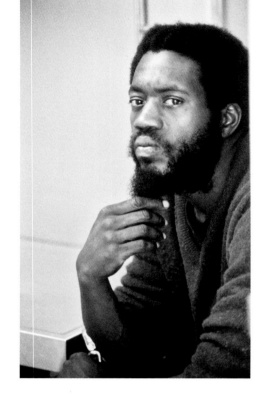

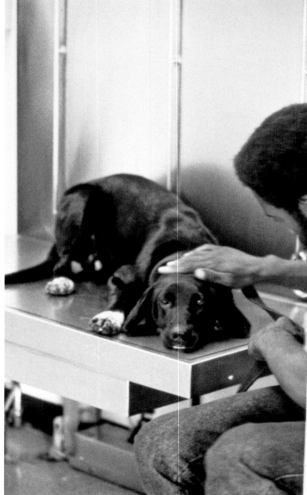

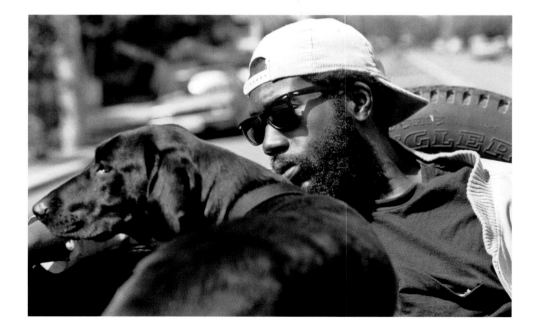

Michael, 2009

I love my dogs. Max is an Australian cattle dog, and Orion an Irish Jack Russell terrier. These two guys complement each other … both are very smart, and both are working dogs … stuck in a loft, in an urbanish setting, instead of on a ranch somewhere. Oh well, I guess it beats the dog pound.

Max and I have been together every day since I got him back in May of 2004 … Orion, I got him in January '08. I take them everywhere I go … except work. They get their walks, chase alongside when I ride my bike, go to the dog park … and each night they fall asleep on the futon, each in his own spot … though often I wake up and Max is sleeping beside me, sharing a pillow.

I have a knack for communicating with dogs … basically, I show them respect, they show me respect. I'm not the Dog Whisperer or Dr. Doolittle, I just have a good relationship with my dogs.

I have a picture of my first dog, Corky, on my refrigerator … that was back when I was, oh, 13 years old. I had a toy poodle named Beau Beau, a cocker spaniel named Princess.

Pepper … Pep was an old soul who loved my rotten stinkin' ass more than I loved me … now you figure that one out. Pepper was unlike any dog I've ever known … she was an angel. Right now, I'm crying like a little girl just thinking about her … this was a very, very special dog to me.

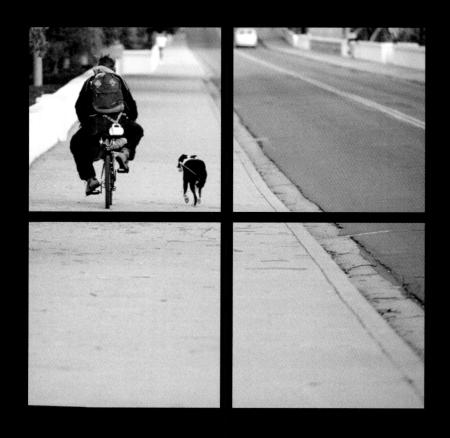

CHAPTER FOUR: BALBOA PARK

Each of the homeless we met was unique from one another. No one was quite like Papa. Papa wasn't like Michael. Neither of them was like Jed, nor did they even like Jed. Funny how a term like "homeless" could dictate how society read people who lived on the street.

HUGH AND I CONTINUED to go to Balboa Park for lunch. Over and over we'd noticed a bald guy, driving a green Jaguar sedan in and out of the park, at noon. So this day we followed him. He headed up Sixth to University and turned east, then parked near a pink stucco joint located at 12th and University.

The guy changed from his suit coat to a pullover, went to a tiny barred window, and pulled out his wallet.

"I'm going in," Hugh said, getting out of the car.

"No way!"

"This is crazy. I gotta see what these guys are up to."

I sat in the car and waited. Fifteen minutes passed. I was worried. Got out of the car and went to the window myself.

"Sorry ma'am, you're a woman. No women permitted in the theater."

What had I done to this kid? He was only 25.

I returned to the car. A few minutes later Hugh got back in the passenger seat. He was uncomfortably quiet. He also smelled. A sour, ugly, mannish odor.

"What happened?" I asked, starting up the Beemer.

"It's bad. Guys on guys, like snakes. Little dark cubbyholes of rooms…lots of them."

*"I'm going in," Hugh said.
I was worried.*

The next week, I suggested we skip the park altogether. Hugh said I'd lost my edge. "You wanna know what's up, let's go."

I drove to the park, this time telling Hugh we needed to get out and eat at one of the picnic tables. An older guy pushing a grocery cart waved at us.

"Hello there," the fella said when Hugh rolled down his window.

"You pretty much live out of this cart?" Hugh asked.

"Yeah, you could say that. Everything I need comes out of trashcans—clothes, clocks, tools to heat the food. My cart is my house."

Hugh grabbed my camera and recorder. We followed the guy to a concrete picnic table. He pulled his cart close to the table and sat down, patting the bench as an invitation for us to join him.

"I've seen you around. I'm Chuck. You're taking pictures of the park, right?"

I explained that we were talking to homeless folks and taking photos.

"Ha, well I guess I fit into that scene! But I never go downtown. Stay right here…"

He spoke about himself, comfortably, saying, "I never had a car, a driver's license, a house, but I learned about people. Mentally, people think I'm screwed up. I just don't function like others. I'm not into material things. I seem to lack a need for possessions.

"Sometime, you should come back when my friend Janelle's here. She's 72, writes and takes notes on us, lives in those condos across the way with her sisters. Nice older gal who loves to visit…I guess with me."

Hugh took a liking to old Chuck and asked if he'd mind if we recorded him while he talked.

"I wouldn't mind," Chuck said and began to talk openly.

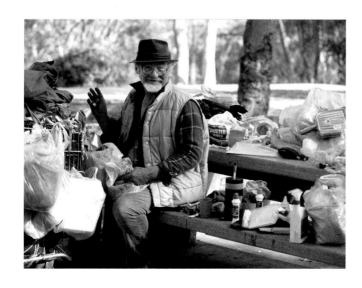

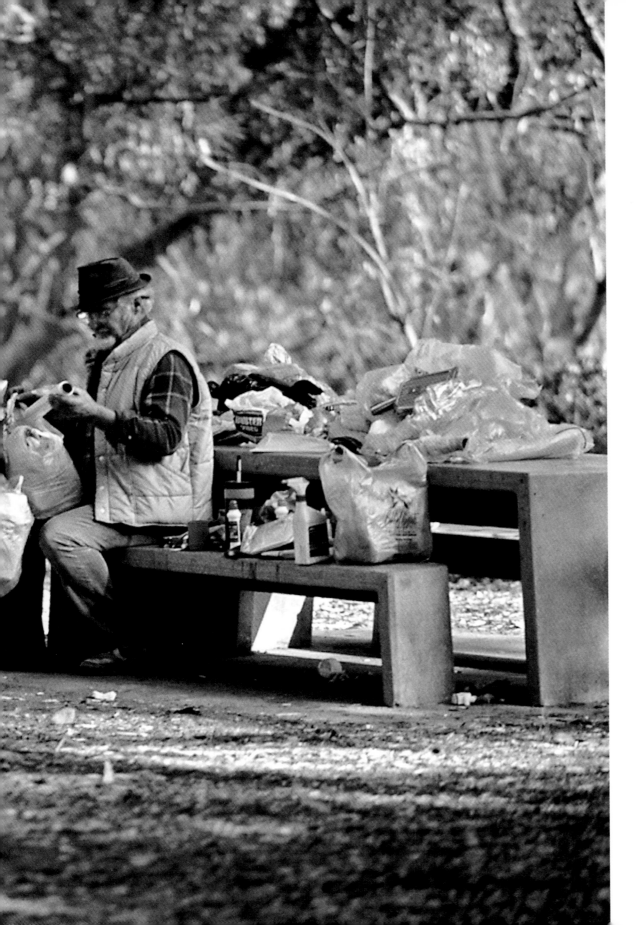

I grew up in a bohemian area. I was born at 1422 Haight Street, close to Haight-Ashbury, in 1936. I used to go out to North Beach before it was all strip joints. Warm wine on a cold winter's night. You'd sit there and listen to bongos and somebody would be reciting some poetry. And you'd look through the front windows and see the fog almost drifting right into the bar. Quiet and still. Somebody playin' the trumpet down the street. Or a flute. It was magical, a whole different world. Didn't worry someone was gonna hurt you.

Guess you could say I'm the black sheep of the family. We grew up as basically good kids, trained to be honest. I wasn't a good student, but I liked school. My mother lacked love and understanding. She always said, "I don't want to hear about it."

My stepdad, Barney, did his own thing. He wasn't going to confront her. They'd argue and he'd go work in the garage or go to a bar.

All five of us kids, two families combined, we were all confused. If we were bad, Mother would get Barney to whip the hell out of us even if he didn't know what we'd done wrong. Then she'd take the kid and start loving him and smothering him. We grew up thinking if you got a spanking it meant your parents loved you.

My mother had a temper. One time she threw an iron frying pan at me. I went flying out the door and took off. She also kept me out of school. We would drive to motels. I would stay in the car while she did what she did. But that was a long time ago. And I knew the guy she was meeting. He was a friend of the family. I think my stepfather needed my mother more than she needed him.

My sister lives in Oregon. I don't know where my kid brother is. I think my stepsister passed. I got a stepbrother somewhere but I don't know where he is, either.

I always felt like I didn't belong. I was entirely different than the rest of them. I've been pretty passive most of my life, and they're all real aggressive go-getters. So, I went into the service. I hitchhiked down to San Jose and enlisted down there.

Jed continued to send writings from prison.

In jail or prison you can make weapons. I could take
a plastic bottle, melt it down and make a knife that
is sharp enough to stab you in the neck. Bombs out of
matches. Dart guns out of newspapers.

There are lawyers and doctors in prison too. And I
love to talk to older guards. You learn things in
prison.

I would just let you know off the hop of this letter
that I'm feeling low for a number of reasons. I have
been thinking about when I get out of prison, what
am I to do? Plus where am I to live and sleep? These
things and others are on my mind each night while I
lay down to sleep. I think of my future.

I am a Blood and in prison, there are mostly Crips. So
I am at an automatic disadvantage. I gotta stay out.
I'm just afraid that I'll be back. I'm not the little
kid with a mouth no more. I'm a man and must live
like one. I just worry that time catches me in the
wrong place at a wrong time. I just will like to be
successful and get off of parole.

I also wonder where and how I'm going to live. Will
I go back downtown or back to South East. I believe
I need a change of life since the me I been having so
far has not been a good one. If you have the time I
will take any advice you give me. I just need a little
communication with someone who I look up to!

We saw Chuck several times over the next two weeks. Chuck liked Hugh and one day said to him, "Seems like you got a lot on your mind for a young fella."

Hugh smiled but didn't comment.

Chuck had a grandfatherly manner. "Hello…some coffee?"

I never accepted the Sanka he heated on a Bunsen burner, but he always offered.

Once again he said, "You just missed Janelle. She came before her doctor's appointment."

I was beginning to wonder if there really were a Janelle.

Chuck talked about his childhood.

I got to thinking about it. I try not to, but here goes. I was boarded out when I was a little kid. I can't remember how old. My mother got divorced and couldn't take care of all three of us. I went to Sebastopol to stay with Mrs. Powers. You talk about hard core. Mrs. Powers beat us. She'd strip us and hose us down. We had to use an outhouse and we couldn't go to the bathroom once we were in the house at night. We had to hold it all until the next morning.

My mother came up on the weekends. I'd try to tell her about Mrs. Powers but she didn't want to hear about it. So I stopped telling her.

I became passive and withdrawn. A family makes you passive. It continues on into your life with the people you meet. And the jobs you work. And the women you know. And the friends you make.

All of us are out here for different reasons. We've adapted to a certain lifestyle and there's a certain freedom in it. Some people are park people because they like the beauty of it. Some are bored to death and get into action. Some like nature. Some like concrete.

I'm at the age where I don't care. I'm not passive like I was as a kid— people-pleasing stuff. Sometimes it does more harm than good.

The green Jag passed as Chuck spoke candidly about his past. Hugh stared at the car. Chuck noticed Hugh's distraction and talked about the kids who stood around, waiting for a pick-up.

"These guys you see out there, standing on the corners or leaning against the trees, they're the male prostitutes. They do that in order to get the cocaine. And they do the cocaine in order to get the courage to solicit. It's like they're on a merry-go-round without a brass ring." But he didn't talk about the men in the cars, cruising.

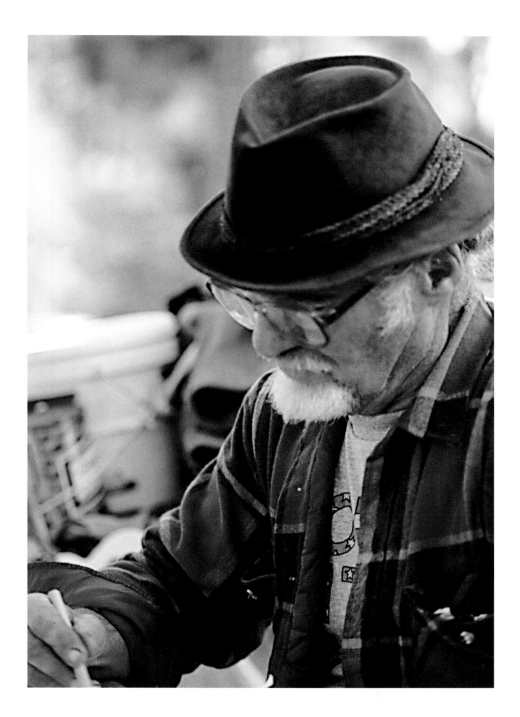

The next week, Hugh didn't turn up at work. He'd worked for me for seven years and didn't even give me the courtesy of a phone call. Nothing. I had no way of knowing that he didn't intend to return.

I went to the park alone. Chuck had told me about his friend Bob, who was supposed to take medication and "got a little crazy" when he didn't. "Sometimes he gets depressed, and needs someone to pick him up. Thing is, I'm here now, but what's he gonna do if I'm not?"

Bob sat at the picnic table, rolling cigarettes and smoking them as he talked.

If they all think I'm crazy, they'll leave me alone. I'm from the residential area of Staten Island, New York. I have imagination. White is my favorite color.

There was never nothing wrong with me when I was a child. Perfect teeth, perfect health. I just had schizophrenia, my parents said. I was standing in a rainstorm and lighted a fire in the walk. The policeman came around and told me to put the fire out and I said I would when I was dry. He told me to put it out and I said I would hit him over the head and bury him. They took me away.

I got into fights with the other kids. Some of the things I did were termed inappropriate for my age. I fear bad things will happen to women, the way I might handle them.

Tranquilizers take away all the hope. They make you manageable to those taking care of you and make you unmanageable to yourself. You get interfered with constantly. I'm supposed to be on them. I usually am. I get them from the psych down the street; an injection every two weeks.

My father was loyal and made sure I had a meal. My mother could care less. She was an alcoholic. This side of my face got smashed in, my brother. He was my mother's favorite child. There was only one good year when I lived with my parents and that was when my brother went to prison for armed robbery. She blamed me for him going to jail.

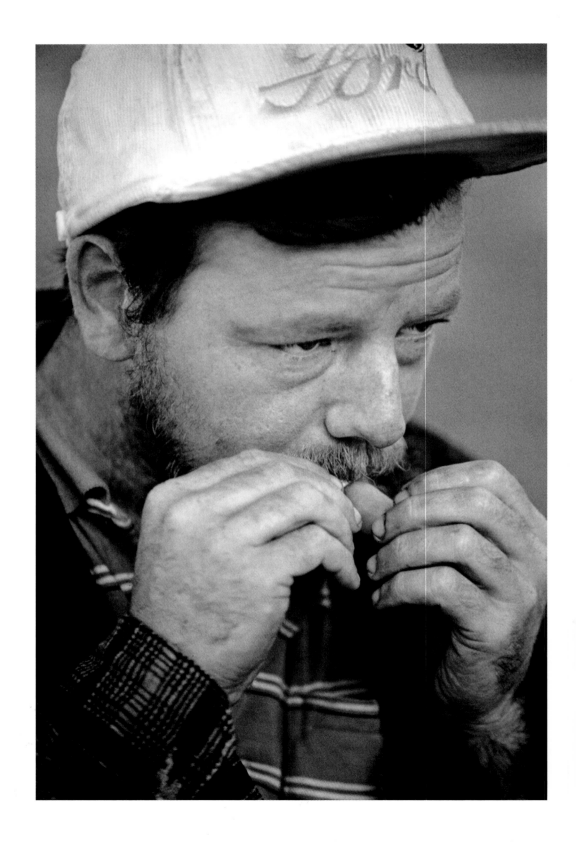

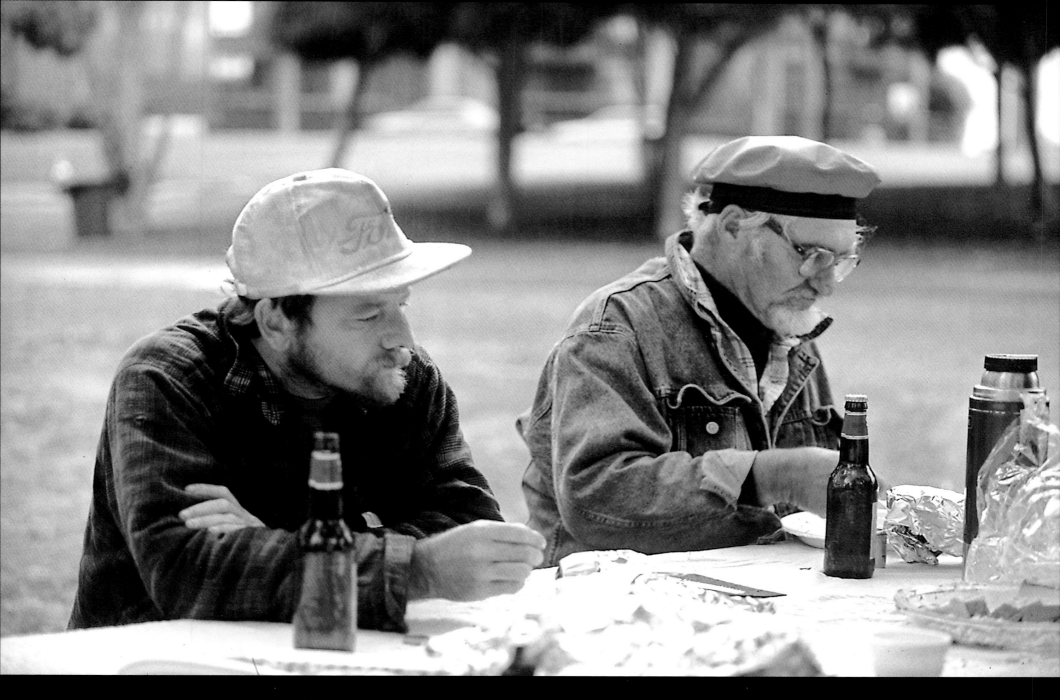

"*Tranquilizers make you manageable to others
and unmanageable to yourself.*"

— Bob

As I was leaving the park, I noticed a tall, young kid talking to the mounted policewoman about his handful of misdemeanors. He was one of the park prostitutes. The policewoman saw me and asked what I was doing.

The guy's name was Todd. Mo, the cop on the horse, said, "He's a good one to find out what's happening in the park."

"I was in the Marines. I got out and ended up doing the first easy offer... porno films."

– Todd

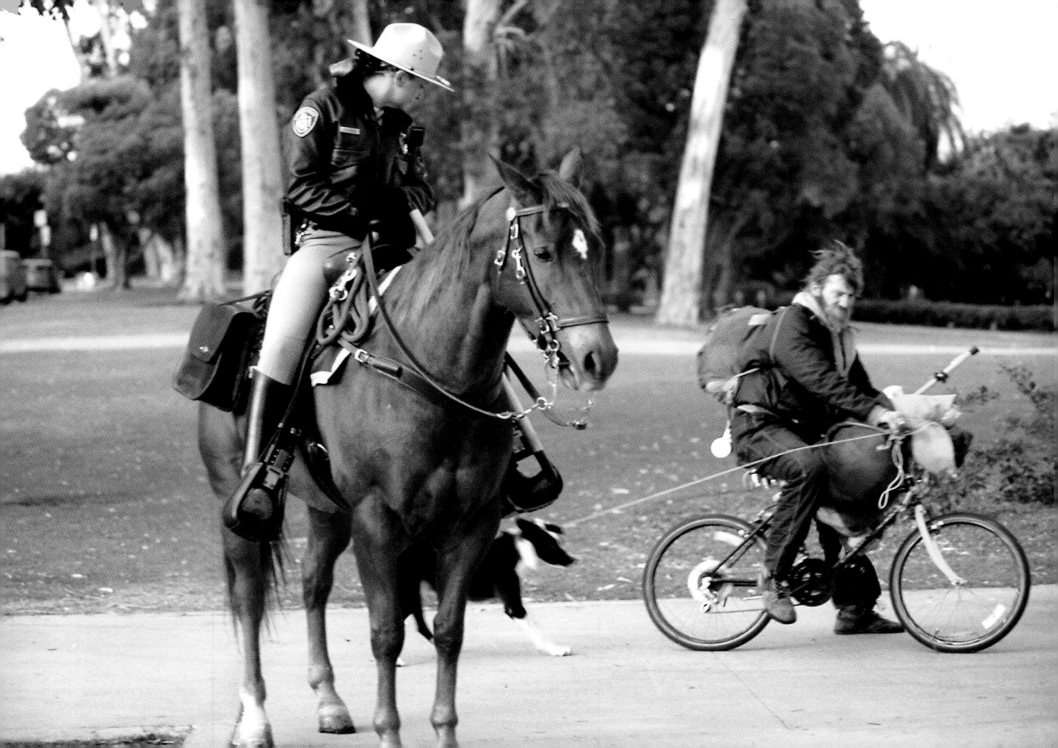

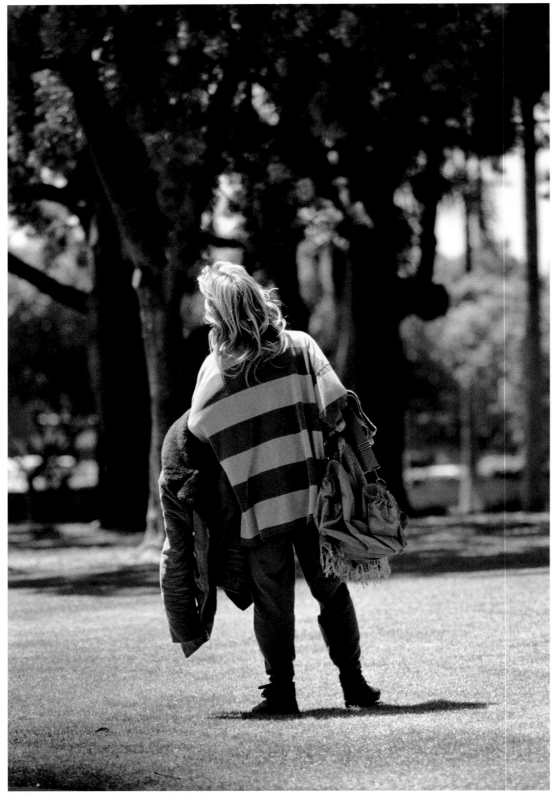

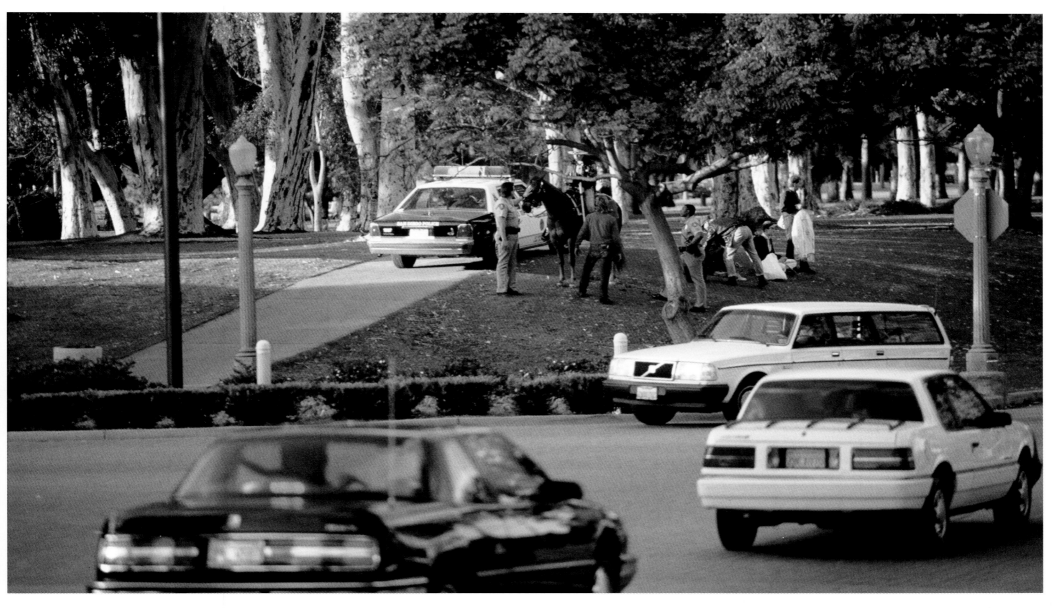

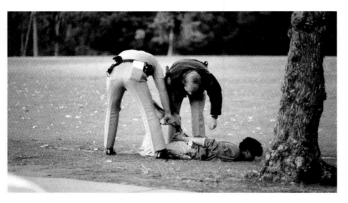

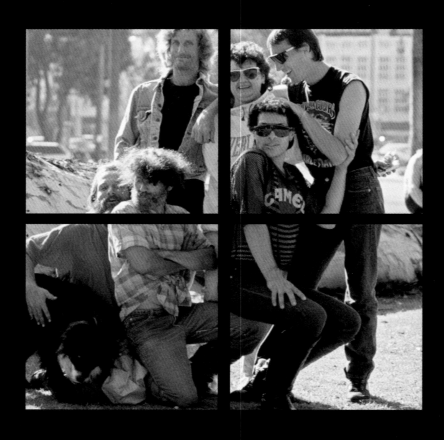

Chapter Five: The Family

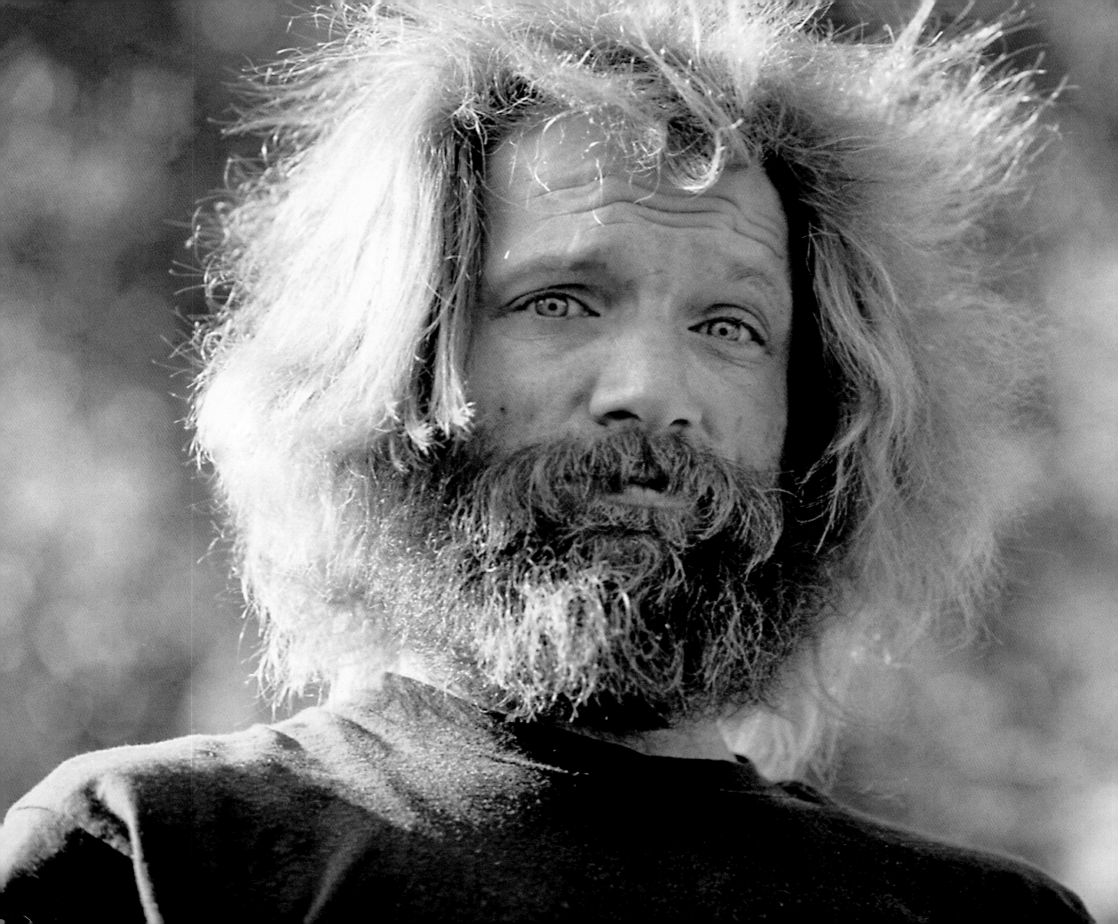

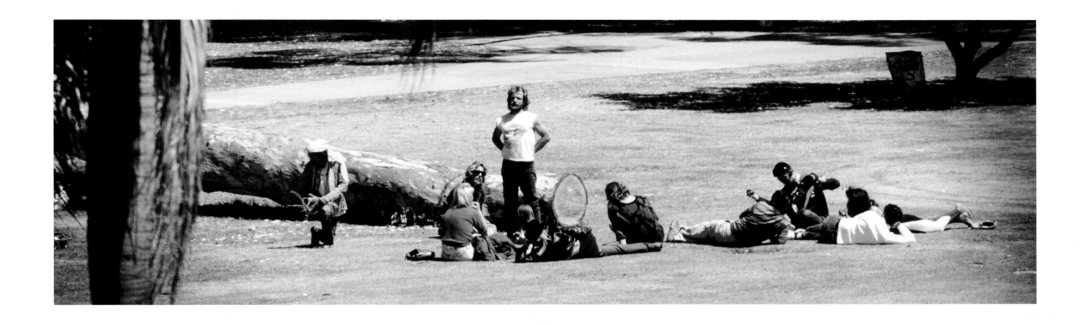

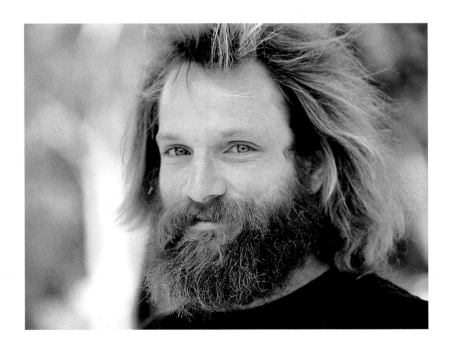

I WAS DOING SOME COMMERCIAL WORK again, to bring in money. I parked by the senior-citizen center, where the lawn bowlers had a game going on, and got out to check on a spot to photograph San Diego debutantes.

As I headed back to my car, a wild-looking guy grabbed my arm.

"What are you doing?" I shouted. Another guy pulled my Hasselblad off my shoulder.

The guy with the strong hold on me said, "Don't be that way. We're going to a party!"

Laughing, he tugged me over to an enormous fallen tree trunk where six more rough-looking characters were gathered, smoking cigarettes, drinking beers, Big Fizz sodas. One out-of-it guy twirled around with the U.S. flag, talking to himself.

A crazed young woman shouted, "Hey you! Linda Eastman! Understand you're a photographer! This is God and don't you forget it!"

The guy she referred to as "God" released me. "Janie, why don't you just chill out? Go find a dick."

Janie ran off, crying, and jumped into the arms of a big black guy.

"Call me Sandy, if you're a Buddhist. Janie, she's crazy...she's hanging onto Red for safety, ha, ha."

Janie wandered back over, sucking her dirty finger. "Hey, Eastman, nice glasses. She's got some class, ain't she?"

I asked for my camera back. Sandy gave it to me, "You better take good ones, huh? Or you'll be meat! Ha, ha, ha."

Another member of the group joined us.

"I'm Jeffrey, Sandy's brother. I'm five years older, 30. I've lived in here five years. Janie is smoked out. Been that way a couple years now. She convinced Sandy he's God. That's how it goes here in the park."

They called themselves the Family. They mingled, laughed, danced around.

"Know what, Eastman?" said Janie. "You could take photos of us and put them in a book. Not everyone's seen God."

A guy who called himself Shane stopped putting on eye makeup and jumped into a pose. I took a photo.

"I went from Hollywood to Brentwood," he said. "I had a maid. I was a fashion consultant working for Chip Davis and CD designs. I was a cosmetologist."

He and Sandy fought with one another, playful and sarcastic. Sandy called Shane a transplant, and Shane shouted back that he made all the money for the Family, who sat around and smoked, did drugs…

"I'm a nature person, a native," Sandy said, twirling around on the grass. "I make money, too. I'm a male prostitute. The good Lord takes care of us."

"Shall we say I don't work the same clientele," Shane said. "I go out at night with the rich ones. It's a job. If you're going to have sex, you might as well get paid for it. You look at the car and the clothes and you size them up."

Sandy interrupted, "I want a group picture. Eastman, you get in it."

Sandy pulled me over to the fallen tree trunk where more of the Family gathered, plus a couple of dogs. They put Sandy's dog, Shooter, up on the trunk and posed.

A blanket tossed over a lawn chair started to move.

"Shall we say I don't work the same clientelle."

–Shane

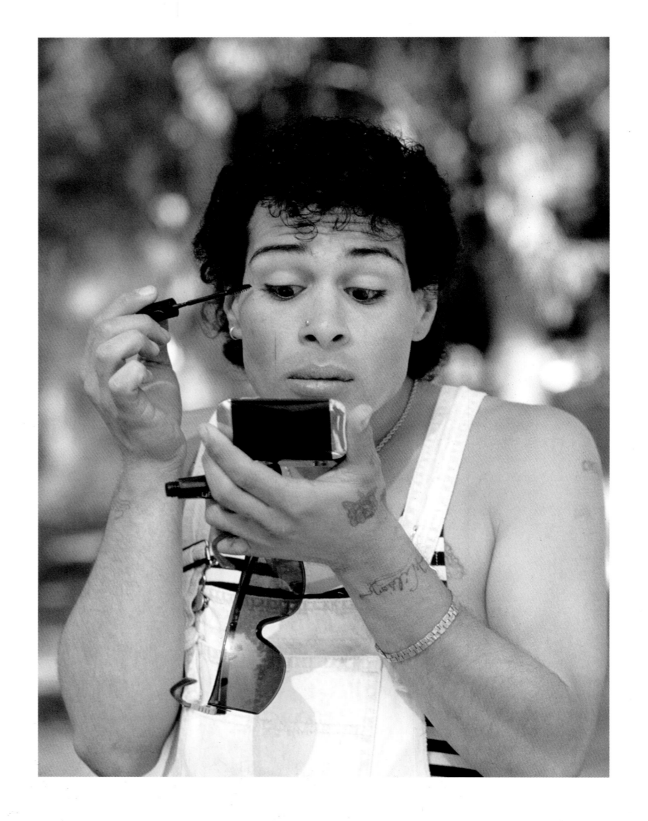

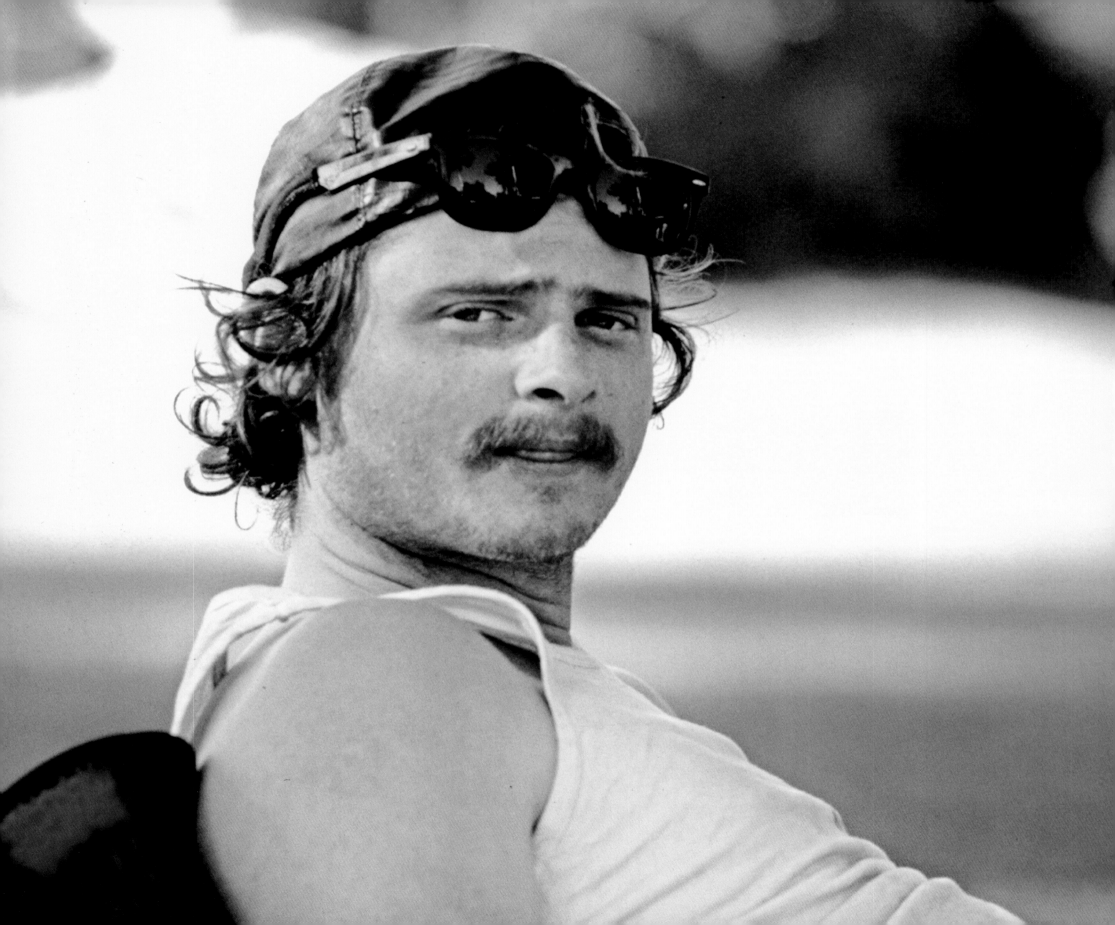

"Ha, ha! The meat's moving!" Sandy howled. "That there's Clive. He's in a bad mood, aren't you Clive? Got out of jail a while back and thinks he's pure as snow."

Clive mumbled again.

Janie asked him for a ride to Imperial, a drug area.

"For Christ's sake. I ain't taking no whore to crackland. Told ya I got my window broke out by some brick over there, last time." It was clear Clive didn't like Janie. "I've known Jeffrey for years," he said. "Jeffrey's been to jail, but I've gone to prison."

"Happy Clive, tell 'em what you was in for, honey," Sandy said, laughing.

"I was in for first degree."

Sandy wanted to show me where they lived.

"Come on," he said. "Let's go to our home. Home of the Family. Queens Circle!"

I followed Sandy and Janie across the road and down a small narrow walk just beyond the lawn bowlers.

"Who needs health? That's one of the problems with this society. They call us humane? We're fucking hypocrites!"

—Clive

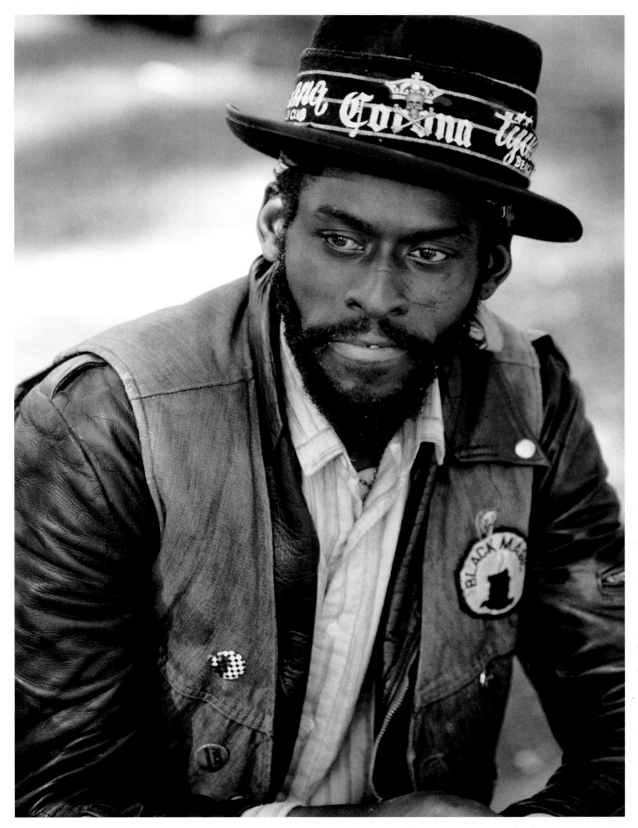

"Look here," Sandy said. He went behind a shed and pulled out a grocery cart. Inside it was a neatly folded sail. "I have a set of sails. We set up the sails for a backdrop. Right here's a perfect bungalow. Look inside.

"See here, we have our grill, electricity on the shed. We eat good, steak, cook outside. We have utensils, a cooler and our bedding, flashlight, just about all we need, wouldn't you say?"

Janie lay amidst their belongings and handed him the flashlight as if it were night. He dropped down, crawled inside, and hugged her.

A gal with scars tugged at me. "I was dead. See my trach scar?"

"Oh shit!" Clive brushed by. "Don't listen to it. She's on the dope. Just wants to get the cash so she and Janie can stay smoked out and they won't know what happened when someone dicks 'em."

Sandy crawled out of the shelter and directed the Family and me to the nearby 7-Eleven.

"Come on, everyone," he said, pulling me along. "It's time for goodies, snacks."

They were probably high, but I didn't sense any danger.

A dog called White Boy ran alongside Shooter, Jeffrey, and Clive. Janie and Shane fell in behind us arm in arm, with Bird Man, Ed and the boy on crutches.

They clutched my arms and skipped across Sixth Avenue, something I'd never done. Inside the store, the owner was friendly as the Family gathered chips, Pepsi, beer, cheese, and licorice.

Clive said, "Who needs health? That's one of the problems with this society. They call us humane? We're fucking hypocrites!"

Sandy, barefooted, was the first in line with his beer and pretzels. "The birds like these things," he said to me. "We get back to the park, Bird Man will show you."

"I don't have any walls to keep me out, any floors or ceilings, except for the sky."
—Sandy

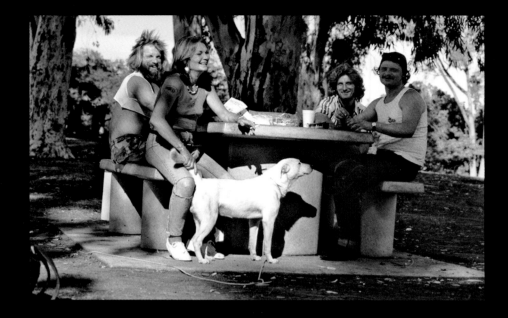

80

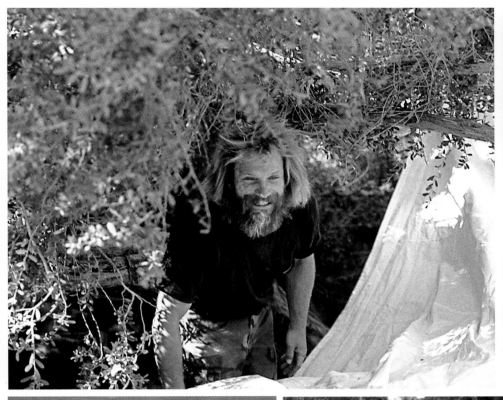

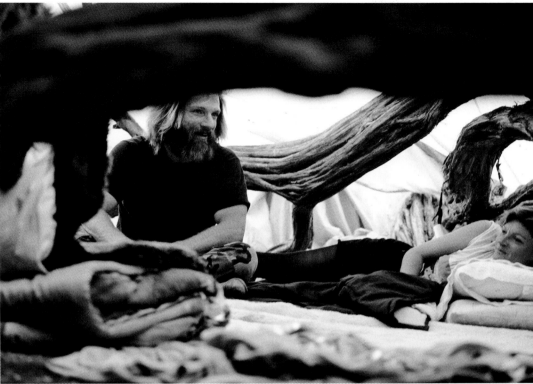

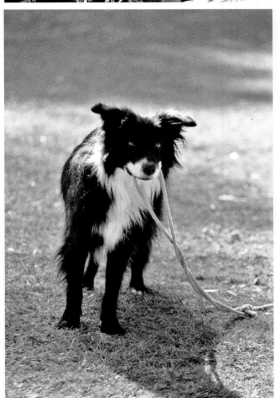

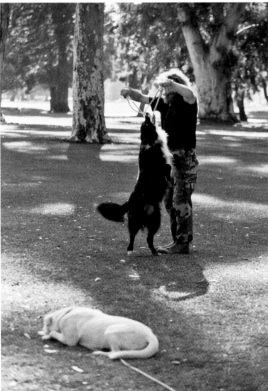

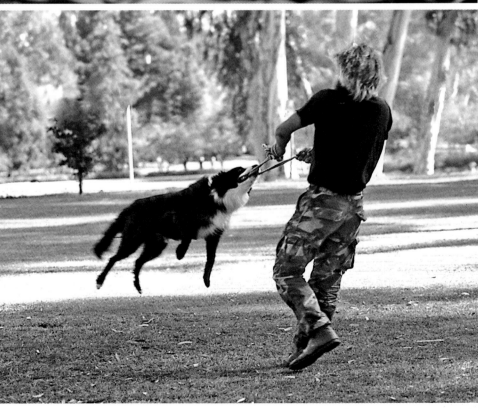

An elderly man collected his change at the cashier and walked through the Family, past me, nodding politely and laughing at White Boy who was lying next to his car.

"That's why we named him that. Can't go wrong with Boy!" Sandy patted the dog's head. "These dogs behave, but last week they were both in the pound. The horse patrol picks them up, says they bite people. Says they're mean and wants to put down White Boy! That old man wasn't scared."

Back in the park, Sandy told me about a murder. He said there'd been five killings in just the past month.

"You know, it's four in the morning, see…and we walked over the hill. The whole group and a couple of guys are lying there. We finally get a lighter right down to this guy, right down to his guts. Right? And we could tell right away that the guy was dead! He was pretty disgusting. His hand was on his guts! The guts was laying all over the ground!"

Jeffrey said, "Yeah, like a cheeseburger!"

I noticed Todd, lying up on the grass mound. He was distracted. He waved and stayed distant.

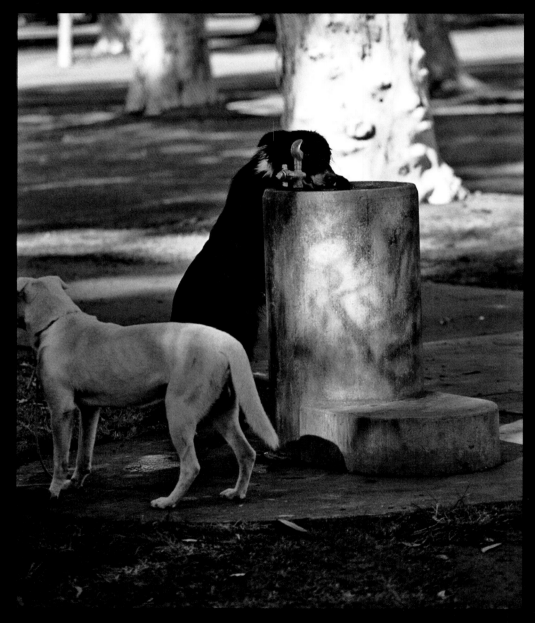

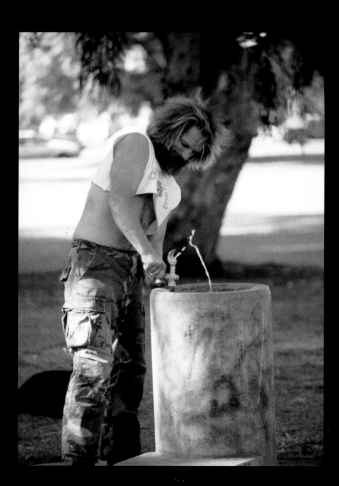

Michael dropped off his writings, daily. We seldom spoke more than a few words during this period.

Morehouse, the Harvard of the South, was the one I went to first, located in Atlanta. It seems as if there are leaders and followers. Being from NY I was immediately chosen to be a leader. I knew Andrew Young's nephew … he introduced Young to us, during the Jimmy Carter election. We got invited to campaign events and got little gold peanut buttons. I knew Philip Randolph's grand nephew.

I came up with this idea of selling pot on campus. I remember people knocking on the door all hours of the night to buy weed. I sold dope to Spike Lee … what a trip. I was able to afford taking dates to places like Peachtree Plaza for drinks, the Hilton, so forth. There were women calling me knowing that I had buds, money, liquor and was able to show them a good time.

All in all, Morehouse was a bit of a culture shock to me. I had gone to school with mostly whites and a few blacks and an all-black or almost all-black environment was new to me. The scholastics were easy enough but the coping mechanisms with the social aspects were difficult. I had grown up in a "black middle-class ghetto." Meaning a really fucked-up neighborhood.

"At Morehouse, I sold dope to Spike Lee."
–Michael

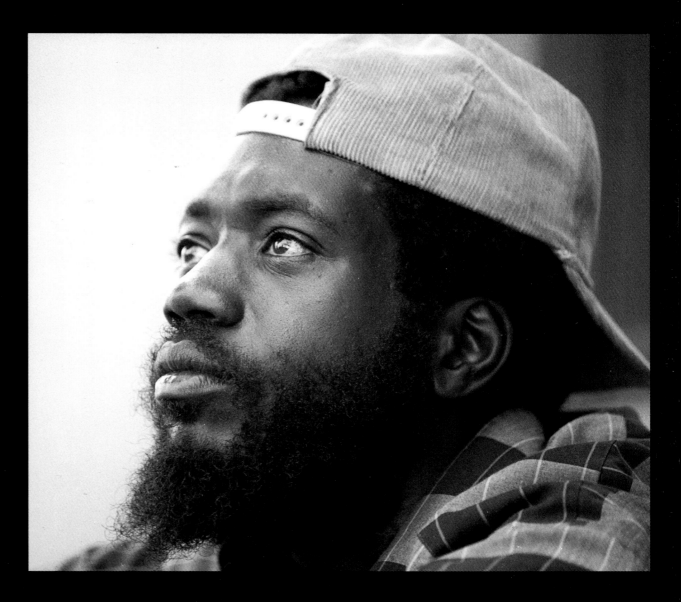

In my work loft, I received a call from Dorie's new retirement community manager. "Your mother is telling jokes and asking people about their religion," he said. "We had another psychological test done on her today, and she's dropped four points. I'm afraid she'll have to move."

This made no sense at all. Her two-bedroom condo was a package deal and very expensive. She loved living there. The people were a little stuffy, but she was adjusting.

Mother called just as I hung up. "Honey, I don't understand. They told me I can't go in the hallway with my swimsuit on to get to the pool. Your sister thinks I need to go to a nursing home..."

I made an appointment with Dr. Dom Addario, a local geriatric psychiatrist I knew by name only, to see if there were any truth to the accusations. When I picked up Mother for the appointment, I didn't tell her where we were headed.

"Where are we going, dear?" Dorie asked.

"On an expedition," I answered, playfully.

"Now honey, I know better than that. Why are you teasing?"

"I want you to meet a doctor who's going to help us with the problems at the retirement center..."

"You think I need a psychiatrist!"

As soon as Mother met Dom, she told him how good-looking he was and entered his suite of offices readily. An hour later, Dom came out and said, "Your mother's an interesting case. She's extremely intelligent—can repeat six digits backwards and forwards with no error—yet obsessing, and I think hypomanic."

I was stunned.

"Has anything other than the surgery happened to contribute to her state?" he went on. "She may have suffered something like a little stroke. I'd like to check her into Mercy and perform some tests."

"Am I losing my mind?"

—Dorie

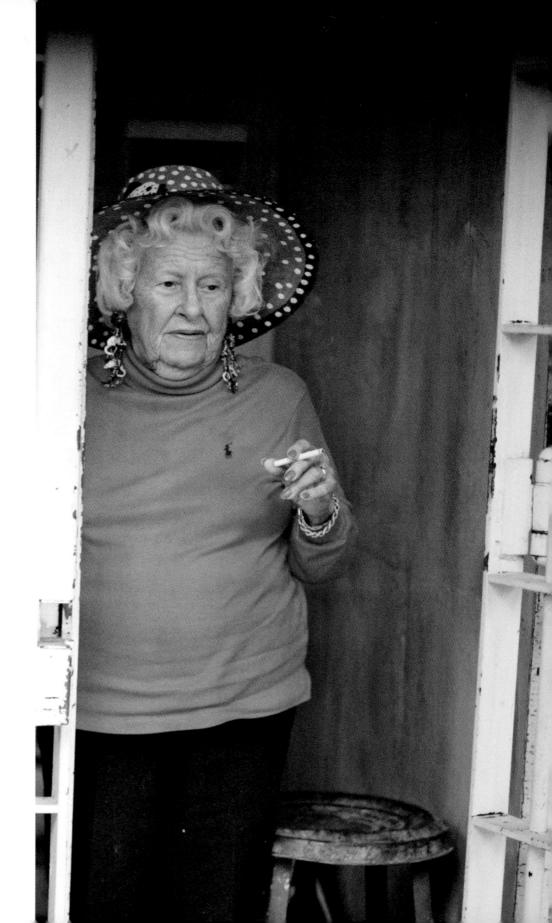

If this imbalance happened to
Mother, what happened to
street people?

Two days later, Rob and I went to pick up Dorie to admit her into the hospital. We found her at the pool, lying in the sun, asleep.

"Dorie, how are you?" Rob asked.

"Huh? What! Who is it?" Her eyes were adjusting to the light.

"Oh, I must have fallen asleep. Where's Susie?"

I left Rob with Mother, went in to pack some of her things, and found burned holes in her bedspread. In fact she hadn't turned down the bed since she moved in. Under her pillows were cigarette packages and lighters, eye cream and Retin-A for wrinkles. Rob came in with Dorie on his arm.

"What's happening, honey?" she asked when I returned.

"Dr. Addario wants to do some workups and see if he can help you become less troubled with your thoughts."

I saw the frightened look on her face.

"Am I losing my mind?"

"Dorie, the problem is you're too smart," Rob said. He loved her and hated to see her afraid.

At the hospital, on the landing outside the fifth-floor elevator, Rob pushed the button to the speaker next to the locked doors.

"Fifth floor, mental ward," a voice answered.

"Oh, honey. Do we have to do this?" Mother held onto my right arm, trembling.

"Dorie, let's just talk to the doctor," Rob said, attempting to soothe her.

The next day, I looked down the hallway and my heart broke. Mother was dressed in her burgundy velour running suit, with her top on backwards and her cigarettes partially stuffed in her pants' pocket. Holding onto the handrail to steady herself, she was too blind to see me 20 paces away. "Ummm, *the old gray mare just ain't what she used to be,*" she sang to herself.

"Mom!"

"Honey, where are you?"

"Just ahead of you."

"Oh, the hallway is so dark. Wait… Oh there you are. You look so young to me," she said.

I kissed her. My heart ached. Dom had given her a high dose of Haldol, and she'd gone from strong and determined to weak and needy in a matter of days. "I brought you some clothes in Pop's old alligator bag."

We went back to her room. "I have something to tell you," she said. "I want to go home."

Dom entered and asked me to come into the hallway. "The tests are back. Her EEG, MRI, and blood work are all normal. In cases like this, we recommend shock treatment."

"No way, Dom."

"Susie, it's quite successful."

"Rob's mother had that," I explained. "It helped her temporarily, and then nothing helped. She committed suicide. Try something else, first."

"That would be lithium. It's a salt. We'll have to watch for side effects."

I drove from the hospital to the loft, thinking about mental health and what Dom had said. He had mentioned heredity, stress, chemicals, lifestyle… If this happened to Mother, what happened to street people? How many were mentally ill before they got on drugs? Did drugs alleviate symptoms and create new ones? Or how many were mentally ill as a result of using drugs and abusing them from early in life?

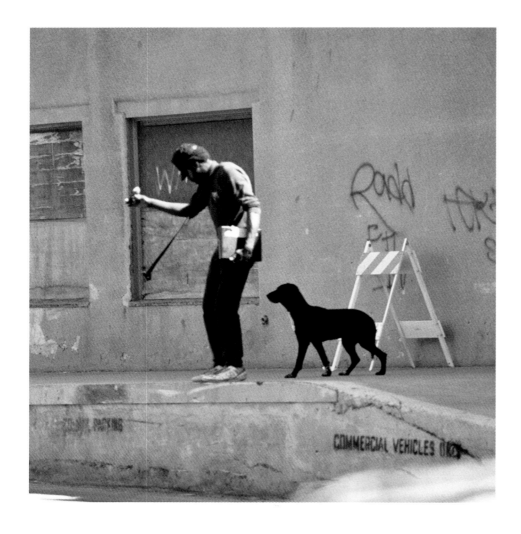

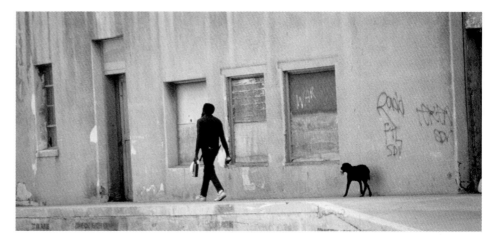

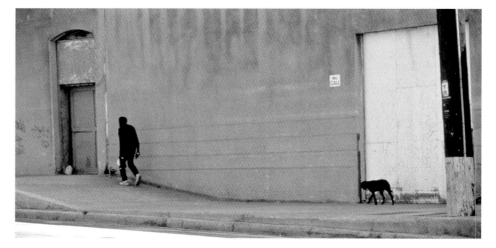

Michael was changing his writing style, writing things he thought would shock me. He was becoming more unpredictable. One night after I'd worked late, he came up behind me, in the dark.

"Like, hey, where have you been?" he shouted.

"Where have I been!"

"Really, where have you been? You're late."

"I'm late?" I said.

"You said you'd be here earlier today. Oh, I get it. You're Miss Thing and I'm the bum on the street, therefore, I can sit and wait. You're sick of me. Right? That's it. I was probably right, you're just some white-assed… I guess maybe I'll split. This place is slow."

He shoved a paper in my hand and walked off with Pep. I had a sick feeling in the pit of my stomach. That sweet dog was trailing him by a good distance. He had a leash in his hand, but it wasn't attached to her. No way for him to trust—anyone. What would happen to him and Pep?

Last night was one hell of a night. Lately when I've been getting high, I've been very paranoid, hallucinating, imagining things.

Well, the fuckin' rock fell into the john. I was pissed. I was going to go by my first impulse. I was thinking sell something. Replace the loss, I was about to sell this god-damned Walkman which I didn't steal. Then I thought of my reputation, how I've never gone to the hood with items, only cash …

As a dope fiend I have accepted that as my reality, my top priority. Does it shock you that I put this shit at the top of my priority list? I have seen many lose their lives for being scandalous in this lifestyle. There is no room for fuck-ups. I have seen bodies left for whatever, I have left bodies. I put my balls on the line for it every day.

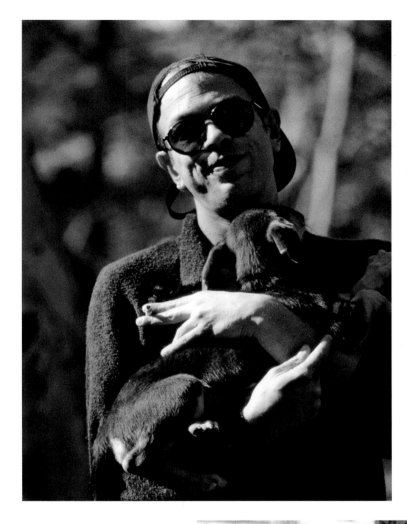

Arthur, a 40-year-old single art expert who worked for Sotheby's, lived and worked in a loft above mine. He'd introduced himself to Hugh and me one day as he walked his old dog, Brownie. He came by my loft sometimes to check out the images I was working on, applying his critical eye to my work.

With Hugh gone, Arthur came to the loft more often. He begged to go to the park with me and said he'd carry equipment, hold the recorder—anything. He wanted to see how I worked.

He said he liked the way I was capturing the people and he wanted to see some of them for himself.

It was two days before Thanksgiving and I was to meet up with Todd. Arthur begged to come along. He was 6'4" and had to scoot down in the old Beemer, making him look even sillier than he already appeared, wearing Bermuda shorts, Doc Martens, and an oversized trench coat. He asked me wild questions about random images he'd looked at in the loft, curious about the person we were going to meet.

Off Laurel, at the west entrance to the park, I spotted a man in a red Acura as he opened his door and dropped a puppy on the pavement. The pup scratched at the car door, but the guy coldly drove off. The pup cowered in the street, shaking, then moved with her tail between her legs over to the grassy area under an enormous eucalyptus. I told Arthur to get out of the car and pick up the little thing. He did, reluctantly, and returned with the dog inside his trench coat. "She's freezing. That man's crazed," he said, angrily.

I headed for old Chuck's picnic table, Arthur rubbing the dog's neck to calm her. We found Chuck and asked if he'd seen the guy who tossed the pup. He hadn't.

"She's been abused. Look at her shake," Chuck said. "Poor little thing. Wish at a time like this I had a place. No room in this old man's cart, that's for sure. I have enough trouble just organizing myself. Hey, you two want some coffee?"

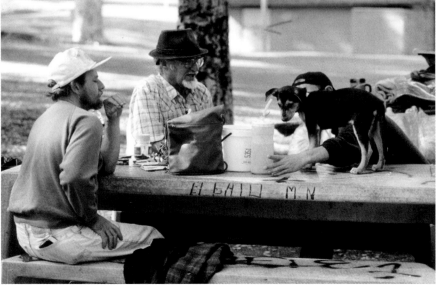

"We're supposed to be meeting with Todd. You know him?"

"Yeah, I suppose. He's just another one of those, you know. I stay away from that stuff pretty much. What they do's their own business. It's not my cup of tea. Well, me, I guess you'd say I'm asexual. I mean I don't have a woman, either." He laughed again, making light of the activity.

The pup fell asleep on Chuck's picnic table.

We met up with Todd at the corner of Laurel and Balboa. We joined him on the grass and pulled out sandwiches and sodas.

"Four Corners," he explained. "You know about that? There's a corner of prostitutes who live and work in the park, a corner of homosexuals who mingle and sunbathe in the park, a corner where illegals are bought, then some scattered independents who get picked up when a driver signals them."

"You're homeless?" Arthur asked. "No bed, no bath, no place to go every day…"

"That's the usual description." Todd swapped his half-eaten sandwich for a blade of grass.

"You're out of work?" I asked. The pup was huddled asleep in my lap.

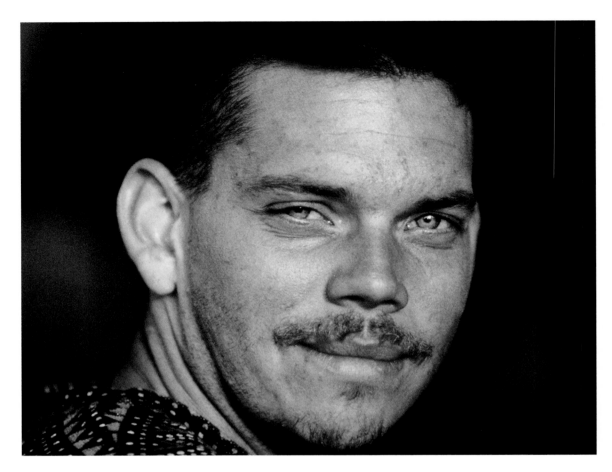

"You could say that. I was in the Marines. I got out and ended up doing the first easy offer…porno films. I was Blade in *The Blue Night*. Now I make money doing tricks. It's become a way of life for a lot of guys. Fuck, they have these golden and brown showers the first Tuesday of the month. Come on, you've heard of that. It's when a bunch of men get together and piss on each other."

He pointed out cars driving along Balboa Avenue. "You still don't get it, do you? The park's not a nice place. It's not a place where a woman comes in with a nice camera and takes a lot of pictures. Look at that Jag." It was the green XJ6, the one Hugh and I had followed to the club. "Now look at the car behind him. They're all here for the same thing. It's hustling! This park's full of men paying for S-E-X. It's also full of drugs! Over there…the Money Tree. Mexicans bring drugs to the other end of the fence, runners carry it to the Money Tree, and hustlers take a hit after they do a trick."

"There're children in this park!"

"Right now, the park's too dangerous for that. There's needles in the grass. Hell, there've been five murders in November, alone. Don't you read the paper? This here is called the Fruit Loop for hustling."

"Why do you do what you do?" I asked him.

"Perform any kind of sex they want? That what you trying to say? Why not just be a nice gay guy and live in a nice gay relationship somewhere, have a nice job and come home, fuck, fix the dinner, that kind of shit? I don't know. Guess you could say I'm fucked up." He laughed. Only he looked sad. He gazed off toward the next car coming along.

"That's the same white Mercedes, isn't it?" I was catching on; the same guys kept circling around.

"Yip. They're all out today. That guy, there…he's head of one of the biggest banks in town. Bank's right downtown. Sits on local boards. I tricked for him. He's fucked up. He's got a family, too. Like two kids and a wife. They're homosexuals living a heterosexual life." He noticed another car and rolled over on his other side. "I don't want that guy to see me. He's real sick. He hits men's bathrooms."

He sat up after the car had passed. "A blowjob from an American white boy is 20 dollars. If you stay with the guy for the night it's 120 for the night. Hey, there's Hunter. Hunter, get over here!"

Todd introduced us to Hunter. "He's been out here a long time."

"Hey, man what you got going? Tea-time in the park? Or you doing hand-outs for the pound? Hi, pooch." Hunter leaned down and the pup growled for the first time.

"Wow, hardly looks old enough to walk let alone make enemies. OK, I don't like you either." Hunter wore a tank top, tightly pulled in, showing a trim physique and well-defined muscles. He had incredible blue eyes, clear crystals. He didn't appear homeless.

Hunter sat, grabbed half a sandwich and made himself comfortable.

"Tell 'em 'bout the traffic," Todd begged.

"What you want to know? Chances are you know some of these turkeys. Well, not the trolls, the old guys, but you may know the wealthy sector, the Rolls, the Jags, Mercedes, yeah the Beemers. That guy owns a restaurant up on University. There, that one, he's a big wheel in some legal firm. The guy has two cars like that Porsche. We call him Old George. He has money up his ass and he takes you out for a bran bagel. He's got four kids and a wife, lives in La Jolla. Cheap son-of-a-bitch. Does it for a couple bran muffins. He uses the ones up on the hill, the ones who'll do it for nothing."

I was shocked. This was the first guy Hugh and I had followed. The principal in a major legal firm downtown.

"Hell, I've done it with him," Hunter said. "I won't go out with him again 'cause the bastard likes to get abusive."

He gestured with his head toward a red Porsche. "That guy's an undercover cop, but he does pay to fire. Undercover cops can now take their clothes off and then bust you. He'll come up alongside you and it's 20 bucks to get in the car and go to his sleazebag place. You collect and leave. The ones he doesn't like, he turns in.

"There's another cop in the park now that's dealing in drugs. He'll smoke a joint with us and drink a beer. A lot of immigration people do the same."

Then a guy from the work lofts appeared in a white BMW!

"The hookers come out at night...not the hustlers. The ugly ones come out at night." He nodded across the street, where several guys in their early 20s stood, one with a Mohawk wearing black leather pants and no shirt, tattoos on the biceps and "socks in his pants" as Todd put it, two others looking just plain dirty and sick and one guy out of it on the ground. "Those guys do it for nothing. They're all homos and want it as bad as the ones in the car. There's even a group that comes around and hangs out same place as we do that's said to have AIDS. Their goal is to spread it."

I asked Todd if he had any family.

"A mom, dad, shit like that? Sure! I got a mom. I got a daughter! She's three, I think. My mom raises her."

"Where's your dad?" I asked.

"Dead. Or I think he's dead. I went to military schools and never knew anything about sex until my two older brothers started doing it on me. I think my parents abused me, too. I think you get it from others in your family."

Todd lifted his head, chewed on his blade of grass, smiled. The repetition of the traffic was a hopeless jungle of sounds and mannerisms. Arthur winked. He was getting high off Todd's talk. I felt it was time to leave.

"I think being gay is hereditary," Todd said, eyes following the last car. "My aunt and two uncles are gay. My brothers showed me how to suck dick when I was 16. That's when I left home. I didn't finish high school. I got kicked out of military schools for being a pest."

"Aren't you worried about getting HIV?" I asked.

"Yeah. You could say that." His eyes welled up with tears. "I probably have it. I've never been tested." Arthur told him where to go to be tested. Arthur volunteered at the HIV clinic.

Now the park was buzzing and the pup cowered behind Hunter. He purposely tried to scare her. She barked and skidded onto my lap.

Todd's eyes were red as salsa. His face was tormented.

Arthur and I took off for the loft. He agreed to keep the pup for the night. I hoped he'd want her. Brownie was pretty old. Then, next day, after I'd finished my Thanksgiving shopping, Arthur called with bad news. The pup was sick. We'd named her Les Misérables, after the musical, then shortened it to Misery. He couldn't handle her in the tiny loft with old Brownie. She was vomiting and had diarrhea. "You have to come and get her!"

I drove downtown and picked up Misery. Poor little thing had failed over the last 20 hours. I took her to our local vet. Ended up, she had parvo! That old son-of-a-bitch must have known the pup was sick and dumped her off in the park to die.

Todd's eyes were red as salsa.

By Thanksgiving, Dorie had adjusted to the medications and was back to her old self. She was living with us while I secured a tiny cottage in the Ranch for her with some part-time assistance. She refused to move in with us.

Arthur and his architect buddy joined us for Thanksgiving. Mother was immediately fascinated with Arthur. They talked classics, art, smoked cigarettes and drank bourbon while Rob enjoyed conversation with the architect. I did the dinner and the dishes with the kids.

After dinner, Rob said he was concerned. Life had changed on the Ranch as he had known it. He warned me, "Honey, no more dogs," as we drove down to the vet to check on the pup after everyone left. Could the vet find her a home, he wondered? But looking at Misery through the isolation-room window was like looking at a newborn babe in a hospital nursery. Rob said, "She's cute…but…no way!" I knew he was hooked.

After Thanksgiving, I saw Michael long enough for him to hand me a scrap of paper. I was growing more and more concerned; he had tossed the typewriter into the bay and was back to chicken scratch.

```
Well Susie, it seems as if the other day you and
Arthur were laughing at me. I'm really not sure
why. Could it have been my dirty clothes, holey
sneakers or what? But, I did notice.

I'll stick to my "20-dollar hit." To each his
own. It's just that I don't get that underlying
ridicule usually from people that I know on
somewhat of a personal level. I was thinking,
maybe I could go back to being a dope-slinging
gangster. But then would it be worth it to lose my
freedom. I balanced the two. To be in jail or to
be poor and free, I have been in and out of jails
since I was 17. I lose count of how many times.
But I'm pretty much tired of it. I just got out
last year from doing six months in L.A. county
jail, the Glasshouse. It was boring. I did meet
some cool dudes however, one guy, T-dog, from the
Insanes, a CRIP set, out of Long Beach. It was
fun. Reminded me of my homeboys.
```

We had a couple of late-night, drugged phone calls. "I'm getting out of here," he'd tell me.

Then he was gone. I couldn't find him and Pep anywhere on the downtown streets.

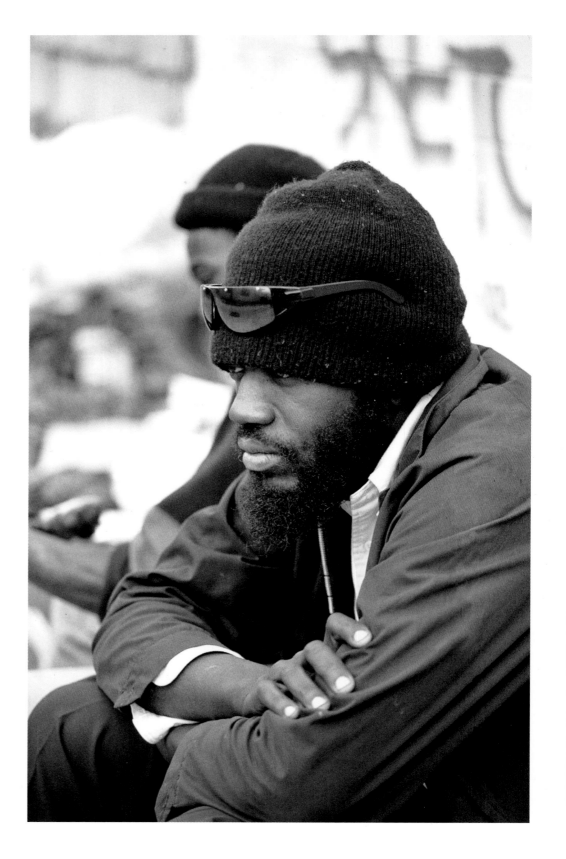

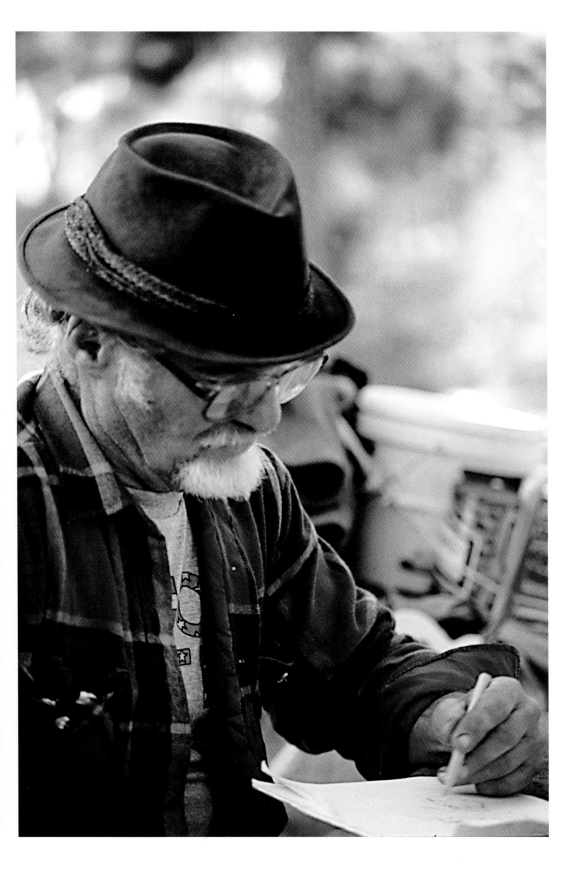

Arthur left for New York before Christmas. Hugh and Arthur were both gone. Our family took a holiday break to Lake Tahoe for skiing with friends, and Misery. She seemed to know that she needed to become Rob's dog.
It was a full two weeks of relaxation, snow and kids.

Early January, I usually headed to the loft after taking the kids to school. I made several trips to the park to see old Chuck and spent the rest of the time transcribing tapes and doing the work Hugh had done. He'd been gone two months and I had plenty to keep me busy. I hadn't seen Michael and Pep since the holidays. Was he still pissed and paranoid? Had the drugs finally gotten to him? I worried about where little Pep might be and found myself driving around the downtown in hopes I'd run into them. Or maybe they relocated?

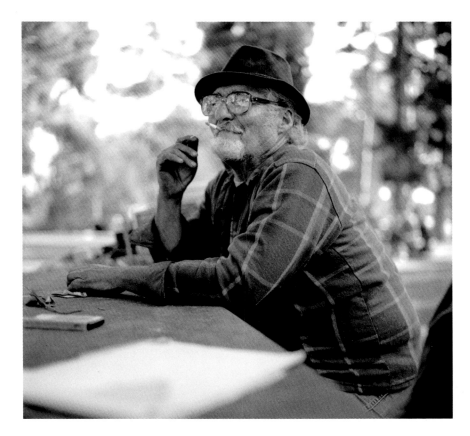

Jed got out of jail in early February. I had taken on another portrait shooting of a debutante and her family. Jed was clean and convinced me he was ready to assist. He was strong, clever, talkative with the clients and enjoyable. No one would ever have known he'd done time. By now, Jed and Chuck, Michael and Pep were part of the family dinner-table discussions. Rob traveled so much that he wasn't too involved with this side of my life, at least not yet.

I helped Jed get into a single-room-occupancy with a little kitchen. I was making money again plus learning about the homeless from Jed's clean-and-sober, living-inside perspective. Jed went to Balboa with me and met Hunter.

Hunter took us to where he used, the back of the aeronautical museum. He lit up a crack pipe and talked about his life in the park.

A lot of people out here have real sex problems. Believe me, sex can be an addiction, almost as bad as drug addiction. I could tell you a story about every damn one of those cars out on the Fruit Loop. I've been here for years. It's called cruising. It's all eye contact.

Heck, earlier this month two hustlers and one UCSD professor were killed in the park. The professor was probably trying to pick up sailors and ran into straight guys. There's a lot more going on than just drugs and prostitution in here. They got harboring of illegals, too... guys in big-assed trucks come here to pick them up.

We call wealthy guys chicken hawks. They drive around in Mercedes and prey on hustlers. There's lots of doctors, lawyers, professionals.

There's this doctor, lives in the penthouse of a condominium. He used to come in here every day in a three-piece suit. He'll give you two 50-dollar bills, lays them out and does his crystal. He has tattoos from his wrists to his ankles, likes to put dog collars around his neck. This is a doctor—a reputable doctor.

I like old Chuck. He's a good man. I thought he was one of the guys who got killed. One night I see his cart and I said, this guy ain't anywhere. I looked up and down for him. He got ransacked. He always has something to offer, like yesterday he offered me a Jack in the Box sandwich.

"See that guy in the Porsche over there? He's a partner in a law firm downtown and he just traded two bran muffins for sex."

–Hunter

Jed ran after another young park prostitute, yelling, "Hey Victor, homie! Hey man, wait up."

He and the kid joined Misery and me back by my car.

"Susie, I knew Victor on the streets," Jed said, smiling.

Victor responded, "Yeah, and you stole my pipe!"

Jed laughed. "Oh man, you would remember that. We did time together since that incident."

Victor talked comfortably until he saw a white car pull up. Without an explanation, he pitched his cigarette on the pavement and walked over to the white car. The driver, a fragile-looking gray-haired man, smiled when Victor crawled in the front seat.

Victor was back in the park an hour later.

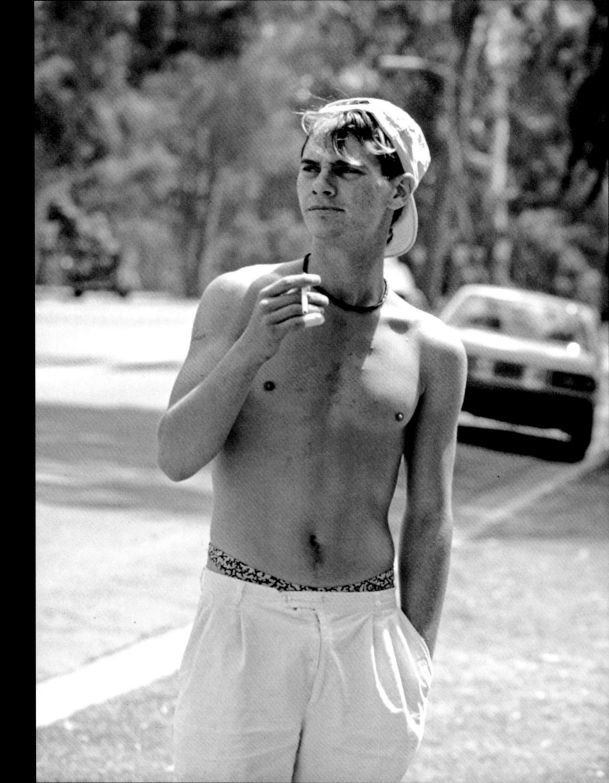

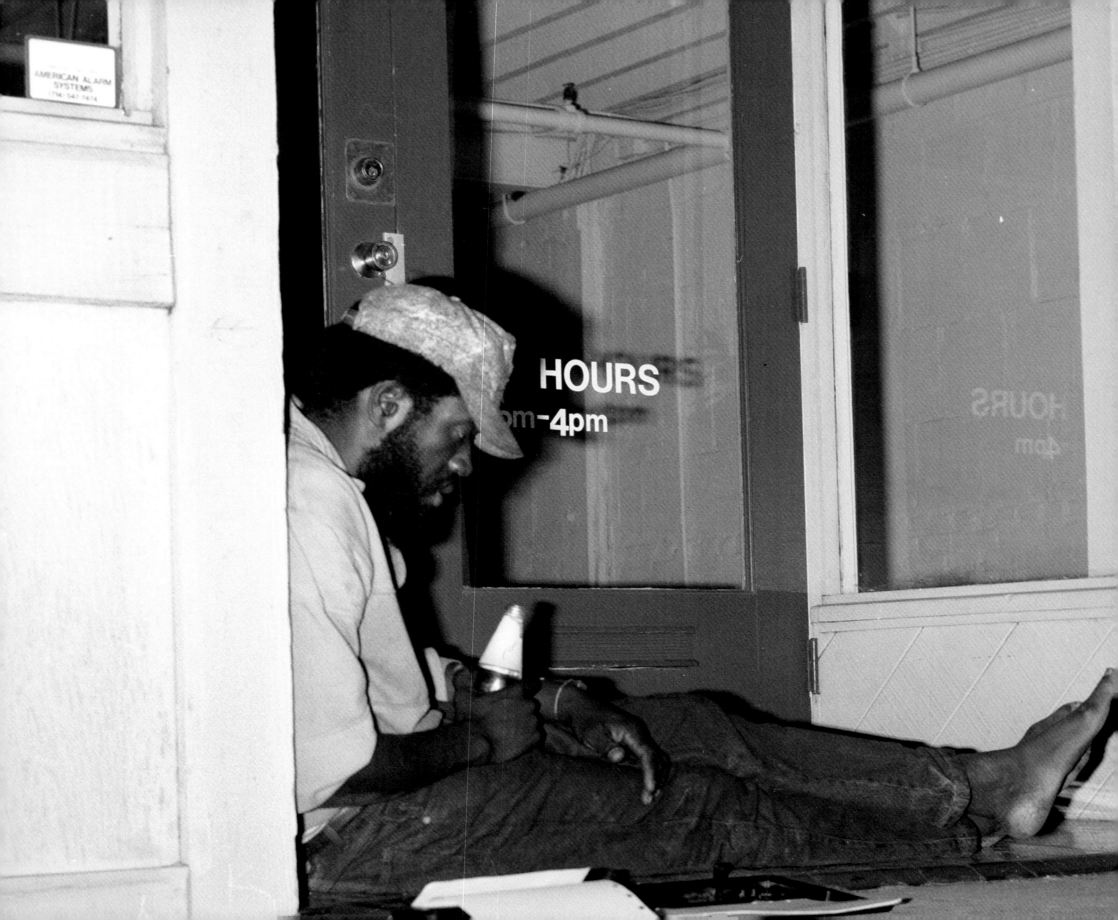

Michael called me at work, collect, from L.A. "Pep broke her leg," he said. "You've got to wire money."

That got quite the reaction out of Jed. He knew of Michael from casual street passing and said, "Homeboy's up to no good."

A week later, Michael called again and Jed answered.

"I think you better take this one," he said, handing me the phone.

"Hey, what's up," Michael's said. His voice was cruel. I could tell he was whacked out on drugs. "Pep is dead."

My heart was in my throat. Poor sweet Pep. Before I could ask for details Michael hung up.

Jed said, "He's a manipulator. I bet he's lying. He might be a homie, but he ain't no friend of mine to lie like that."

I called Michael's mother, Mabel. We'd stayed in touch, to compare notes on Michael. "The dog isn't dead," she told me. "I know my Michael. He would have let me know."

The next time Michael called collect, he was in jail. I accepted the call but only to find out where Pep was. Michael told me about two women he'd met, Esther and Olive. Their office was next to a hotel where he liked to steal a swim in the pool to clean up. Esther had taken Pep, but it wasn't working out with her own dog, so Michael wanted me to call her to make new arrangements.

Esther was clearly intrigued by Michael. She knew the administrator at Ambassador Animal Hospital, Fred, and said Pep would get good care there. She also told me Pep was pregnant.

I wanted to go up and get Pep, but Rob said, "No way. Let Michael handle his own problems."

I contacted Fred and wired money for Pep's care. I asked him not to turn the dog back over to Michael without letting me know.

Fred called me two weeks later, mid April, concerned and apologetic. Michael had been released from jail. He'd turned up at the animal hospital and sweet-talked an attendant into giving him Pep.

I heard nothing from Michael. No "Thanks for your help, Pep's OK." Nothing about where he was going to live until she had the pups.

I decided to check on old Chuck and found him pushing his cart past the restrooms, headed to the south end of the Fruit Loop. He spotted my old Beemer.

"Where you been? Stop for a minute, huh?"

We sat at his picnic table and talked. Janelle showed up and sat down next to Chuck. She enjoyed her outdoor time with Chuck. In a way, she idolized him.

Janelle told Chuck to tell me about a relationship he'd had, years ago.

Chuck: *It was actually by accident. I was in the service. I had been drinking with this woman. It was in the afternoon on a Sunday and I was supposed to be back by morning. Well, morning came and I wasn't back yet and each day it got harder and harder and I got more scared.*

Janelle: *You left the service because of the young lady you had intended to marry.*

Chuck: *I floundered. I used to have a hard time dealing with my emotions. I would shut them off. If I got confused, I'd just turn them off. When you live outside, you don't have to deal with your emotions. You can just get up and move.*

Janelle: *Tell Susie about San Francisco.*

Chuck: *Oh, I was born in San Francisco and as a kid I used to live on 24th Avenue and went to Catholic school. I went back to the city one time and I lived out there in Golden Gate Park just about four blocks from where I went to school. I had a lean-to in the park. I had two big old bucket seats underneath a big umbrella and it was all covered over for when it rained. And I knew the gardener. I'd gone to school with one of the gardeners.*

"Would you kindly hold my hand, please? Because I want your strength."

–Janelle

At night, I got those lunches the kids threw out. I was traveling up and down the streets at night picking up cans and whatever in the same area that I used to walk around as a kid. I'm an adult and I'm living out here and I'm walking up the same streets, but I'm doing something completely the opposite. And I'm thinking, maybe I'm up here looking for something I lost.

Janelle: His mother was from England.

Chuck: That's true. Brought over here and adopted. My real father was a Cherokee Indian, born in the American Embassy in Shanghai, China. I never knew him but I heard that he was mean. My stepfather was a good provider, but not a good father.

Susan: Did your parents make you feel incapable?

Chuck: I was slow as a child. Growing up, I just accepted things as they were. That was how it was. Later on, I found out I couldn't have children of my own. It was a big disappointment. I do get into some depressions sometimes. And confused.

Susan: What do you mean by confusion?

Chuck: Confusion is when I'm not sure what I should be doing. I went down to the welfare office and filled out a paper and the woman said, "You can't do that. You can't do this. You have to put something down there. You gotta lie a little bit." It confused me. There's a certain amount of sadness on the street. And a certain amount of humor. You run into interesting people. I met Janelle on the street.

Janelle: Yes. My doctor told me to walk. "Go walk in the park." I did and that's how I met Chuck. And after talking with him a bit, I said, "Sir, you've got a terribly heavy load there." And after a bit more conversation I thought, this man don't belong here. And I came back every day. One day, I said, "Would you kindly hold my hand, please? Because I want your strength." I felt that he had strength. When I met Chuck I had been ill and I had no desire to keep going. But he gave me something to want to live for. My sisters thought I was out of my mind. They said, "There goes Janelle again."

> **"Maybe I'm up here looking for something I lost."**
>
> –Chuck

Michael, 2009

I was over near Lafayette Park, at a 7-Eleven near Wilshire Boulevard, and a couple of brothers came up to me and said, "It's gonna be on!" … I had no clue. Then moments later, a couple of guys were lighting newspapers, setting the place on fire …

That's when all hell broke loose … people were busting into stores up and down Wilshire, off Vermont and the surrounding area. Chaos. I loaded up the cart with beer and alcohol, smokes and such … I didn't even know what was going on … I was trying to "come up" so I could get high.

That's the night the pups were born. Pep was all excited, running back and forth from me to something on the sidewalk … I took off my T-shirt, picked up the pup, and headed back to the house, tracing my steps to be sure there weren't any others she might have dropped. I sat with her the entire time … smoking crack and drinking beer. She had a pup about every half hour, 45 minutes. She had seven, five male and two female.

A couple nights later, I was out on the street … I had just looted some dog food when I got snagged by the National Guard. They threw me in the back of a jeep … one guy shoved his combat boot into my ribs the entire ride to jail, calling me "nigger" and saying how he could kill me and no one would know … all type of smack.

I didn't even know what the riot was about until I got locked up … but it was justified … take a look at the tapes. This particular situation was so wack … so blatantly racist … it boiled over and out into the streets. The cops were scared to death … they were outnumbered, that's why the message was so strong. Being alone I was an easy target.

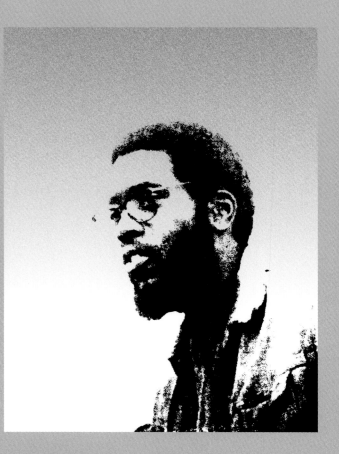

On April 29, a jury in Simi Valley acquitted four white police officers accused of beating black motorist Rodney King, and riots broke out in Los Angeles. I listened to the news reports, concerned things could turn out like the Watts riots years ago.

On May second, I got another call from the L.A. jail.

"I got picked up for stealing dog food. Yeah, I was out getting food for Pep and her pups."

"Michael, where's Pep?"

"That's what I'm calling about. She's at the abandoned house we were staying at. They picked me up last night around 11 o'clock. Took some gold from my pockets. Hey! I saved a piece for you!"

"Will you cut it out?"

"No, seriously, it's a Chanel chain."

"Michael, get serious. What about Pep?"

"Yeah, could you come get her?"

"It's dangerous up there, Michael! I can't just drop everything and go into a riot zone." But I also knew that Pep and her pups would die without food and water.

"Oh I had some water and shit," he said. "No food really. I told ya, that was what I was out getting. I was taking the food back to her when I was picked up."

"When did she have the pups? How many?"

"A couple days ago. Seven. Yeah, they look like her, too. They're all real cute. Healthy, fat. Yeah, it was two days ago. The first one was born on the street, during the riots. I picked it up and put it in my shirt and said, 'Hey girl, we gotta get home.'"

"What's home, Michael?"

"Oh yeah, you'll like it. You should see it. It's a big abandoned house. Fifteen rooms. It's real cool. There's a sofa outside that we hang out on." He sounded proud to tell me he was living at a house. In San Diego, he'd only let me see where he bedded down for the night one time. A street secret. "But then this riot broke out and there was shooting all around us. The dudes in the back were shooting at me and anything. It was real strange."

"Michael where is the house, exactly?"

"Korea town. On Hobart and Wilshire.

"How long are you in for?"

"I don't know. They take me to court Monday. I'm in for a while, this time. I'll call you as soon as I know."

The kids were gathered around. "Mom, did Pepper have her pups?"

"Yeah, and Michael's in jail again."

I had to do something about Pepper. I called Fred again at Ambassador Animal Hospital.

"Susie, I was going to call you. I've been thinking about Pepper. Has she had the pups?"

"Yeah, and Michael's back in jail, for breaking curfew, assaulting a National Guard officer, and looting. Pep and the pups are at an abandoned house over on Hobart and Wilshire with no food."

"That's not far from here. We were hit next door and across the street. This is really terrible. The reports go from it's easing up to another blast and people screaming over the newscasts. We just hope it won't be another Watts."

We decided Fred would call Esther to help with the pups. "Don't try getting into this town. Forget it. I'll check it out and get back to you."

Four days later, Rob said, "You've lost your mind. You're taking your 87-year-old mother, who's hardly a help, and Jed? There's a riot going on."

I knew Rob was fed up with all this activity. I worried that the whole homeless venture had gotten out of control, but this was about Pep and her pups. There was no way I could abandon them.

We drove to L.A. on May 6. The RV I rented was 36 feet long. I'd driven one like it when I moved the kids and animals from Denver to San Diego.

"Man, Susan, you really get into driving this damn thing," Jed said, reaching out his window to see how close I got to the semi trucks.

"Will we see buildings burning?" Dorie asked. "Are we going to the Wilshire for dinner? I brought a dress."

Cars swerved in and out of the lanes. I kept my eyes on the road.

Jed and Mother moved to the back. I could hear rap music over the hum of the RV, and smelled cigarette smoke. I glanced in the rearview mirror and saw Jed lighting another cigarette for Mother.

I was 40 minutes up the highway from San Diego's peaceful climate, headed for more dogs. "Bring another dog home and you'll have one less husband!" Rob had said.

I checked the rearview mirror again. This time I couldn't see Mother. "Where is she?"

"In the bathroom. Don't worry about nuttin'. Remember, I worked in a convalescent center, the one we pass all the time in Balboa?"

Yeah, for a week.

"Hey, Susan, don't go acting like this is a BMW. She's on the john!"

I was pissed at Michael. First I had to talk him into Pep's immunizations, then I had to take her to the vet for chicken bones irritating her intestines, now he expected me to save her and the pups! He had no clue what it took to raise anything!

"What you expect of a black guy from New York who thinks he knows everything?" Jed said. "Never been in a gang."

We got off the freeway onto surface streets. Some gang types were hanging out in front of an *ampm*.

"What did I tell you?" Jed said. "The town's still hot. This rioting ain't over yet."

"Do you see the burned buildings, dear?"

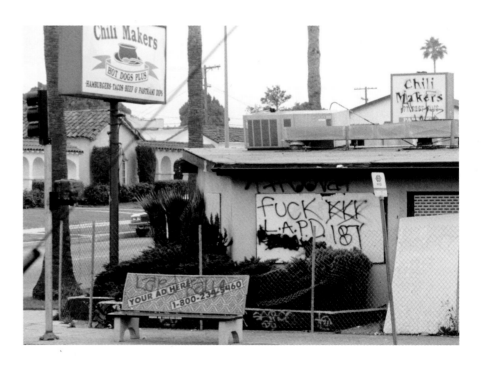

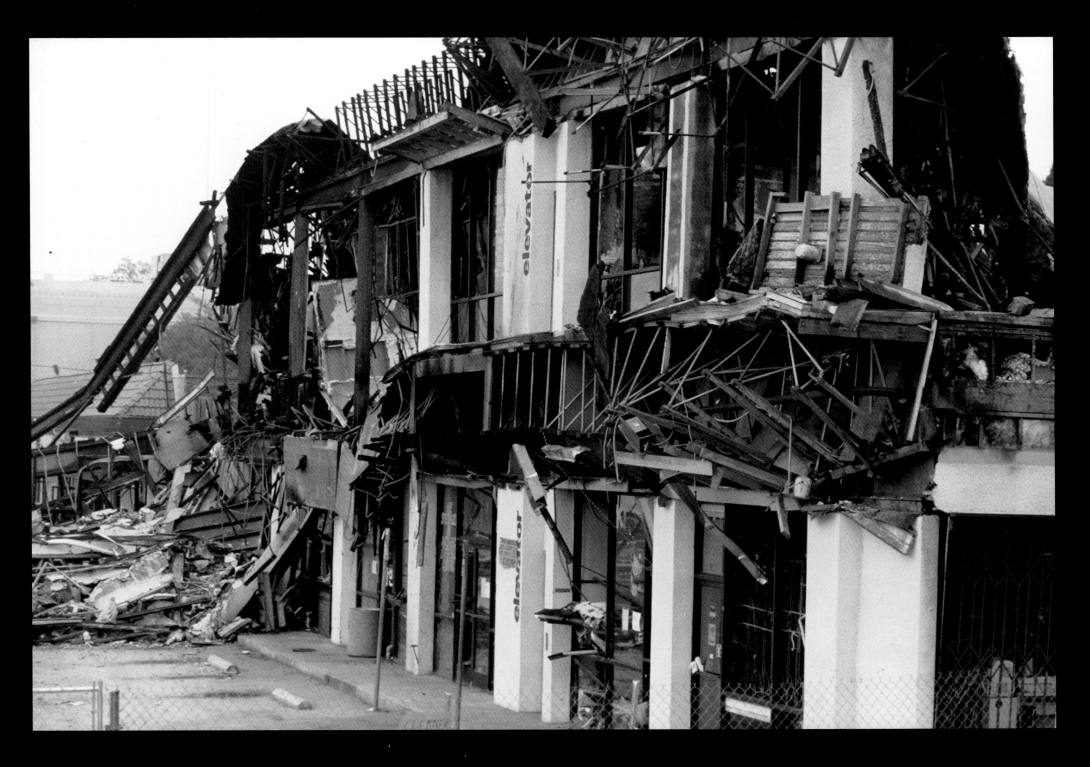

"We were hit next door and across the street."
–Fred

We arrived safely at the animal hospital. The Mexican restaurant next door and the furniture store across the street were burned to the ground.

The waiting room was filled with folks who looked like their pets. An emaciated old man, hunched over, petting his old Yorkshire terrier. Another man with a cat in a carrying case. "She's real old. Can't see or hear."

Fred brought Pepper out on a leash, wagging and twisting her body in excitement, then went back for a cardboard box full of puppies.

"You gotta stop by and get some photos of that abandoned house," Fred said. "You won't believe it."

He told us he and Esther and Olive would meet us there for a post-riot, successful-rescue glass of wine.

Jed loaded the dogs in the RV and we drove the few miles to the house. Not quite as terrific as Michael had made it sound, though it might have been grand at one time.

"This is a horrible place," Jed said. "Look at them foxtails everywhere. Every fool knows that ain't no good for a dog."

The front door was boarded up but there was no glass in the windows. A man came out. He was nice and said, "Take a look around. I'm going out drinking. Be gone when I get back, though."

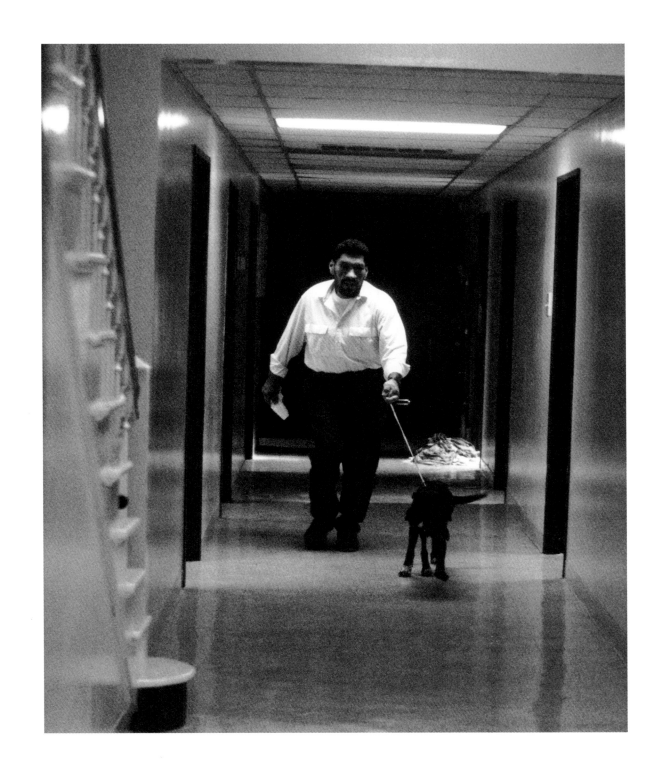

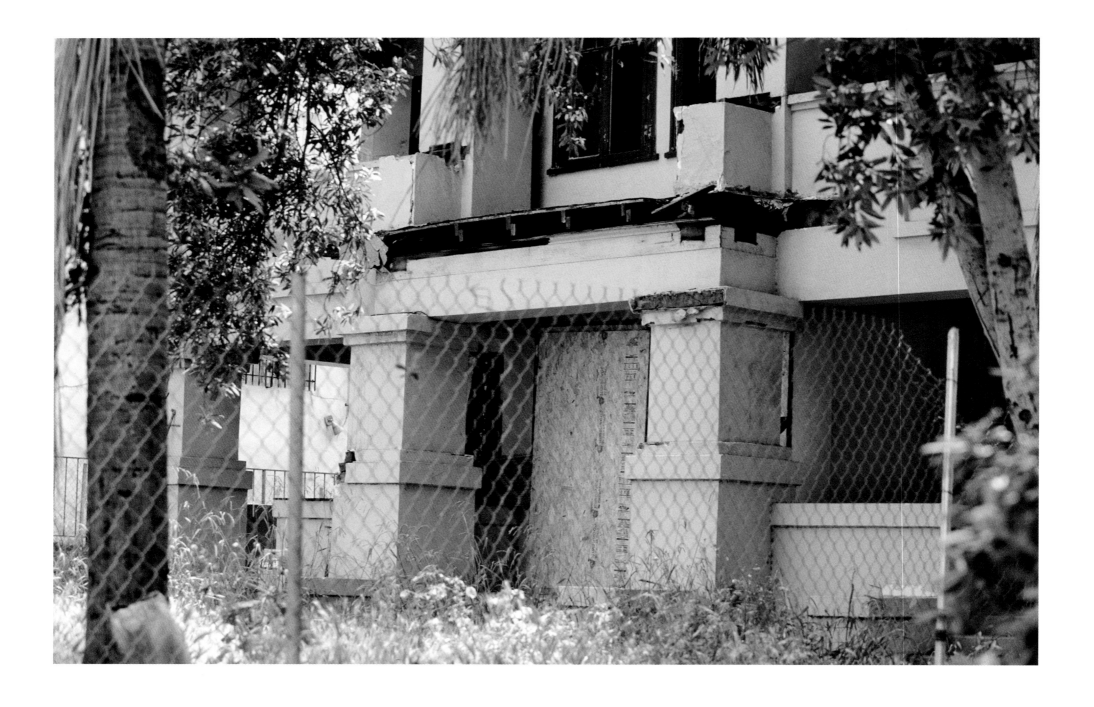

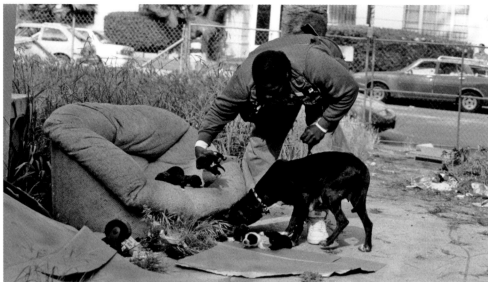

Another man shouted that I had no right trespassing. Mother stayed inside the RV, watching from the dinette window.

Pep was anxious to get out. Jed unloaded the box of pups for a quick photo. Pep ran to the pups, picked up the fattest one, and tore around to the back of the house. Before I could get back there, she was on her way for a second pup. Where had she put the first one? Three Mexican children had been watching the action.

Jed was out front arguing with the bystanders. A crazed woman was waving her arms at him and yelling. I yelled louder for him to help me.

I followed Pep. She was taking the pups under the house in a nasty crawl space. I had no choice but to get inside the pit. Jed told me to wrap a T-shirt on my head to avoid spiders and put socks on my hands, warning me about rat or opossum remains.

Spiderwebs, broken bottles, and debris. Pep crawled around me, both of us on our bellies. The first pup was halfway back, about 20 feet. I crawled and reached the pup, then combed the area and found two others by following their whimpers.

With all the critters accounted for, I took a few fast photos. Neighborhood children were inside the RV talking to Dorie when I loaded the pups. I went back for Pep and found her at a large dish, drinking some stuff that looked like milk and water.

Fred, Esther, and Olive turned up just as I got back with Pep. Everyone stepped inside. Dorie asked Esther many questions. "How did you meet Michael? Isn't he handsome?"

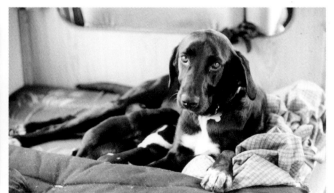

A unique celebration. We'd just met, yet we all knew each other. Chardonnay and brie, a little fill-in about the riot horror enmeshed with stories of Mike and Pep.

National Guard jeeps patrolled Wilshire. In the middle of Beverly Hills, Pep cried and had to get out. I pulled over. Jed got out with her. She strained, as if in pain.

An hour later, we landed on Venice Beach. I had packed steak, baking potatoes, salad, and ice-cream sundaes in the RV fridge.

**National Guard jeeps
patrolled Wilshire.**

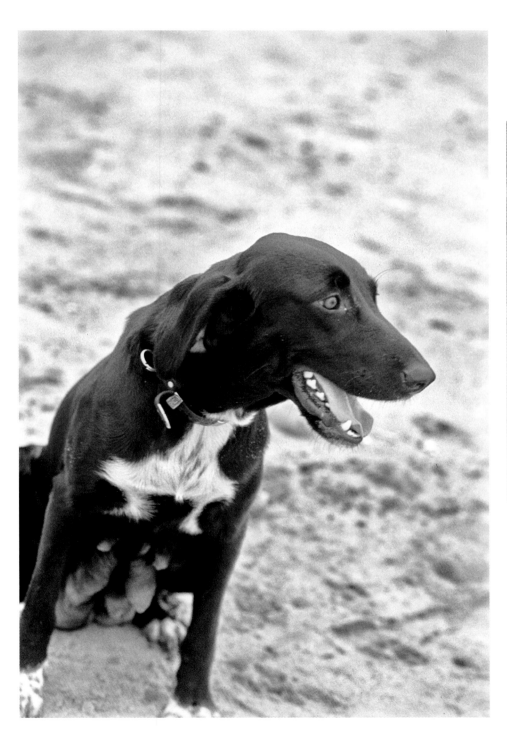

Dorie loved everything, including her vodka. Jed and I laughed at her college stories.

The beach was lovely. Pep ran with her full udders swaying. She was happy.

Pep, her pups, and Dorie attracted visitors. Jed helped an elderly couple up into the RV. Soon Mother knew where the couple had gone to university and how they had met.

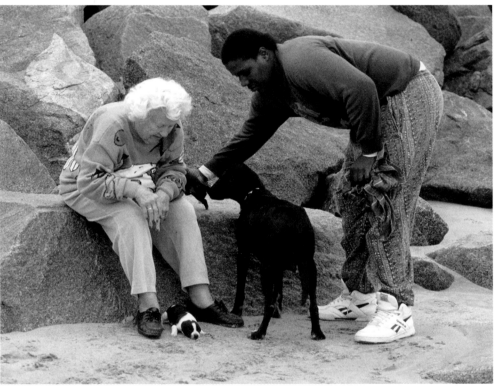

In the morning, after coffee and sweet rolls, we headed back into the city. "Dear, will we see more burned buildings?"

I was relieved to see as much of L.A. intact as it was. I drove back along Wilshire Boulevard for Dorie, then turned down Normandie.

Jed kept warning me about the danger. "Don't stop this machine for nothin'!"

Several miles along Normandie we witnessed flattened buildings and cottages. I pulled over for a photo of a gal standing on a pile of burned rubbish.

"What are you stopping for? We're in Crip territory," Jed cried out.

We crossed the intersection where Rodney King had been beaten by police.

"Susan, I used to know a lot of homeboys from this whole area. Oh man. This is real bad."

We passed houses, small businesses, markets, liquor stores, burned and collapsed. There was an aftershock feeling in the air.

The city was too quiet. A few tanks on the roads, no people except occasional reporters.

We had to stop twice for Pep to potty on the way back to the ranch. Jed took her out, alongside the highway. "Bad stuff and I don't mean the traffic," he said.

I pulled into the arena of the old property and tucked the RV in a place that wasn't obvious to the locals…or to Rob. I needed a day or two for Jed to build a safe kennel in Dorie's tiny back yard before moving the pups and Pep.

We crossed the intersection where Rodney King had been beaten by police.

*er my dad left, I
a crooked line
d stayed there."*

—Jed

Jed handed me the story of his life once we returned from the L.A. journey.

The way I look at it is the things in life I wanted, I never could get. The things I wanted to do, there was always somebody saying no. And there were things I didn't want to do. But I did 'em. Take her gardening. I didn't want to do no garden work. That's her garden. It turns out I learned a lot from messing with that garden. My mom showed me a lot of things that are useful in life. I ain't gonna down my mom. I never will. But I don't approve of her drug habit.

Most people think gang members only sell drugs, commit crimes and do nothing else. Gang members is nothing else but regular people. Police is a gang. The Elks Club is a gang. Gangs can help people out. Mowing lawns, fix their cars, throw a party. There were times when we looked out for people's safety.

When I was a teenager I was more into a small street gang, but the deadliest one in San Diego, Lincoln Park. They're Bloods. We pretty much relied on burglaries for our drug habit. We'd steal a car and sell it to the drug dealers for drugs. If we'd steal tools, we'd go to the auto mechanics or carpenters and they'd get it for a cheap price.

I had stole a Cadillac before. A Eldorado. Me and my friend stole it. The guy actually wanted it tooken away for insurance purposes. He wanted half of the money after we stripped it.

I have been going in and out of jail since the age of 12. I'll be 30 this year. Every year I have done some type of time. When I was a youth, it was more aggressive crimes. Assaults, robberies. Yes, with deadly weapons. Auto theft. I never got caught for burglaries. That was pretty much my specialty, burglaries, but I had stopped doing those because I started getting scared.

Have I ever hurt anybody? Oh yeah. I have started aggressive behavior since junior high school. I guess it started from my dad. He beat me. But I feel that if my dad had been there longer, I would not be like this. He wasn't there for the times that got you straight. After he left, I went to a crooked line and stayed there.

My mom broke my heart, some things that she did. Like entertaining lots of men. Men that wasn't right for me and my sisters or my brothers. At 10, she'd slap me around. I broke my foot on a park toy, and my aunt would take me to the doctors and the hospital. My mom wasn't there for me and I really needed her.

Then it seemed at age 12 I actually didn't really care about nothing, nobody except me. I'd snatch people off their bikes. One day I was in Balboa Park and this was the first time I went to Juvenile Hall. The kid don't want to give up the bike so I had to hit him with a large crescent wrench. I hit him maybe five or six times in the arms and the wrist till he let it go and I took the bike.

He was in pain. He was about 12. It turns out that the kid was a councilman's son. I wanted that bike. And I would have done anything to get it.

My mom went to prison, CIW, when I was 15. California Institution for Women. A lady came in there asking for money as though my mother owed her and pulled a knife out and my mom threw some hot boiling water on her. While my mom was gone, it was my sisters and my little brother. My little brother was having problems with his blood. He was a hemophiliac. He had to have his spleen taken out, I think. All this time my mom was in prison.

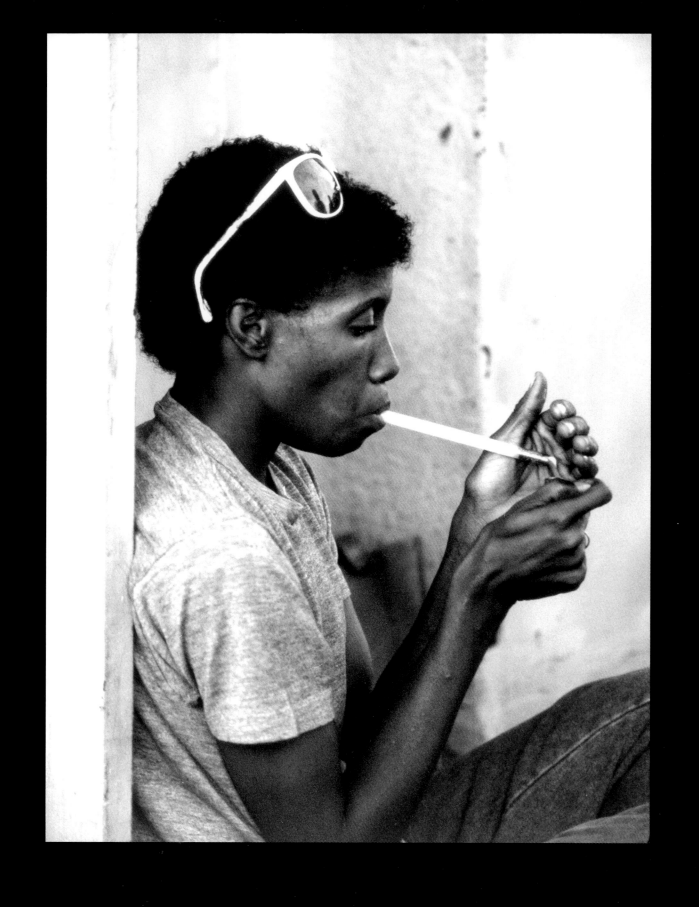

I returned to portraiture during the time Michael was in jail. Jed was good at assisting me with carrying equipment and I gave him enough money to keep him off the streets, but he couldn't type and help out with office work. This was when Scott arrived from the secretarial pool. He was a theater director temporarily out of work, and could transcribe tapes of the homeless. Overqualified for the job, he was hardly a personality content to sit at a desk. Occasionally he went to the park for some of the interviews, telling me his thoughts about the homeless. He didn't like Jed, called him an idiot, and warned that I wasn't going to get a book done if I kept Jed around. I didn't like Scott's judgmental nature, but I needed his fast hand at typing.

Scott was a great organizer. He confidently took over the transcripts and computer work and I got him at a decent rate. Jed went along with me on all photo jobs. Jed's macho nature tried to put down the theater director at every opportunity. Scott would shake his head and retreat to his computer.

Papa came by occasionally. Then one day his granddaughter Corina drove him to the loft, and he proudly introduced us. I learned that she knew Chelsea, when out of nowhere Chelsea turned up wanting to have photos taken at "a secret location." Chelsea and Corina greeted each other like old friends.

Many individuals professing to like street life moved in and out of jail on a regular basis. Chelsea had been back and forth to jail a couple of times since the last time I'd seen her. She said she knew a photograph location that would tell a real story of life on the streets and I agreed to meet her the next week at a building on G street.

Pep and her pups lived with my mother at a rental house a mile away from our home. Pep survived a prolonged illness after we returned from L.A. Turned out that it was due to the liquid she drank on the abandoned property.

The pups were neutered and immunized. We found good homes for them and kept one, along with Pep, bringing our total to eight. We were a family of kids, dogs, horses, turtles, parrots, a Toucan and multiple relationships with the homeless. Fast-paced clip and a new intensity.

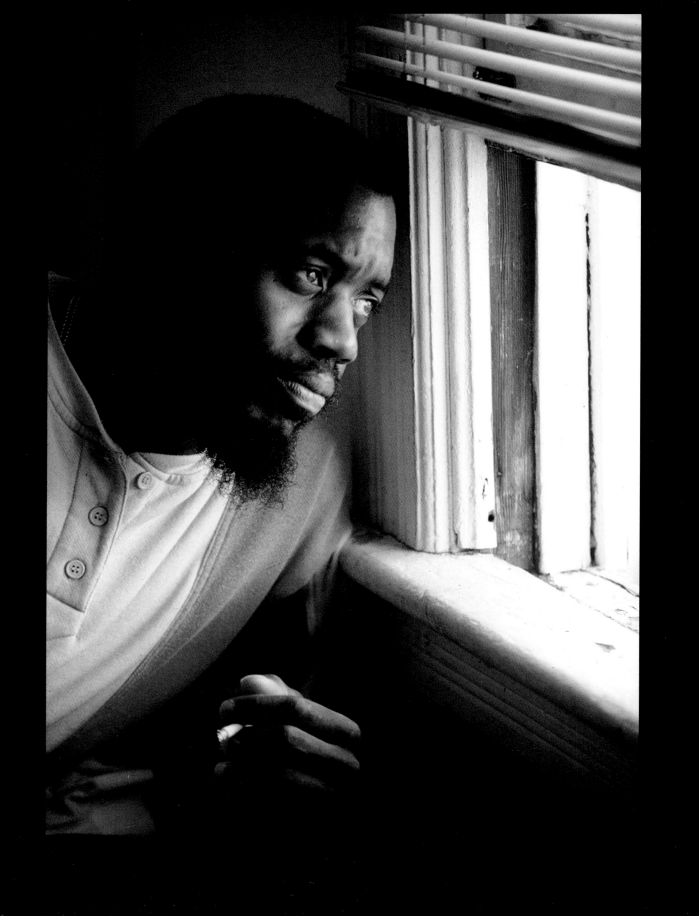

MICHAEL WAS RELEASED FROM L.A. JAIL in early June '92. He took the train and arrived back in San Diego. I picked him up and took him to the Palms to meet Richard White, part of the agreement if he were to meet up with me in San Diego. Plus, I informed him that Pep was no longer his. It was time for him to stay clean and get a job.

The Palms was an old downtown hotel located along the trolley line, one of the hottest drug areas of downtown San Diego, unfortunately. Several shelters were located in the same vicinity, including the Salvation Army and St. Vincent de Paul. I'd met Richard White earlier in the year. He'd worked at the Rescue Mission, and was now running the Palms, working for Drug and Alcohol Rehabilitation at Episcopalian Community Services. Richard had his own history of drugs, jail, and street life. He'd been clean since 1986 and was the first person I'd met in the social-services field who seemed like he was doing some good.

"We're an employment program," he told me. "ECS, more than St. Vincent's, deals with hardcore homeless. Most of our people have been on the streets a very long time. Our contract for shelter—we have contracts from federal, state, and city funding—is limited to six months, three months rehab and three months to find a job. Get a bank account, get on your feet."

I introduced Michael to Richard White and then Michael entered the program.

First day at the Palms. Rough—drugs, food, not comfortable, scary—hearing shopping carts, smelling crack through the window.

The fog has lifted and the sky is clear for take off … now I just have to make that copilot I decide on know how to fly.

I really don't know how to feel. My main concern is the transition stage, reentry into social life.

Thinking back a couple months ago, I was homeless … I'm changing my physical features, skin is clearing, I feel so clean and I enjoy it!

I'm glad this has all happened. My true civilized being is coming out once again.

Cocaine will take one to a living hell. I mean I totally forgot where I came from, my values, my standards … amazing. My etiquette, goals shrunk, my dreams of success, fame, fortune … all lost. I spent four years chasing a rock. It was meant to be I guess, like paying dues in the gutter, jail, dope house, in the fast lane … I learned and probably should drop to my knees.

I wonder what I may have been looking for in a lady. I can't recall a mature, good relationship … sharing conversations, going places, doing something positive. I usually went out with some dope-fiend broad. Every once in awhile it wasn't like that, it would be a nice girl. But there would always be something to screw up the situation.

I really can't see myself being tied down again, or married again, no way in the world. For some reason, it doesn't agree with me. To me, marriage makes a man ugly and pussy whipped.

It's like everything is fresh and new as far as relationships. My parents have moved and have a new house, I'm in a place, drug free, I saw my kids on video, pictures, it's all nice, it's not "hell."

Sometimes I just sit and wonder, where did I go wrong. I remember when I got the scholarship to go to Alabama State … spoiled brat. A chain of bad reactions from there.

The first couple of weeks I could visit Michael at the Palms. Later his schedule would permit some free time to come to the work loft, typing part time. He settled into the facility and showed a serious acceptance of their program.

Michael was turning around. He used his skills, attended AA/NA meetings, and showed brilliant potential. I was astonished. There was no temptation however to release Pep to him, ever again. Michael had to stay focused.

He continued to write during his time in the rehab program at the Palms.

"First day at the Palms. Rough—hearing shopping carts, smelling crack through the window."

—Michael

In the loft, I read Michael's writings, sometimes grasping where he was coming from. Sometimes feeling he had been a lonely kid. Scott, on the other hand, as he typed Michael's words into the computer said, "He's full of shit." Scott disliked Michael. He found Papa and Chuck interesting, but Scott wanted nothing to do with Michael or Jed.

Michael's mother visited from Florida in late June.

```
I have to get into gear. This loneliness is killing
me ... I don't have Pepper to keep me company. I try
to stay occupied ... drawing, writing. I'm waiting for
something to happen.

Seems like one of my biggest problems is growing the
fuck up. I'm so demanding of others, and too self-
centered. I need to shut the fuck up, and go along
with the program.

These past few weeks have been pretty good. I'm
feeling just great. The excitement of my mother
coming, then dealing with her leaving, have all
settled. Now getting a job, going to school, going
to NA meetings, my drawings, and of course seeing
the kids in July or August.

I'm still clean, drug free ... and boy am I putting
weight on. I'm up to 205 or something. On the bench
press I can do my own weight. It's going to be two
years I've been celibate. It's a long time, isn't it.

Where am I going to live? Where am I going to work?

Will I be able to swing it?
```

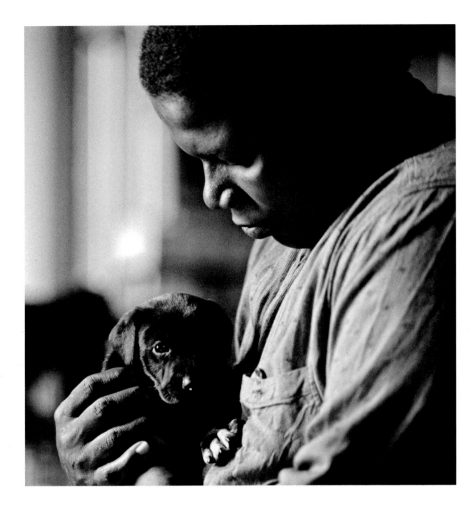

Jed, now that Michael was back, was argumentative. He had excuses for everything like a disgruntled spoiled brat, making Scott and Michael see right through him. He went to jail again. This time he managed to get out. I told him he'd have to get into a program. Too many excuses and inconsistencies. I suggested Richard White, since it was working for Michael. Maybe that's why Jed made certain it wouldn't work for him. He went a couple times to the Palms, but claimed that Richard White was too busy, or "there was a female there talking," or he didn't like being around people he didn't know. He decided getting a car was what he needed. He said he got into trouble with drugs when he had to walk places rather than drive. He tried NA/AA but complained that people were coming in "all drunk and tweaking off their crystal."

More and more excuses came from Jed.

I took a summer break from downtown San Diego, to Tahoe with my family.

At the end of August, I arranged for Michael to visit his kids at his parents' new place in Orlando. He'd been doing well in the rehab program, and cleared things with his probation officer for the trip.

8/28 My children were fun to be with. They enjoyed me, hugged me, called me Daddy or Michael, gave me kisses. We played with Tinker toys, I read them bedtime stories.

9/9 Well, I did it! Three months of the drug rehabilitation, completed. One step at a time…

Who'd have thought that a young, black, dope-fiend crack addict would be willing to change? Willing to trust the structure, the model, how do you say it, a representative of the "system" with his life?

Susie, I've truly been saved from that living hell that I was living.

I was sitting here thinking about my son-father relationship. He was too old to be the type of father I needed but I give him credit … he made sure I wasn't a sissy … he did instill a kind of stubbornness and bullheadedness and some cocky behavior. The eye-twinkle shit, the sly smile, that's what he gave me. He was an asshole but I guess if he wasn't my father I'd think he was a pretty cool dude.

The whole productive, honest, truthful, relating, expressing, explaining, creative, nurturing, sharing, fun, serious, investigating experience has truly enlightened me. It has changed me. I'm not the same person I was three or four months ago.

How the body can rejuvenate itself … how the environment and one's involvement can change a person, how one's posture can change. When I look at myself, I don't see a an ex-addict. My eyes are pretty clear, still have teeth and no scars. I'm lucky!

Michael, 2009

The twins are in their 20s now … they have their own lives. They were about six months old when their mom left me … that's when the party started, so to speak. Six months after that I was smoking crack on the plane headed toward Los Angeles. I had barely got to know them when I left … and that still exists. I've tried to rebuild … it just can't be done. It's like that saying, "You can buy me a watch, but you can't buy me time" … the time has passed.

On the other hand, my son from my second marriage … Adam. I've been there the entire time … it's been very rewarding.

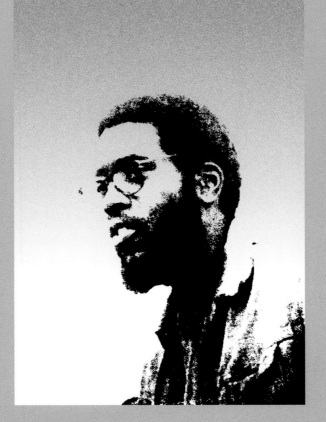

The twins' mother was weak … with little to no maternal instincts, and as a result our kids are actually my parents' kids. Obviously, Angelica and I didn't know what we were doing … (who does?) … so perhaps the kids were saved. Who knows, it's what it is, and they're doing fine … you can't argue with success. I keep it moving, and live in the here and now. I know there are forces that reward what is right and true … karma is a bitch! … so I keep my heart right, and love them anyway.

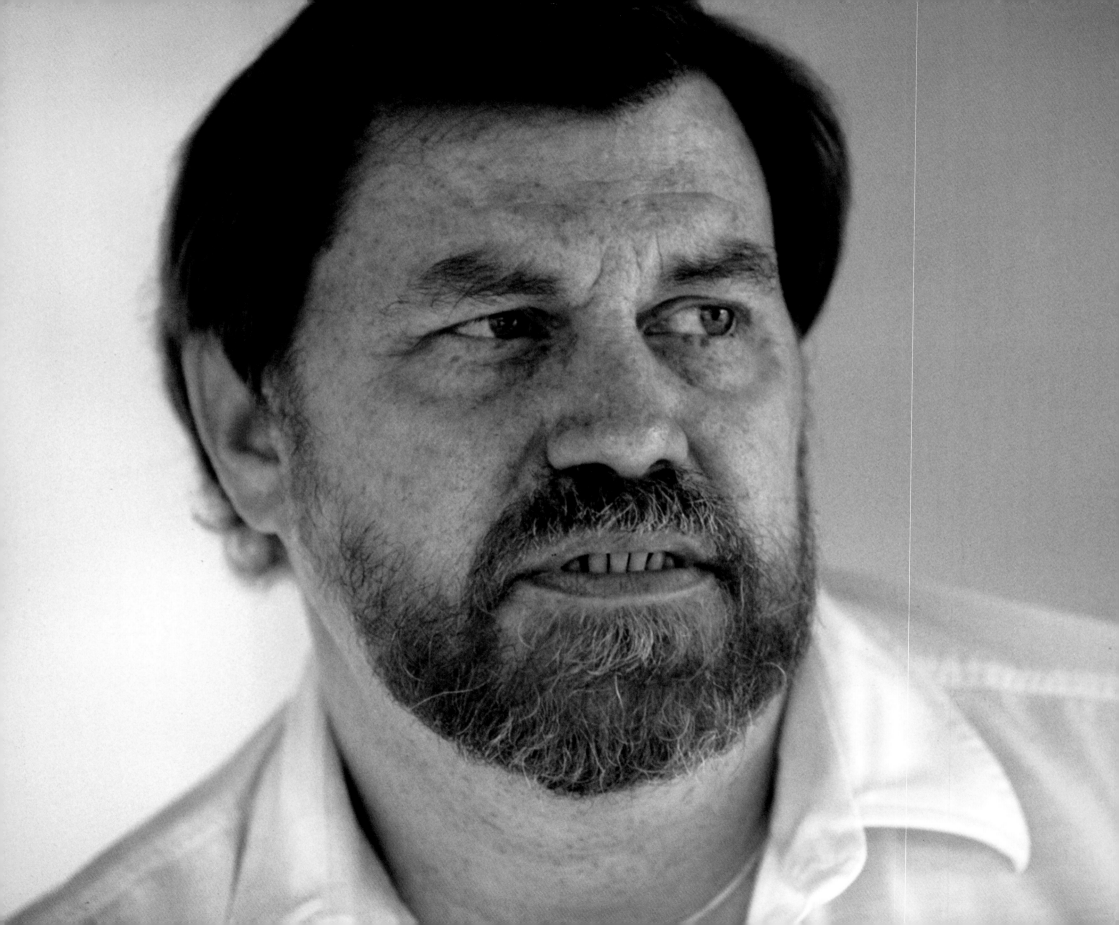

Scott and I sat down in September to interview Richard White. The more I knew Richard, the more I liked his style. He wasn't a born-again Christian, nor was he a flaming rehab clinician; he was a true indicator of what it takes to recover from a life of drugs. Scott was curious to meet the man, curious how someone could believe Michael could make a lasting change.

Susan: *How's Michael doing?*

Richard: *He's graduated from the three-month rehab program, and he can look for work now. If he gets at least a part-time job and wants to pursue this or go to school, then we can help him get into longer-term transitional housing.*

Scott: *How did you get into this line of work?*

Richard: *By being a recovering alcoholic and an addict, and on and off the streets for 22 years. My father and other relatives were alcoholics. I started young.*

Susan: *What were your parents like?*

Richard: *My mother was very quiet, very reserved. My father was a functioning alcoholic. He had a good job, he made money. One night when I was 16, Dad came home at two o'clock in the morning. They started arguing, and he slapped her, the only time I remember my dad getting physical with my mother. But that was it, I calmly loaded the shotgun, walked down the hall, ready to kill him. My mother stopped me.*

Scott: *Is that when you started drinking?*

Richard: *Pretty much. That and heredity. I started drinking heavily at 17, and then I got into drugs. I liked the feeling of crystal. I liked the taste of booze. I got so bad at one point and so paranoid, I'd close myself in the closet to use. I was living alone in an apartment up here on Fifth Street. I'd wake up in the morning in the closet. Afraid the cops were watching.*

Scott: *How long did this go on?*

Richard: *It varied. I'd lose a job and lose a wife. I've been married four times. I'd go into AA and see a doctor just to get my wife off my back. I'd stop drinking for six months just to show them. It all stopped in June of 1986. I'd been through halfway houses, hospital programs. I OD'd once, totaled four cars. I should be dead.*

Scott: *June '86. What happened? What did you do?*

"Oh god, it's never easy."
–Richard

Richard: *I went into the rescue mission, just to dry out, get cleaned up. I turned 40 at the mission and decided if I'm gonna change, I have to do it now. I stayed nine months, then worked for the Salvation Army for almost four years. I finally got back into believing in God. I became chaplain and program director in March of 1990. I met my wife there and we got married in their chapel. We had 400 people at our wedding. Everybody from homeless to college professors.*

Scott: *Once it stuck, was it hard or was it easy?*

Richard: *Oh god, it's never easy. There are times when it comes back. There are times when I see white powder in a bag and my nose starts to flare and I can actually make a run just holding it in my hand.*

Susan: *Are you better able to help people because you were there?*

Richard: *A lot of them have known me for years. This was my stomping ground. Once they start talking to me and I relate my experiences, they feel a little more comfortable. But I know that 90 percent of them are bullshitting me. I'm willing to give them a chance, but I know they're lying through their teeth. I played that game before, and I let them know it.*

Scott: *What's the ingredient necessary to be rehabilitated? Why does one person make it and the other doesn't?*

Richard: *I guess the main ingredient for making it is accepting some kind of spiritual concept. Without that, there's no will to change. If it weren't for my faith, and my wife, I'd be in Canada right now. That's my pattern. Running.*

Scott: *Are most people successful at the Palms Hotel?*

Richard: *No.*

Scott: *Is Michael exceptional?*

Richard: *Yes. He has a will.*

131

In addition to working at the loft, Michael started taking classes in graphic design. I helped him start a little business, encouraged him to get a license, bought him some T-shirts in bulk. He connected with a silk-screener and started printing his designs on the shirts.

```
Class last night was just great … everyone was
impressed with the T-shirt. And oh yeah, as I
was leaving the gym this afternoon, walking up
Broadway, feeling good … wearing the clothes … I
walked past a copy shop and I saw a father-and-
son team making copies of flyers, like a catalog
of sorts. Turns out to be a T-shirt company from
L.A. and homeboy turned me onto a convention at
the Convention Center open to the trade only. It
was perfect! Exactly the type of
folks I needed to meet … girls
in bikinis, and the ravers … all
the T-shirt companies were there.
I'm going tomorrow, too! Couldn't
believe it, used my business
license to get in! Showed some
of my stuff around. I'm liking
it. You know, for a long time, I
haven't enjoyed my life … I was
always kicking my own ass.

I'm really going to get it
together.
```

In early November, it was pouring rain. Scott and I drove toward my parking lot and noticed two men and their three dogs, one of whom could have been Misery's sibling.

They were up to their ankles in water. Sheets of rain were flooding the streets. San Diego had no storm sewers. The men's carts were tarped over with string and canvas. They had on army raincoats and boots.

"Jesus, I hate weather like this," Scott complained. "It's like Minnesota. You can't photograph in this."

I got out of the car and jumped over the puddles to meet these guys. They suggested meeting in the Embarcadero when the rain stopped.

The two men and their three dogs were up to their ankles in water.

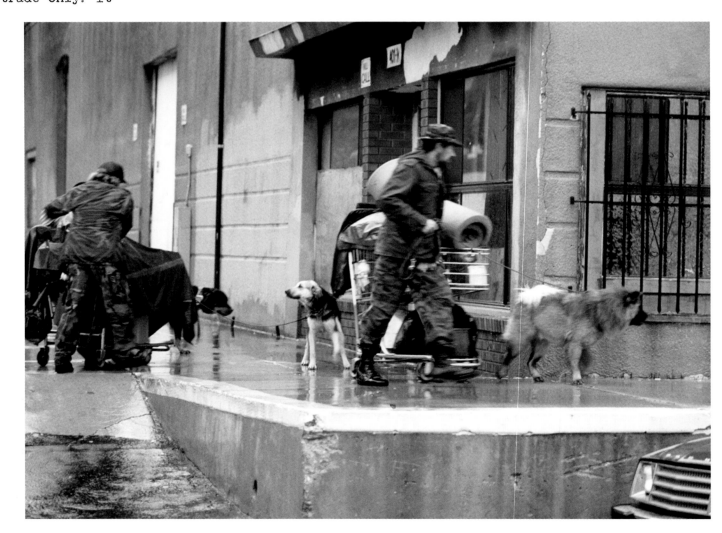

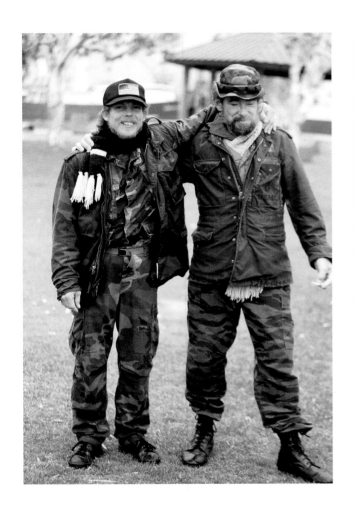

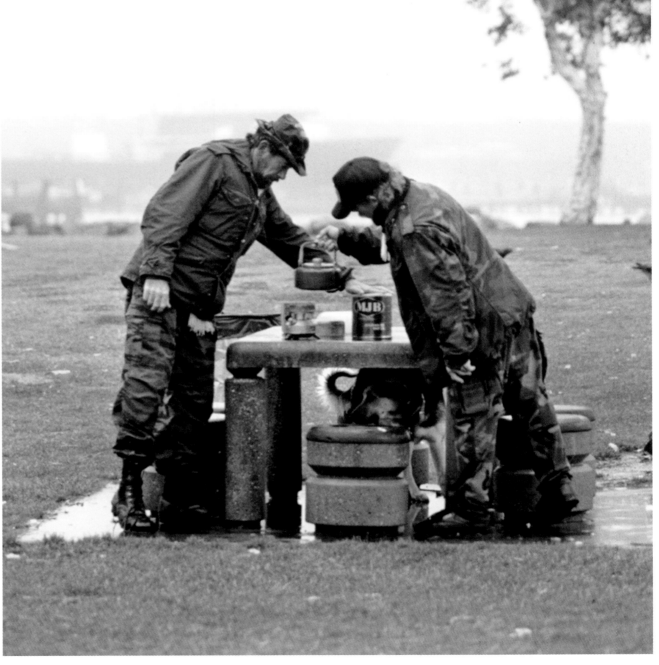

133

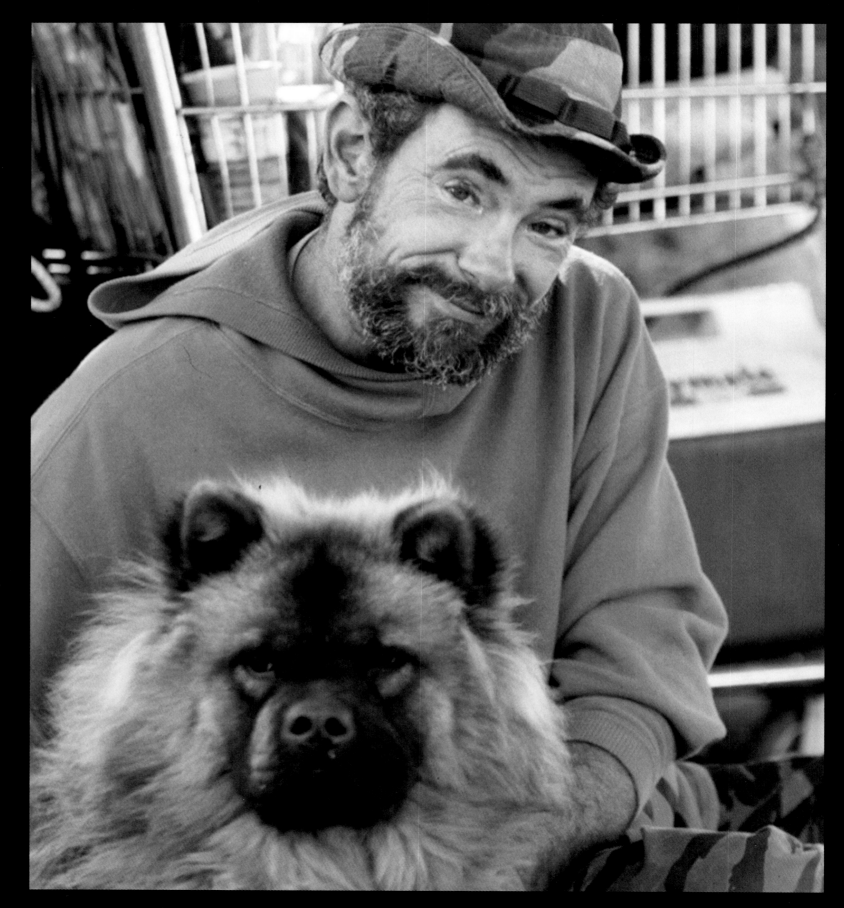

"I don't believe in panhandling."

–James

The next day, the sun was out and I jogged over to the Embarcadero without Scott. James and Tim had a makeshift campsite and offered me a cup of soup. I passed on that but had a good conversation with James about life on the street. He grew up in southern Illinois in a minimum-wage factory town. He'd always had a dog. He loved the outdoors, fishing and camping.

James: I worked in the furniture division at the Sears warehouse, driving a forklift and moving crated furniture. I was living at the Maryland Hotel. The management and I got into a hassle and I just grabbed a blanket and hit the street. I've been sleeping on the street about three months, and I got to thinking, Why can't I have a dog? I gave the Humane Society a friend's yard size and address, and I picked up the dog with 65 dollars.

Susan: How did you know Mo was going to be such a great dog?

James: I didn't. I put my finger in there and he just kinda nuzzled up in the cage. I thought, that's the one I want.

Susan: Are you looking for work?

James: I live comfortably on the street. It's a simpler life. But once you've been out on the street it isn't easy to get work even if you're qualified. You carry around a stigma with you. The Social Security program, General Relief, you have to work anyplace they want and that's difficult because I can't take the dog on the bus or the trolley.

Susan: What do you live on?

James: I live on about 25 dollars a week. I go twice a week to the plasma center and that's how I live. I don't believe in panhandling. I think that's a disgrace and I don't believe in crawling in and out of a dumpster. Time to time someone will come up and say here's a dollar or two, get your dog some dog food. I stay healthy. I see to me and the dog. The dog has never missed a meal.

Susan: Are your parents still alive?

James: Yes, they are. They know I'm alive, but they don't know where I am or what I'm doing. I haven't seen them for six years. We don't get along. I grew up during the flower-children years when things were changing. There's really no common ground.

Susan: When you were little were you out making friends?

James: No. I had very, very few friends. When I was born I was blind. All the muscles in my eyes were paralyzed. When I was two they did an operation in each eye. They took tendons out of my leg to replace all the eye muscles. I was still legally blind in the fifth grade. I had to sit in the front of the class just to see the blackboard.

Susan: Have you ever fallen in love?

James: I was engaged when I first went into the military. When I was discharged after two years in Northern Ireland, she was engaged to someone else. I've been a loner ever since.

Susan: You seem to make decisions easily.

James: I've never had a problem with that. Once I make a decision, it's my decision. Once I sever the tie, it's done. I thought I'd miss work and I don't. To me this is an adventure, a challenge. I almost feel like I'm a cork floating in a pond, surrounded by drugs and other negative things. It's just a matter of how well I can not be affected by it.

Susan: What's the most important survival technique you practice?

James: Choosing the people, the associates you're with on the street. I prefer to be with people who are Christian. There's five hundred parking lots here in San Diego. And we have a drug-free, alcohol-free lot. Around seven at night we set up. I have a little Coleman stove. The other day, we roasted hot dogs with horseradish mustard, and it was the next best thing to sitting out in the boonies with a coat hanger and marshmallows. There's a streetlight. So if a person wants to read, or say Francis wants to look at his Bible, he sits under the streetlight. You won't see people who are genuine and proud over at St. Vincent de Paul. They're junkies and winos. They're camouflaged.

"*I live on about 25 dollars a week.
I go twice a week to the plasma
center and that's how I live.*"

—James

135

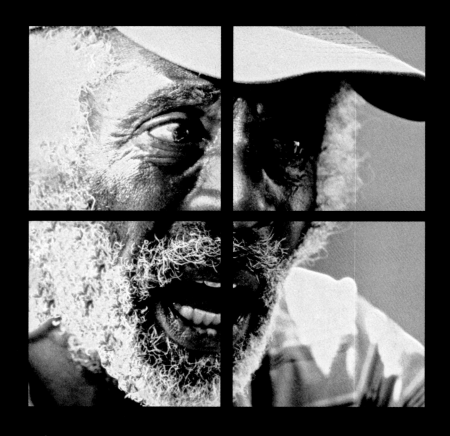

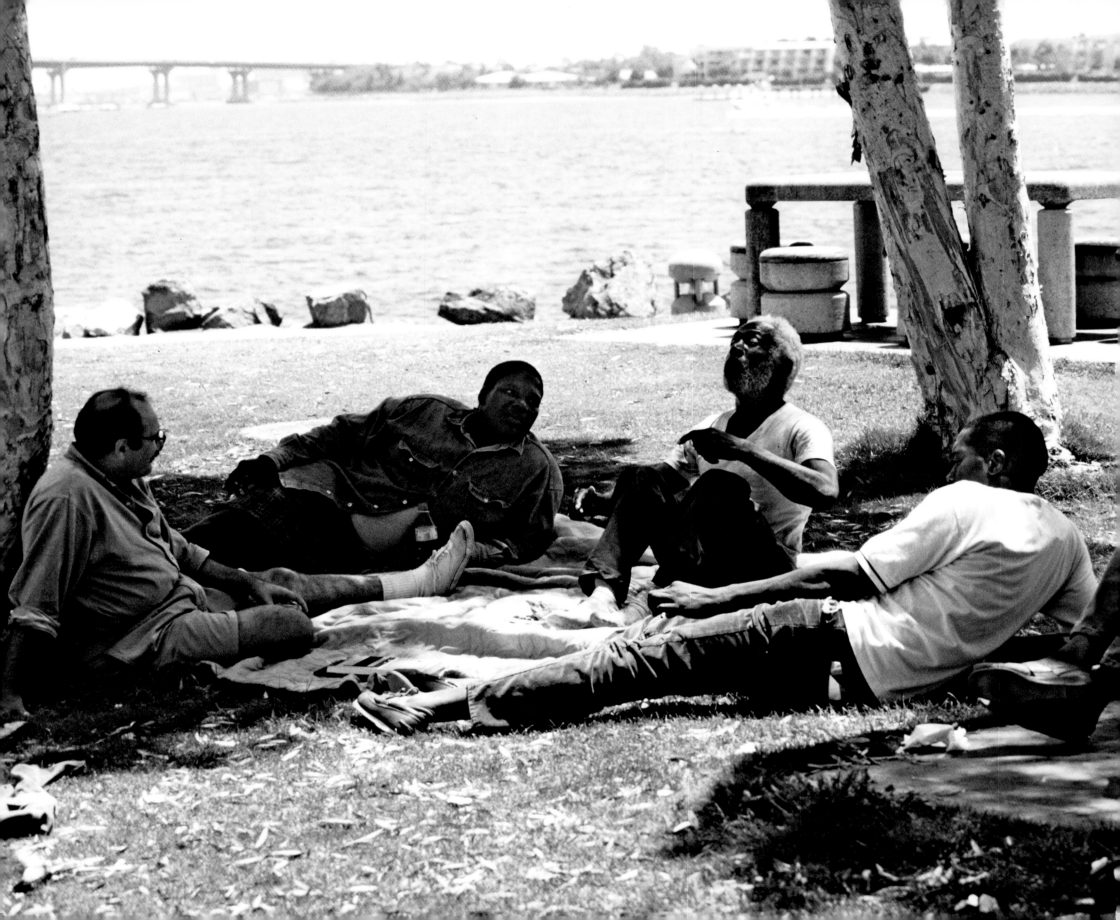

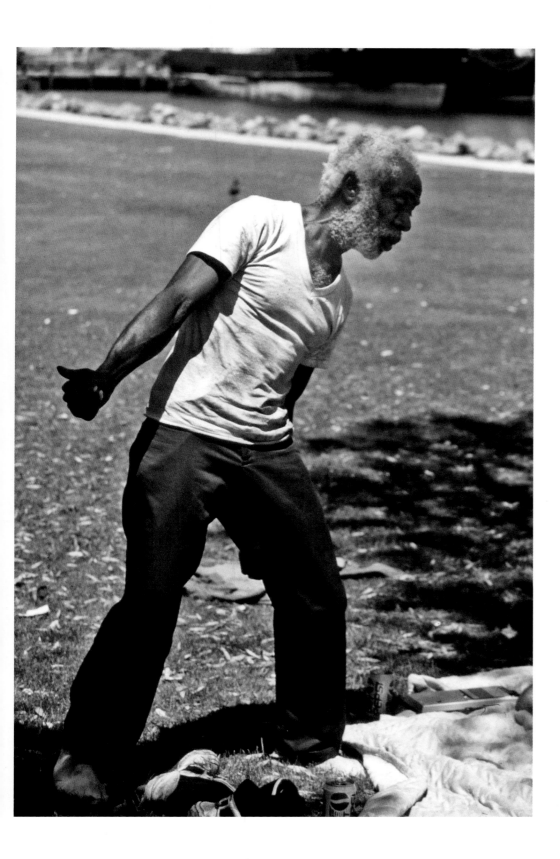

PICNIC AT THE EMBARCADERO with Michael, Jed, and Papa. Beautiful day. Papa got to talking.

The highway is my home. The graveyard my bed, the tombstone my pillow. I'm free out here. I don't have to answer to nobody. I can't stand to be housed in too long. I can stand it for four or five weeks, four or five days. And then I gotta go.

I got a pillow on the street. I got a blanket on the street. I got a sleeping bag on the street.

Back when I was young in Tennessee my daddy used to make moonshine. He kept liquor in the water bucket. I used to drink. And I turned into a alcoholic. I left home at 13 and I didn't settle down in one place very long.

Some of these women on the street, though. Back in my days, my mama would beat my sisters to death if they did anything like that. It's like one of them nasty movies.

When I lived down in St. Louis, Missouri, I used to work on the Mississippi River, loadin' flour on barges. It would be down below zero. And we used to get that glue, put it in a bag and sniff it. I used to do acid. Drop acid on your tongue. And there's cocaine cooked with ether. I took too much of that stuff once and it blew me away.

If you live on the street, people say you're crazy. I'm a Nigger. And an Indian. I'm from Geronimo's tribe.

I like being out. I'm as free as a bird. You put a wild bird in a cage and he'll die.

Michael joined our big gathering of family and friends for Thanksgiving dinner. As the days got shorter and cooler, he struggled.

```
It seems there's no way out. I feel trapped, like
the walls are closing in and time is running out.
My dog, the T-shirts, the ECS Program, the kids,
a job, the street, drugs, cigarettes, liquor,
lack of control, my hunger, bullshit … I feel
like saying "Fuck it!" I tried it your way, damn
it. I tried it. I tried to do things right … to
handle things in a more mature logical manner, to
formulate logical answers to my problems, to look
at things for what they are, and not how I want it
to be, to be self-reliant, to be clean, to live
right and I'm just about to say "Fuck it!" … but I
think of dying. I think of having my brains blown
out, I remember the feeling of some punks pointing
a gun at me and playing God with my life … they
could have smoked me at any time … and that's why
I don't go back.
```

Jed had a place to stay, was pursuing his high-school diploma, and had a job within blocks of his loft. Then he lost his job. He left his place to his brother only for the police to break in and find marijuana growing there. They took the brother to jail. Jed's car he owned with the brother had been in a hit-and-run.

P.O. Murphy told me he would put a warrant out for Jed's arrest unless he turned up by "tomorrow" at three o'clock. Jed didn't show up. A week later he called and said he was sorry for his attitude and needed help. I attempted to deal with him. This was not the fella who went in the RV with me to get the puppies. This was a scoundrel.

"Baby, it's Papa. You gotta come down, quick. I'm sick. Baby, I need some change."

I went to the call box. Papa stood like a little kid waiting for a treat. I noticed a band on his wrist and asked him what it was.

"I was in the hospital! They put the tube down my nose and everything. I had a fever of 110. They said I just about died. I just got out, Baby. The doctor lady told me I was gonna die. I told her, 'Dr. Bitch, Papa ain't gonna die!'"

He came over closer, one step down, and grabbed me around the waist. "I told her she was a good doctor and all, but I ain't gonna die."

"You're on the street now?"

"Yeah, just 'til tomorrow."

"Papa, go see Corina and stay with her."

"Ah, no, she's a bitch, too."

The next day , Papa was back at the call box.

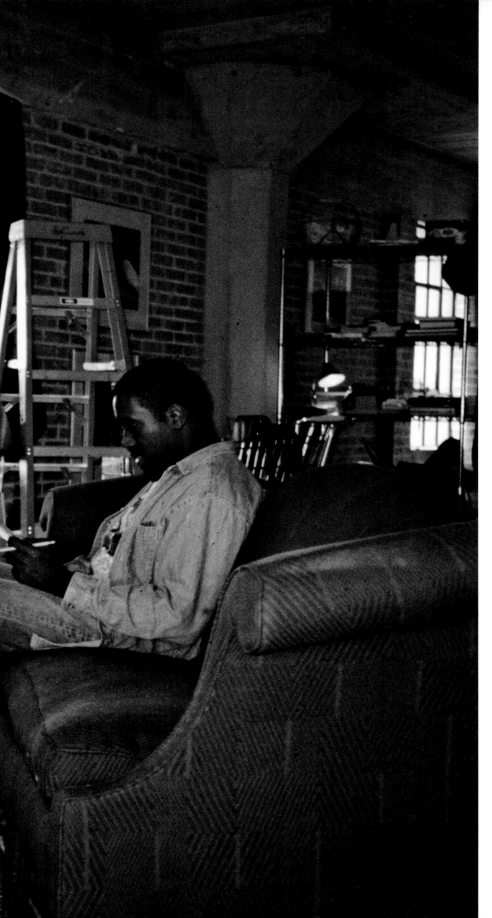

"Hey Baby, you bring Papa a coat? It's cold out." He was shivering, running around in a little short-sleeved T shirt.

I didn't see Papa for a while. The wind chill factor had dropped the temperature to less than 10 degrees. I hoped he'd found a coat.

When I heard he'd moved in with his granddaughter, I was relieved.

This period of time I remember as being very intense. Many relationships, and to my astonishment they stuck. Sure, I was paying a few bucks for some writings, photos, or working on shoots, but I wasn't just handing out cash. Papa was the only one I helped out, from time to time.

> *"I'm back out on the streets.*
> *I've got a fine big cart now."*
>
> *–Papa Smurf*

Walking to the front door of the building in early December I had my arms full of laptop computer, 16" x 20" prints, satchel, purse, pass card and there was Papa, sitting on the electrical box across the street, wearing a burnt-sienna, fake-leather jacket. He was well groomed and seemed OK.

"Hey Baby, you bring your Papa a coat? Look at this one."

He pulled open the sides to show me the skimpy torn lining had no warmth. "I need it bad."

I gave him a little cash.

"I feel so bad doing this, Baby. Look here what I have for you."

He laid a large blue hardcover book on the top of a car parked at the curb.

"Didn't it work out to stay with Corina?"

"No. I'm back out on the streets. I'm down on 13th. I got a fine big cart now."

Just as Papa was taking off, Jed turned up, fussing about the conditions at his new job. Papa laid into him. He said, "You playing that Black thing too far, boy. Stop your whining. You're young and strong. If you got any brains you keep that job and work hard. You got too much self-pity."

Papa talked about the wars, his family as slaves. "During those times they liked working for the white man. They knew what to do and how to do it back then. Many of the whites were good to their black folks." But it was hard for Jed to listen when Papa's example was using crack and living on the streets. Nothing Papa said made any difference to Jed.

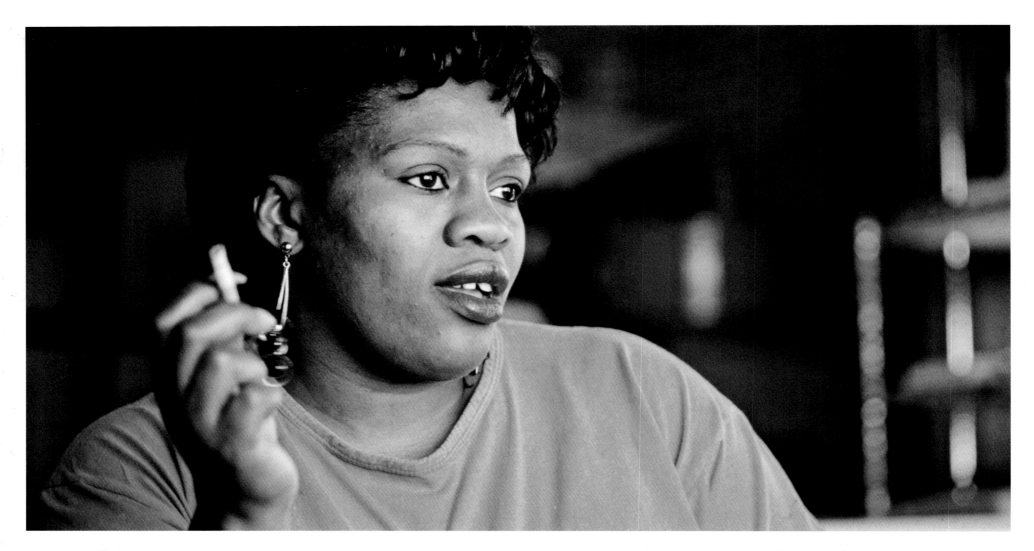

I called Corina.

"He's done this so many times, it's pitiful," she said.

We met at my work loft the next week for lunch.

"He stayed with you and then he just split?"

"Yeah. He's like that. I gave him the place upstairs. Well, the garage. It's clean. Real nice. Has a bed. The only thing it doesn't have is a bathroom. I fix his food."

"He isn't happy inside."

"He gets agitated," she said. "I been there, I know."

"How does he relate to your kids?"

"Oh, fine. He's good with them. He spoils them even. He gives them things."

"How is he with you?

"We had a couple of arguments. He missed the streets. You can't make a person change. He's old now. No obligations to nobody. It's different for me. I have a responsibility to the kids. He'd say, 'Let me have a 10.' 'Let me have a five.' 'Let me have three. I need a pack of

cigarettes,' and I'd give it to him. Did you give him any money?"

"I always give him a little for an interview."

"How much?"

"It depends. I gave him 10 the day Scott and I dropped him off outside the dentist."

"Yeah, but that's also 25th and Imperial, right?" Corina asked.

"Where do you think he is?"

"Probably on that empty lot where they hand out food and all the carts are."

"You said you've been there. Meaning?"

"Oh, yeah. My son was taken from me and put in a foster home. I was put in jail. When they took my son, that was all I needed. I quit. He was all I had in the world."

"You were in jail."

"Oh yes. I know what it's like. You're doing stories on people who've been on drugs? I'd like to be one of your stories."

"He's good with my kids.
He spoils them."
 –Corina

It had been a quiet afternoon. I was typing. Michael was at the light table when all of a sudden, he got up and used the phone.

"You want to leave?" I asked.

"Yeah, if you don't mind. I'm done with the photos."

It was four o'clock and Scott had left.

I had told Michael a couple of days before that I had about two months left I could afford to have him just do odd jobs. If he wanted to learn PageMaker, I'd make room.

The next day he didn't show up at 9:30. Scott was curious. "I don't know, maybe he's working out at the YMCA. I won't go there with him again. Hell, he had me on every machine telling me, 'You can do one more, Scott, come on,' and I had to lie down. I was faint. Ooh and look who's here," he said as Michael entered. "So you were with 40D?"

"40D?" I asked.

"Yeah, I didn't tell you that part. I told Scott last week. I mean she's big. Yeah, in fact last night I had to leave my ID at the front desk to go up to her room and someone stole it," Michael said.

"No way," Scott said. "No one stole it. They sold it, maybe. Now what are you going to do?

"I went this morning and applied for a new one."

Scott was surprised. "You just got a bank card too, didn't you? You better make sure no one rips you off."

"Michael, can you get this cashed for me when you notify the bank? You going over there?"

"Yeah, I will." He left.

"See, just like Jed. You just don't leave your ID with anyone," Scott said.

"40D must be pretty good. I hope she isn't a ho'."

"Sure she is. Why else would he have to leave an ID?"

Scott had a point. For about a month now, Michael had been acting as though he was pretty satisfied with himself. I didn't have much to pay him and it was going to a prostitute?

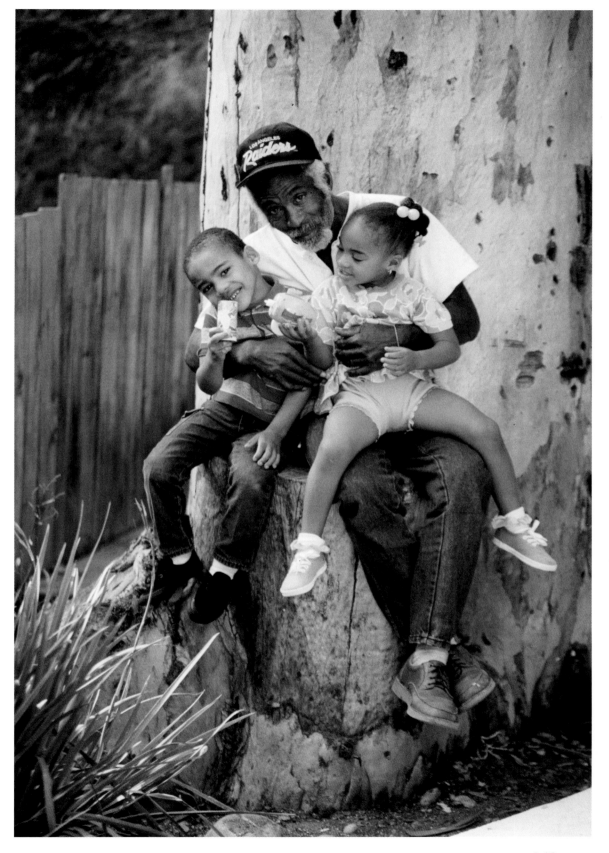

143

Michael had moved into the Champion House. He also attended meetings at the Palms and told me a girl there wanted to talk to us. He warned us that she had a different way of talking and had been known to hit herself.

He'd written about her, back when he was living at the Palms.

```
I woke up one day … I heard the pop! pop! pop! …
the sound of meat being smacked. Pop! pop! like
someone getting spanked on the ass. And then I
heard Cat saying … to herself … "Now just stop it!"
I should have known something was wrong with her
when she said, "Good morning" to me late at night.

In the bathroom, smacking herself on the legs …
smacking herself in the face … beating herself up …
bruising, punishing herself. Then she comes out of
the bathroom trying to change her whole composure
and acts as if everything is alright.
```

The next week, close to Christmas, Scott, Michael and I visited the Palms and met Cat.

Susan: You're staying at the Palms.

Cat: The Residentialized Palms Hotel you mean. I finally got my shit in gear and set this deal up.

Scott: How did you find this place?

Cat: See, you don't listen to me when I talk to you. I be me, nonhuman. You're being human. There's no such thing as sleep. Sleep is for humans. Cat can't do that. But since I was on this maggot-comb-curb-type deal, I wasn't zapperating and making my parts all the way wide-awake enough. OK?

See, you're authenticalated. Authenticalated, human, motherfuckers crash out. They rest. They sleep. So I was a little bit brimming to the fact that during my nighttime, fucker twilight shit I wasn't scoping onto the way I was. Finally, when I brimmed back in, it's like now I can actually brush my teeth and do all this stupid shit. I finally slapped myself around enough to get the fuck up. Going through this daytime-bright-time towel is the second part of the mission. This is like phase two. Let's clean and sweep and comb the maggot-assed, homecurb detail out.

Susan: How did you get your name?

Cat: My name? Another lifetime. What was I? The same thing I am except I'm living at the re-residentialized, upscale, fucker, remodeled Palms Hotel. Hotel mainland. Catland territory.

Susan: Catland?

Cat: Yeah, get it to where I'm happy and shit. It's the truth. I don't have to prove fuckin' jackin' shit to nothin' or no one. If you don't like it, everything is already on the automatic database fucker program. The only main motherfucker hinder is the fact that I was sleeping like a human, dumbfuck, motherfucker asshole. And I'd slap myself…I'd slap myself around a little bit. Finally, I brimmed in and woke the fuck up.

Susan: You have a main man?

Cat: Yeah. Shaman. That's my dude, that's my man, my life. He's kicking back on the bed watching everything that's going on. You can see him. I'm the one with the contact lens problem. Not you guys.

"Let's clean and sweep and comb the maggot-assed, homecurb detail out."

—Cat

Susan: *Would you mind going back and sitting with Shaman? I'd like to get a photograph. What about the teddy bear?*

Cat: *That's mine, yeah.*

Susan: *What's normal?*

Cat: *I'm getting to that. I'm talking about feelings and shit. One person, one deal, one motherfucker feels toward another motherfucker. And then what happens is peon, personalized personal peon jealousy attitudinal motherfucker probable bullshit. That's just normal. Everyone's gotta have some kind of pet peeve.*

Scott: *What do you love?*

Cat: *Myself. I love life. "To thine own self be true." I love my*

computer. I love my boop boops. I love myself to beyond having piece parts made of Cat, by Cat, for Cat.

Scott: *Is there something you hate?*

Cat: *Authenticalated motherfuckers being the authenticalated fucks that they are.*

Scott: *What's the thing you like least about yourself?*

Cat: *Right now, it's my lenses. Wearing my lenses, my piece parts. My eye parts tell no lie. If my eyes lie to me, who can I trust?*

Cat said she had never had good photos taken of her and wanted us to take some pictures of her at her favorite hangouts.

The phone rang … it was Papa at the call box. I went down to talk to him.

"Baby? You won't believe this. Papa is really sick! I went over to give blood, plasma, you know, yesterday. I got bad news. I got hepatitis B. Yeah, my liver. From some infected needle somebody gave me. Here, I found this for you. A nice cup and a red pen you can use for your writing. I ain't going back to that bitch doctor."

He hobbled off. He was scared and probably for the better. Papa was losing weight and starting to get a tremor in his right hand. I had seen some real changes in him over the last year.

Back in the loft I told Michael and Scott about Papa.

"What is this, a plague?" Michael asked.

Papa hobbled off. He was scared and probably for the better.

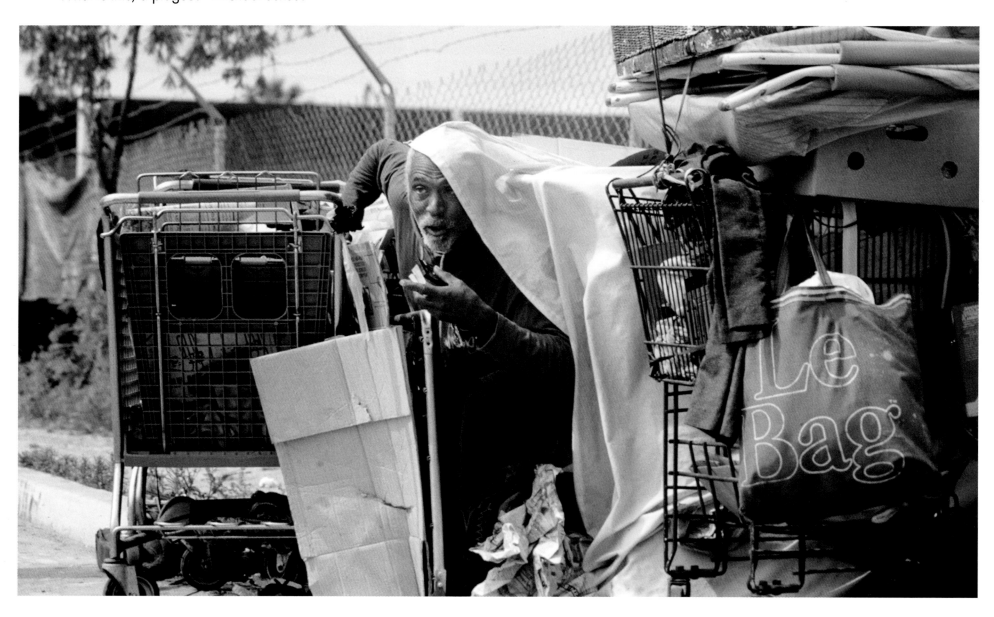

Chuck dropped by the loft with Janelle for a visit. He was off the streets and applying for SSI. He gave me something he'd written.

```
I've been on and off the streets for years. Ever
since the service. I was very young and I used to
hitchhike all over the country, all over the United
States, working here, working there. I got kind of
messed up when I was in the service. I went over
the hill.

I seem to have taken a trip arranged by alcohol;
a kind of physical and mental fare. The kind of
obsession that quietly volunteers when I stray out
of the sober courtyard and assume the role that I
can't deal with myself.
```

We took off a week at Christmas. I wondered how Michael would do—I remembered his mother's comment that he always got depressed at Christmastime and his birthday.

December 27th, I returned to the loft. Michael and Scott were already at the computers. I was glad to see Michael strong and positive. Scott on the other hand had not shown up for Christmas dinner at our house.

"Guess who I saw yesterday?" Michael said. "Chelsea. I think she was in jail because she looks good. She even has a butt on her. I told her to come over today. That alright? About 11 o'clock."

Michael suggested Richard White come over and talk Chelsea into entering the Palms.

Chelsea called at 11:45 and said she would be at the loft in 30 minutes. She was at the welfare office. Richard arrived and we all waited until two o'clock. I was disappointed and mystified as to why she even bothered to call.

Michael returned. He'd gone on errands so Chelsea wouldn't feel pressured.

"Homegirl's on drugs. What did I tell you?"

Nearly a month passed. We didn't see Chelsea or Cat. Jed called with some pathetic needs and complaints. On January 27th, Michael's 34th birthday,

Jed showed up at the loft. Michael said, "Look who I found," and Jed came around and stood in front of me.

He was dressed in nice clothes and looked good. Still pretty heavy. "I been having it pretty rough. How you all been? I still have the job at the stadium at times. But I'm calling on a guy today for a maintenance job out at some run-down apartments in southeast San Diego. I just need a couple bucks for the bus."

Later in the morning, Scott and I were coming off the elevator and saw Papa with his cart loaded. He had on a clean, brilliant raspberry, mod T-shirt and jeans, a baseball cap and huge grin.

"Over here, Baby, these are for you. These two bags are hair supplies for you. I got them from this gal who does hair. They're good, you hear? Now, this is for my son." He pulled out a used golf bag and laid it on the ground. "You give it to my son. He's my son of course, 'cause you're my daughter." I laughed. Papa's life was a mess, but he was sweet and real.

"Here, this is for you, too. It smells real good. Nice, huh?"

It was Givenchy lotion. I kept it to please him.

"You put some of that on and I tell you, no man can stay away unless he's…you know. Now, take these bags of supplies!"

"No, I can't use those."

"Oh, you never take anything I give you."

I asked about the vacuum in the cart.

"You want it, you can have it."

I said, "Papa, Corina was here yesterday."

"She was?"

"Yeah. We're having a birthday party for Diondre in a couple of weeks, his fifth. In Balboa Park at the kiddy jungle-gym area. All the folks I interviewed for the book. I want you to come."

"Yeah. I'd like that."

"Will you get Big Man and Walter for me?" I'd decided the Leica R-3 issue was history.

"Yeah, I see 'em, I can do that."

"It's February 14th."

"That's Valentine's Day!"

"I know, and it's Diondre's birthday. Your great-grandbaby."

Scott talked to Papa as I took a couple photos. "Papa, you said your mom died, your daughter died, and your wife all in the same month."

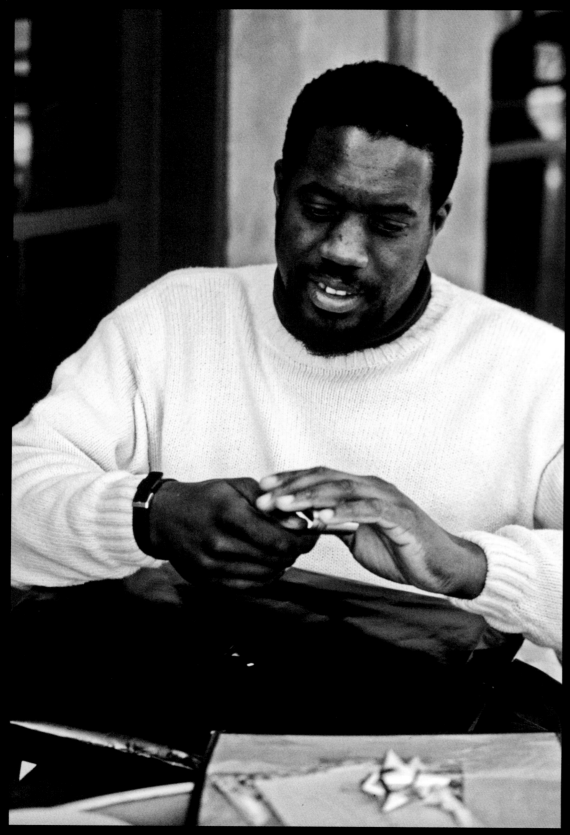

"No, that woman didn't die. She sued me. No, it was my momma, then a week later my sister who raised me with her husband, and then a week later it was her husband. I loved 'em all. No, not my wife. Hell, no! She just sued me for everything. That's when I started drugs. I went through $1,000 a day in cocaine for four months, in 1980. I told you, didn't I, what you do with a woman, the four 'F's'? You Find 'em, Fool 'em, Fuck 'em and Forget 'em."

In front of Fios, Michael came along and jumped the wrought-iron rail where Scott and I were seated, eating the good Italian bread dipped in olive oil and balsamic. Michael was wearing a new off-white cotton sweater and Banana Republic cotton trousers and shirt. He looked sharp and acted as though he knew it. It was his birthday, and Michael wasn't depressed.

I handed him a gift. "I know what this is. It's a portfolio case," he said as he opened it. His old one had sprung the zipper, stuffed with drawings from his classes and T-shirt originals.

Michael ordered salmon and Scott ordered the salad and bean soup. I had the usual salad and decaf. "Hey, I saw Jed get into his sister's car," Michael said. "Just a little bit ago. Over on Fifth and Market."

"See?" said Scott.

"He didn't take the bus?" I said.

"No, honey, he had a ride all the time," Scott said.

Michael, 2009

Birthdays used to have certain pressures, but all this talk of me getting depressed around my birthday … that's just my mother being my mother, creating some drama. I can't change her … faults and some really good qualities, that's my mom. I still love her, and always will … the bond between mother and child, that's the closest.

This year, I turned 50, one of those milestone years … the big four-o hasn't got anything on the big five-o, and I'm sure the big six-o will bring 50 into proper perspective. I received calls from friends and family … including Susie … wishing me well, that's always a good thing. Last year, Rob, Susie, the girls, and their husbands came down to Golden Hill and took me out for pizza. At Luigi's … it was cool … it made for a memorable evening.

A lot of people don't make it to 50 … especially when they've done the things I've done … so already it's a good year.

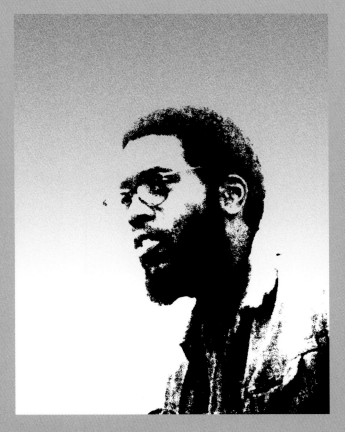

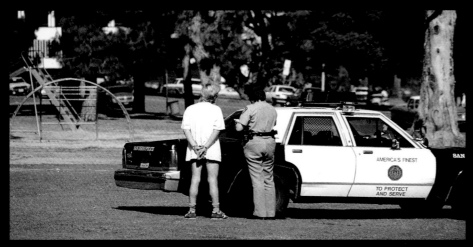

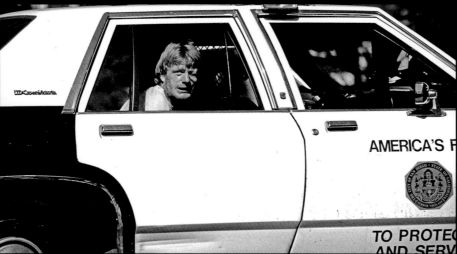

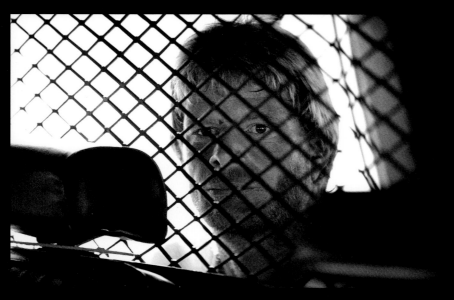

THE FIRST OF FEBRUARY, my niece arrived from Denver with her 18-year-old son. Syd had flunked out of photography classes at a local college, and the plan was for him to stay with our family for a month and help out around the ranch and at the loft. Syd was shy and reluctant to initiate conversation after his mother flew back to Colorado. He'd never been away from home before.

I made several trips in and out of the park. The Fruit Loop seemed more active than normal, and I contacted one of the news stations and left a detailed description of park activity and how unsafe it was for children. They made a story out of it and the city barricaded the lower end of the Fruit Loop, preventing cruisers from easy access to pick-ups.

At the south end of the park I spotted two police cars up on the lawn with Kenny and his buddy Speedy in handcuffs. Shooter, Sandy's dog, was tied to Speedy's cart.

"Speedy, what happened?" I asked.

Speedy stretched his neck forward to the grate separating the cops from the prisoners. "They got me for some warrants. Please don't let them take my cart. I don't want to lose my things."

"Pardon me, ma'am, but you can't talk to the prisoner," said the officer. He was a nice guy; I'd seen him in the park many times. He told me they were cracking down, taking people in for misdemeanors. Sandy and Jeffrey had been arrested, too. They were being held in the upper park area by Sixth Avenue.

"How do you know these guys?" he asked

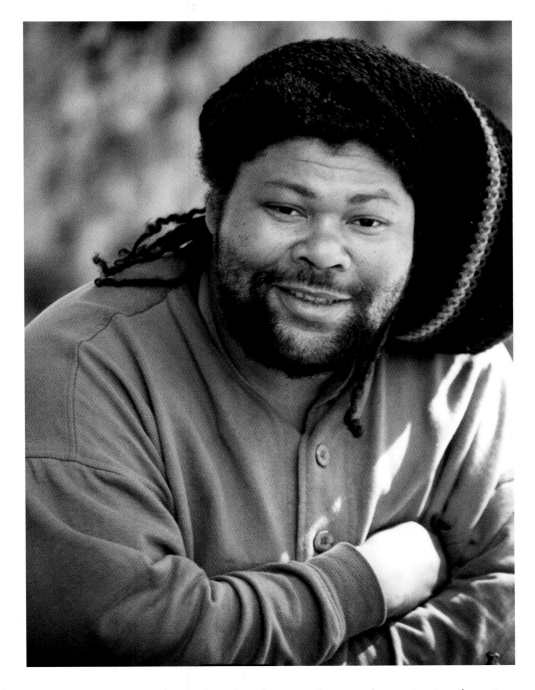

"I've gotten to know them by photographing and interviewing them."

"Do you mind watching the dog, or should we call the pound?"

"No, I'll watch it."

"Susie, what are you going to do?" said Scott as I stroked Shooter. "Rob won't stand for another dog." He was right. I'd already taken on three dogs because of my homeless project, Pep, her pup, and Misery.

"You don't have a dog," I said.

Scott shook his head. "And I'm not taking this one."

Scott reluctantly pushed Speedy's cart with Shooter tied to the front of it.

I saw Red, sitting at the Family table, staring intently at a chessboard.

"Have you seen Janie?" I asked.

"Right over there. How you been?"

I called out, "Janie!"

She looked at us from down by some trees. She was worked up and arguing with another Family member.

"Pipe down," she screamed back at me, then flipped me the bird.

"She's in a mess," Red said.. "I'll handle the dog 'til she comes around. You don't want nothin' to do with her now."

"Sandy and Jeffrey were picked up and so were Kenny and Speedy," I said.

"I know, the cops were around here already. They're picking up everybody with warrants.

Shooter settled down with Red.

"Mind if a friend of mine comes in here tomorrow and plays chess with you?" I asked.

"Naw, bring him on," he said, laughing. "Who's the dude?"

"Michael Johnson. Ever know him on the street?"

"Black dog?"

"Yeah."

"Cool. Hey, excuse me a minute. I been waiting for someone."

Red walked off to meet a car parked next to the curb.

"He's eating a brownie," Scott remarked. "Laced with pot, I bet."

Next day, I arrived with Michael and located Red sitting at the picnic table under his big elm tree. He got up without noticing us and moved over to a red Datsun. He shook hands with a guy in the car. Michael said, "Don't take a picture. It's a drug deal."

Red returned, said he was ready for a game, and asked if we wanted a brownie.

A wild-looking guy jumped up on the picnic table bench and put his hands on his shoulders, then on his hips, stuck his tongue out and made a couple other head jerks.

"That's Ernst," Red said. "I wouldn't do anything to upset him, if I were you. He's real touchy at first."

153

"You were over on 16th?" Michael asked.

"You got it, man. Not my thing anymore. I ain't got any warrants or nothin'. You play the game?"

"Drugs?"

"Well, that too. But no, I was talkin' 'bout chess."

"Yeah. I'm rusty. I played a couple in jail…"

"You got a bed there too, eh?"

"Not anymore. I'm through with all that stuff."

Ernst had jumped onto the corner of the picnic table and reflected the sun into a mirror toward my lens.

Red said, "Ernst, cut that out! Behave or I'll send you on errands."

"God damn, that's the third game in 10 minutes," Michael said. "Either I'm real rusty or you're damn good, man!"

Red smiled. I asked about Ernst.

"Ernst and the mirror? Yeah, he has a couple of those up his sleeve, but he just gets a kick out of 'em. I don't think he'd ever hurt anyone. He just won't talk directly back to ya. I mean, every now and then you can find him talkin' and talkin' but then you ask him a question and he freezes."

Red won another game. "I just pick up some money playing the chess game here, make 40 or 50 bucks or maybe even 100. I play five, 10 a game. Hey Blue!"

"Yeah, man. What's goin' on here? Don't use that camera on me! Don't you even think about it!"

"Come on, man," Red said.

"Yeah, you just wait and see yourself on sugar cubes, packages of cereal, the 11 o'clock news."

"Why did you come over and sit down, then?" I asked.

"See what I mean? She's hostile."

"I met you a couple weeks ago with the Family. Remember?" I asked.

"Blue, old man, you of all people, the suave dude, the WASP cop of the park…"

"Hey, Red, don't do that to me, OK? I been in enough bad deals without having you on me."

"Tell her you're sorry. She's OK."

Ignoring Red, Blue continued, "You know what? I was a cop. I dealt with shit all day long and I got so tired of being attacked for just being a cop, I wouldn't do it again. I'd rather be on the other side for a while."

"That's on tape!" Red warned him, laughing.

"You see that sign on the police car?" Blue said. "It says to protect and to serve. That means to protect the rich and serve the poor, like Rodney King,

serve them jail sentences. You have to have a sense of humor."

"No one held a gun to their head and told them to be police," Red argued.

"OK, and after five years serving this city, I'd rather be on the street looking at them than being in that squad car." Blue got up and marched away.

"Right," Red added, "I've been locked up in places where they didn't feed me for three days. You don't get no mail, you can't write, you don't see no newspapers. But someone of higher authority goes into jail and they got videos, TVs, visit their wives. There's a difference, you not really locked up."

**"I wouldn't do anything to upset
Ernst, if I were you.
He's real touchy at first."**

—Red

"Man," Michael said, "the guy can play chess. I mean, I used to play quite a bit. He just took seven games like nothing."

By now a crowd had gathered around Red and Michael. A funny little guy with his barking, squealing dog, two others transients, and a woman named Sue Ann settled in to find out what Red was up to. She hung on him, kissing his cheek and whispering in his ear. Red tolerated her.

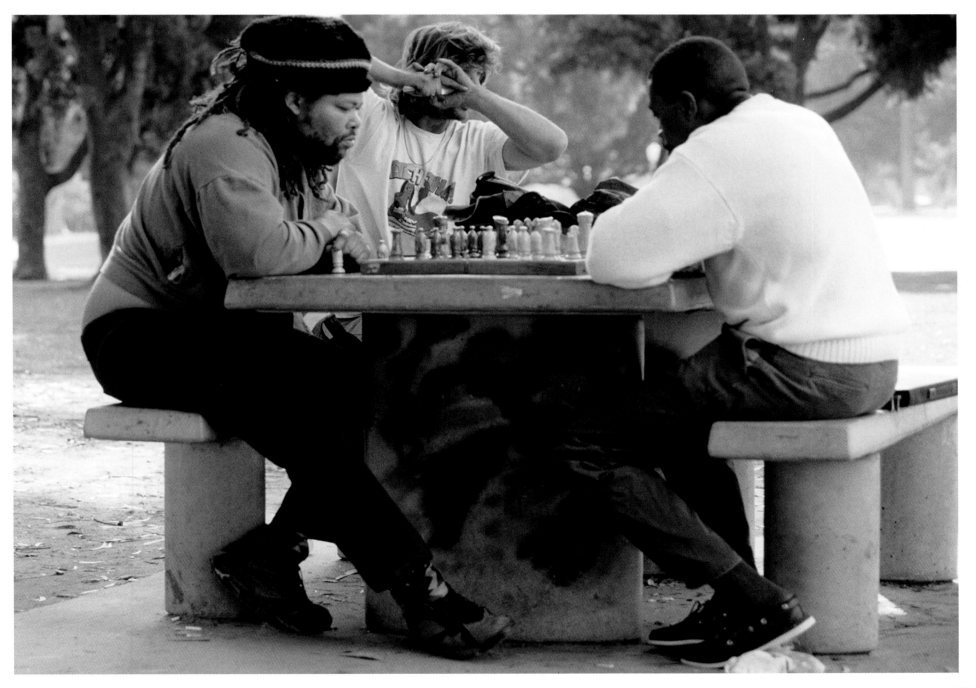

Breakfast with Red at Alex's Brown Bag was set for the next morning, seven o'clock.

"Yeah, I eat me a big breakfast there most every morning. You can park in the back. That's where I keep my car. I sleep in it."

Scott and I drove to Alex's on Fifth. Red was already seated in the back of the charming café. The chef came to the table and said, "What can I get for you? I already know his order. He's here every day. He's like my son. I take care of him. He does nice things for us, too. Cleans the floors and the johns, you know."

"Are you Alex?" I asked.

"No, I'm Uncle Benny, but I own the place."

He was not from San Diego, that was for sure. He took the order and went to the kitchen, visible from outside. A full wall of windows showed off Uncle Benny's wife flipping bacon.

A breakfast of hash browns, omelets, pancakes, the works. Salsa, hot sauce… Red really got into the food. Uncle Benny came to the table. "Yeah, we're from New York. I'd give anything to go back, but can't afford to."

It had been two years since I started the project. It was Scott who'd suggested we turn the birthday party for Diondre into an end-of-the-era party with the cast.

I had heard that Hugh was working for one of the primary local caterers and I tried to reach him at the French Gourmet.

Hugh returned my call. It was the first time I'd talked to him in over a year.

"I head up a catering outfit," he said, matter-of-factly.

"Good. I need a special birthday cake in Balboa Park for February 14th."

Hugh sounded calm and settled in his new lifestyle. We didn't spend any time talking over past hurdles. He said they'd contribute hot dogs, cake, and supplies.

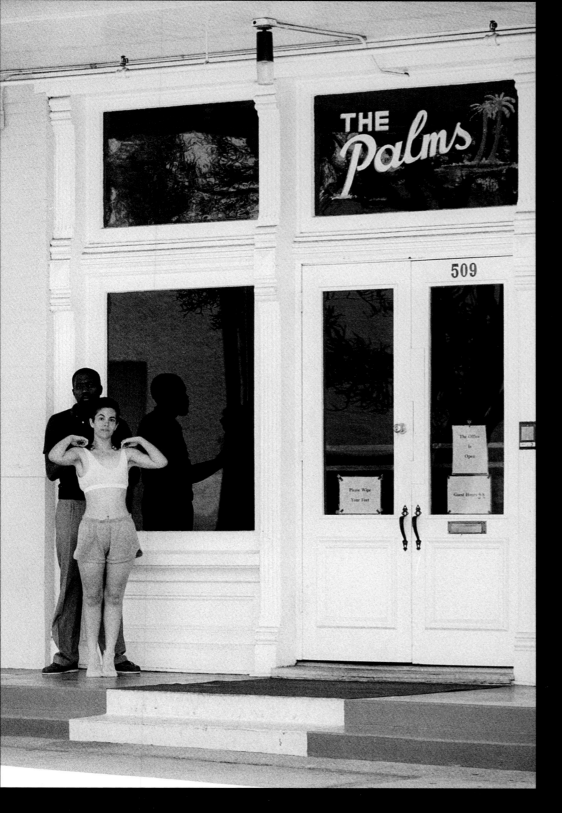

After a couple of weeks assisting with Michael and me, Syd had perked up and started asking sensitive questions about the homeless. The office had plenty of room for me and the three guys, but Scott grew more and more distant and stayed to himself now that Syd was on the scene.

Michael said he'd run into Cat and she wanted to see us again.

Cat met Michael, Syd, and me for a photo shoot. She had studied ballet in her teens and wanted to show off her expressive and creative side. Syd hauled the camera gear, but was clearly more interested in the subject matter than the actual act of taking pictures. Michael seemed to understand Syd and got along with him. Syd liked Michael's humorous and carefree style. I liked it when Michael exhibited a serious and intelligent side for Syd to see. At those times, Syd listened with interest to Michael's descriptions of the street world he knew so well.

The day of the party, Hugh told me he would come with the French Gourmet to set up the barbeque grill and prep tables for our food and their gourmet cake. Papa had said he wanted to come for some cake, so Stacey and I headed out to find him on the street and drive him to the park.

Papa looked as if he hadn't slept for three days. "Baby, it's been cold."

He smelled so bad, and I was proud of how Stacey engaged with him in the car, despite the strong odor. She kept him going with questions about World War II.

"Yeah, I was in all those wars. Papa can't read or write but I could fight."

We got to the park and Corina was there with her kids. Jenny, Chelsea's daughter, was playing with Diondre, but Chelsea's grandmother, Bertha, had gone home. Michael said he'd seen James and Tim and given them directions, but they probably wouldn't be comfortable around this clan.

Michael had noticed Big Man a half block away, but he'd hesitated and then copped out with a friend. They were all funny about the park if it wasn't their territory.

Hugh had sent someone with the cake and tables but hadn't shown up himself.

Syd's assignment was to go to the Palms and pick up Cat. He attempted, but came back saying she'd refused. Stacey and I left the party set-up and went to encourage her. Outside her room, Stacey noticed the doorknob on the floor. Once we tapped harder on the door, Cat abruptly pulled it open and looked at me disgruntled.

"This is my daughter, Stacey," I said.

"Why do you say that, Susie? Sounds human to me."

She was not herself, even the self I knew.

"I'm not up to the party. I'm sorry." She looked awful; pale, swollen face, red eyes.

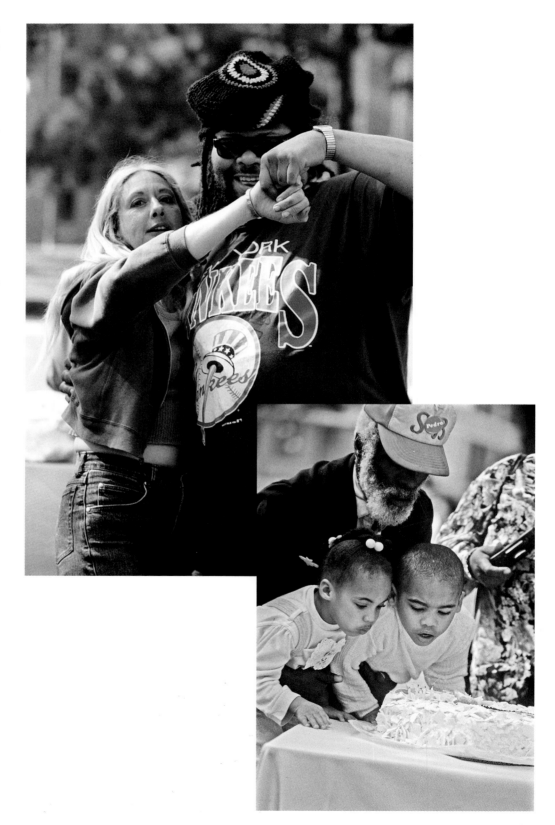

We got back to the party. Hugh still hadn't arrived. Richard White and his wife were talking to Michael and Jed. I mentioned my concern over Cat's appearance. Richard said he'd check in on her, but he wasn't too alarmed.

The party grew. Sandy and Jeffrey turned up, exuberantly, but Janie was shy and stayed back, untrusting. Bird Man even came. I hadn't seen him for several months.

"Where's Hugh?" Michael asked. "Isn't he supposed to show up and shovel the food with us?" Hugh had a lot to catch up on with Michael a new man, 50 pounds heavier and dressed smartly. But Hugh didn't turn up. Michael became the chef. I had cut and peeled 40 potatoes and prepared the potato salad. We'd brought a vegetable salad, too. They were all in line for the food. Forty or more.

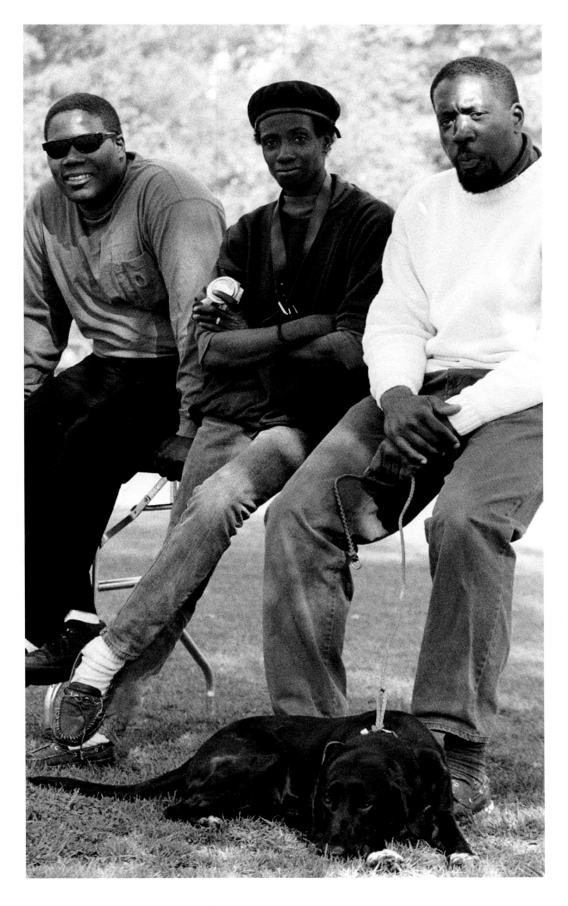

"Baby, I got to go. Serve the cake for the grandbaby so Papa can go. I need some sleep." This was the worst I'd ever seen Papa.

Big Red came along with his ghetto blaster and blue sunglasses. He was a vision. He had a happy, carefree nature, Pied-Piper-like. He marched through the gathering, gave me a hug, and pulled two spectacular pieces of turquoise and silver from his pocket, one rounded and the other rectangular.

"Thought you'd like these. They look like you. I want you to have them."

Chuck left—too many people—but Janelle stayed. Sue Ann danced with Red.

Jenny hadn't been gone for 60 seconds when a new black convertible drove up and let out a slim black female. Who was this? It was time for the party to wind up. Once I saw her move, I knew it was Chelsea. We were out of food, even cake. She ambled over and talked to my friend Barbara with her eyes checking everything out. "You just missed Jenny," Stacey said. That sent Chelsea into tears. She turned and walked away.

I called the French Gourmet again and they said they had several parties and this one was a giveaway, therefore not a priority. Hugh was still at another event.

"I'll stay," Michael offered. "The equipment won't be here in 10 minutes if I leave, you know that."

Scott had been working mostly in the office, avoiding interactions on the street. He'd had it with Jed and for some unknown reason had grown more and more irritated with Syd. Until Michael had razzed Scott into going with him to the Y to work out for his health, Scott had been condescending toward Michael. Maybe it just took a little nudging and encouragement for Scott to ease up with the attitude.

The Monday after the party, tall blond Syd and big dark Michael walked around downtown San Diego with me. An old woman sitting in a wheelchair held out a Styrofoam cup to passersby and said, "Thank you," when a businessman dropped a dollar in the cup. She noticed the cameras around my neck and Syd's. I'd been letting Syd shoot with the Leica I hadn't lost to Big Man.

"Can't you stop for a minute?" she said. "Here, take a picture of me. Come on, you got nice cameras. I got the newspaper after me all the time. See me on the cover of *Currents* three weeks ago?"

"Yeah, that was you, wasn't it?" Michael said. "The guy you're with… he's on crystal…I've seen him around."

"Brody? Couldn't get along without him. He's gone after my cigarettes up on 13th and Market. We save over a dollar a pack."

"You smoke?" Syd asked.

"And I suppose you never smoke anything, huh?" She laughed. "You just don't want her to know. She your mother?"

"No, my aunt," he said.

"Come on, take my picture. My face! Not my feet." Her manner changed as Syd handled the camera. "Look through the damn thing!" she snarled. "They don't produce them the way they used to. Look at you. You got a pro here and you don't even ask her a question."

Michael nodded. "She's tough, but she's right."

"No, no, no. Enough. Let her take over. Show the kid. He's asleep. There, see? She knows. She studied the light. I like that. I want you to do a story on me. I want you to take my birthday pictures. Them guys with the paper don't know what's going on out here. They spent six hours with us and didn't pay but two bucks. I'm losing money right now, just talking to you. Oh, the second reporter had a credit card. What good's plastic gonna do me? I look like Robinson's department store?"

This old gal was sharp. It was obvious she made good money by sitting in the wheelchair, a flower in her greasy gray hair. Her deeply lined face spoke volumes.

"You said your birthday?" Michael asked.

"Next Tuesday, the 22nd. Listen, bring the camera. You're OK. Here comes my love. Here's Brody. Brody, we got ourselves a birthday present.

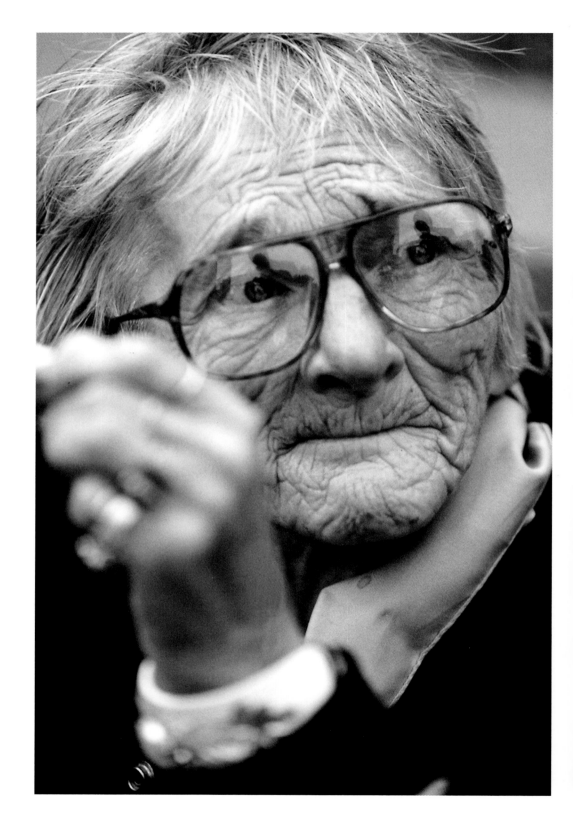

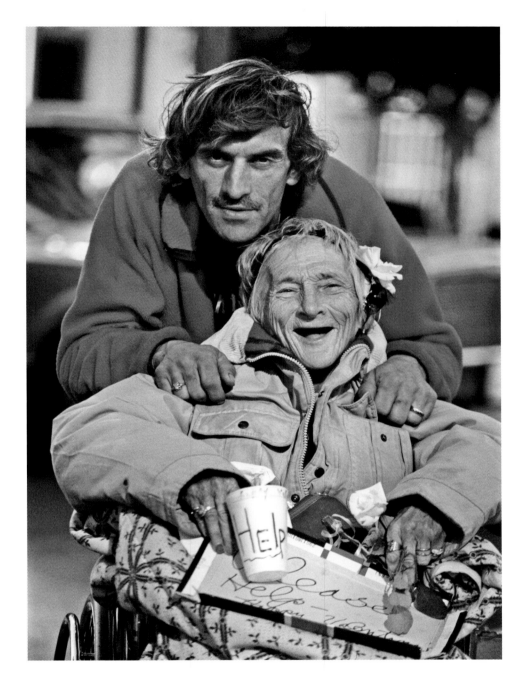

Next Tuesday…"

Michael shook Brody's hand. The man was in his early 40s and out of shape, yet friendly and attentive to the old woman.

"I've seen you," Michael said.

"Yeah, you were on the street, right?"

"Six months ago," Michael said.

"How'd you do it?"

"I'm in a program at the Palms."

"Must be alright for you, to stay with it," Brody said.

"Can't complain. You help her out, huh?"

"Sometimes he's more trouble than help," Pauline said.

"You forgave me," Brody said. He leaned down and kissed her on the cheek.

"No, Brody, I resent that very highly. I'll say what's in my head.

I stood to the side and asked questions so as not to interfere with Pauline's panhandling.

Susan: *You lived in England?*

Pauline: *Of course. My children gave me a one-way ticket out of the country. I have a son in Houston, a lawyer. He's also a stockbroker and an investment banker. I haven't seen him for two years.*

I was a live-in companion for a lady in New Orleans. The woman died. I went to my daughter's home, Peggy. She's the supervisor for an atomic energy plant near New Orleans. She asked me to leave and called her brother in Houston. He called my oldest son, in Lafayette. He's paralyzed with a very rare disease and didn't even want me to stay and help. He told me I wasn't his mother anymore.

My family went to New York when Hitler came to power. My father was half Jewish. I got the National Medal of Honor and the English award when I graduated from high school. And this is something I'd like you to print because I was always proud of it.

My great-grandfather was an English Jew who sailed the Seven Seas. I'm sure he had a slave trade, but nobody in the family will admit it. He's in Who's Who in Banking. Abraham Lunde. He owned a plantation. The bank still exists in New Orleans. This is a very old New Orleans family.

Brody: *She says that the American people are more interested in their cars than they are the people.*

Pauline: *Let me finish… My father had a nervous breakdown. We were in Great Neck, New York. My mother and he weren't compatible. She wanted to take me back to France and I have a little sister called Mary Josephine Gloria. Mimi is 10 years younger than me. She's 62.*

I went to London. I rented a stall on Buckingham Palace Way and did a painting on black velvet that hung in the Tate Gallery for six months. I came back here because I had a cousin in Fresno who left me some money. I wanted to open a small shop in Paris or London. This little inheritance would have been the ticket. So I came back here to expedite it and I got pneumonia. I met Brody at Saint Vincent's.

Brody: I was higher than a kite... This door opened. This little old lady appeared. She said, "I got two hundred big ones." And I was tweaking my ass. I was eight days on crystal.

Pauline: St. Vincent and I are friends but don't tell me I gotta go home by 7:00 p.m. You gotta be crazy. Seven o'clock's when I wake up. I'm a night person. Nicotine and caffeine. Oh yes, I love my Baileys Irish in coffee with whipped cream.

Brody: I walk around the block or sit across the street because people won't walk up and give her money if they see me.

Pauline: When he comes down from tweaking, he's mean. He had flashbacks a couple of times...

Brody: She walked in the house in black pajamas. A black silk outfit with a hat, all dressed like a Vietnamese. I said please get out of that outfit and the next thing I know, I'm dodging bullets on the floor. I had a flashback real bad about a lady and three kids who tried to blow me up with a grenade. I cornered her and started slapping her.

Pauline: He broke my cheekbone. And the police...the 15th precinct came to me and said this man is a bomb waiting to go off. He's never been deprogrammed.

Brody: PTSD. Posttraumatic stress disorder.

Susan: How long were you in Vietnam?

Brody: Ten months, eight days. At the tail end of it—'69 and '70. I was a helicopter mechanic, a crew chief in the air. A door gunner was shot down, and I got four holes in my leg. Twenty-three out of the 25 were reported killed. They bandaged me up, flew me by helicopter to Cameron Bay, direct-flighted me back to Ohio. My father had died six hours before I got home, a massive heart attack. Two days after that I was shot in the wrist at Kent State University, May 4, 1970, when those students protesting Vietnam were killed by the National Guard.

Pauline: I haven't had a birthday party since I was 50. When I turned 50 I got so depressed. I was in the nut house, Mandeville. I want a felt hat. I sold one in Reno, Nevada, for 50 bucks. It had roses on it.

> "I'm losing money right now, just talking to you."
> —Pauline

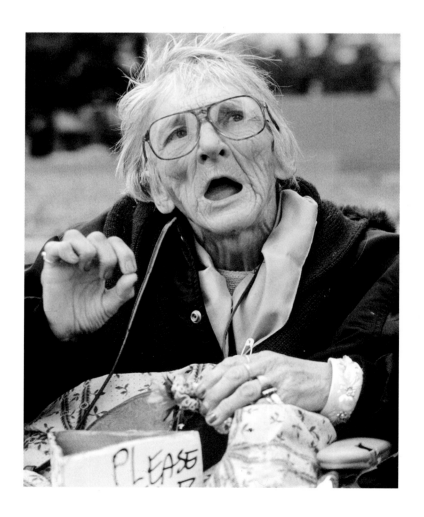

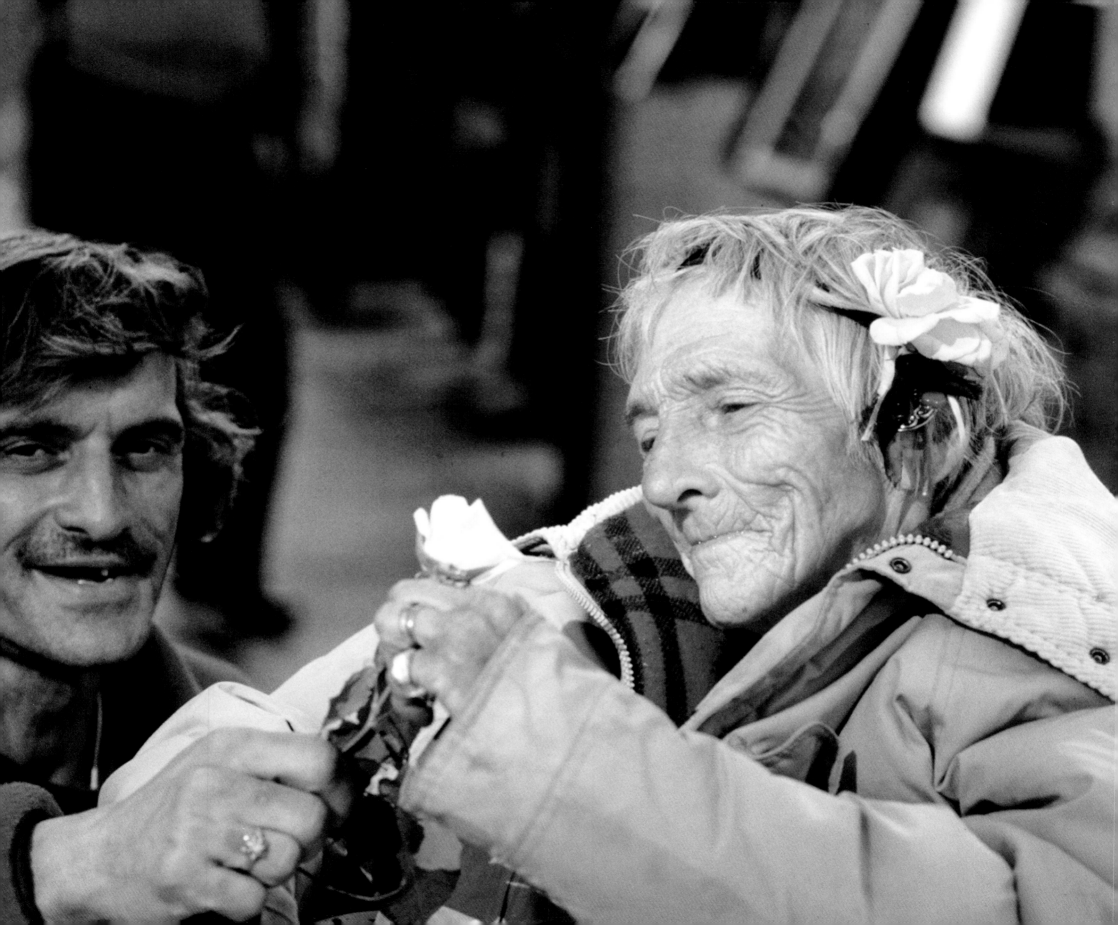

Syd made sure Dorie was coming to the birthday party for Pauline. He took delight in imagining the two old women talking together.

He got to the loft ahead of me the day of the party. When I walked in, he looked concerned.

"Scott and Michael aren't here," he said.

"Well, we'll give them 15 minutes and then we have to head for the Embarcadero."

Scott walked in at 10:10 and looked glumly at Syd. I asked if he was joining us for Pauline's party.

He didn't answer and went to his computer. He hadn't taken his cap off. What was going on?

Syd and I drove by Pauline and Brody. They'd been waiting for us, but I couldn't find a parking space. I was in a fog, preoccupied about Scott. I kept having flashbacks of his earlier tirades.

"Honey, I have to go back and deal with Scott," I told Syd.

When I walked back into the loft, Scott didn't say anything. He still hadn't taken his cap off.

Then he exploded. "It's just all about you! I had a friend die last night but you have to have that kid down here and go to another interview!"

"Was it Victor?" I knew how ill Scott's friend Victor had been.

"You didn't have to yell at me over tapes in front of Syd!"

I hadn't yelled anything, but Scott kept screaming, not making sense. "I'm quitting!" he said finally.

"Fine."

I was upset. I went down to Mekka Java to settle down. At last there would be no more "mother fuck me's" screamed at the computer, at Michael, at the phone, at anything.

"What was wrong with Scott, today?" Sherry the owner asked me.

"He told me he's quitting. I said fine." Weird.

I decided I'd better go up and reclaim the office before Scott started flinging things around.

He'd gathered his belongings together. "Where are my car keys?" he yelled. "Did you take them?" He waved the check he'd made out to himself in front of me and shoved his invoice across the table. Why couldn't he have just said he needed to move on?

I wanted to wait until he'd turned over his key before I joined the others at the Embarcadero.

At the door, he turned and quietly said, "Call if you need anything."

I got to the Embarcadero, where Michael and Syd had organized a couple of picnic tables. My friend Pam had picked up Dorie. They were all chatting as I approached.

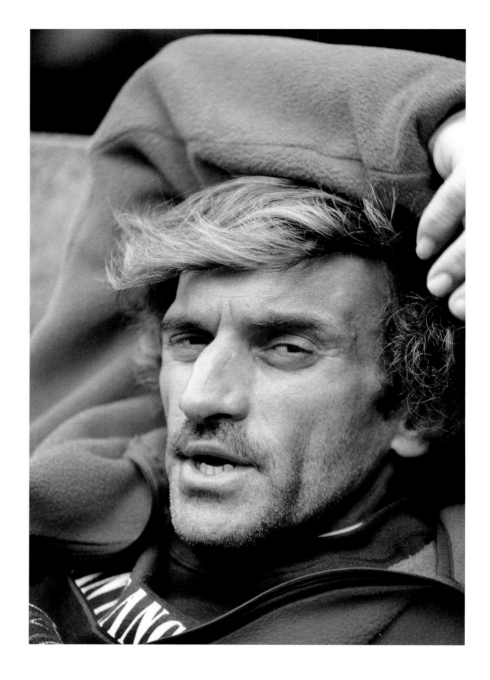

"Yesterday he was complaining and running around saying, 'Here's what you need to take over my job,'" Michael told me. "But just last week he raved about how artistic you were and how much he enjoyed you. Plus he told me this was the longest he'd ever worked anywhere."

"But why did he have to scream and act out?"

"Leave it alone," Michael said. "I'll help you. I can do the typing and organizing. He knew that."

Pam was serving the two old women their lunch. Dorie was sitting in the wheelchair; Pauline sat at the picnic table. This made me laugh. The two women were totally engaged in simultaneous conversations about the Second World War and the style of hats, men, cigarettes.

"I just love hats," Pauline said, as if they were best of friends. "Your daughter gave me this one, a brown felt hat like I wore years ago. Remember these hats, Dorie?"

They blew out candles together as we sang Happy Birthday. They argued about politics. Pauline was more talkative than Dorie at first.

Michael stood back, arms folded, and watched them in amazement—homeless, manipulating Pauline and bright, difficult Dorie. He gave me a little nod, as if to say, "This is OK. I get it."

Brody lay in the grass and ate. Pauline had requested chocolate birthday cake. "My favorite!"

Dorie said, "Pauline, thanks so much for letting me sit in your wheelchair. That concrete bench is too hard for me."

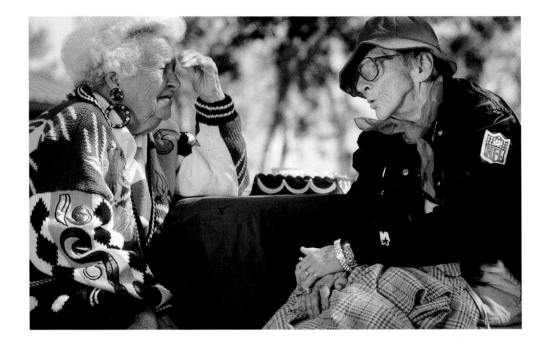

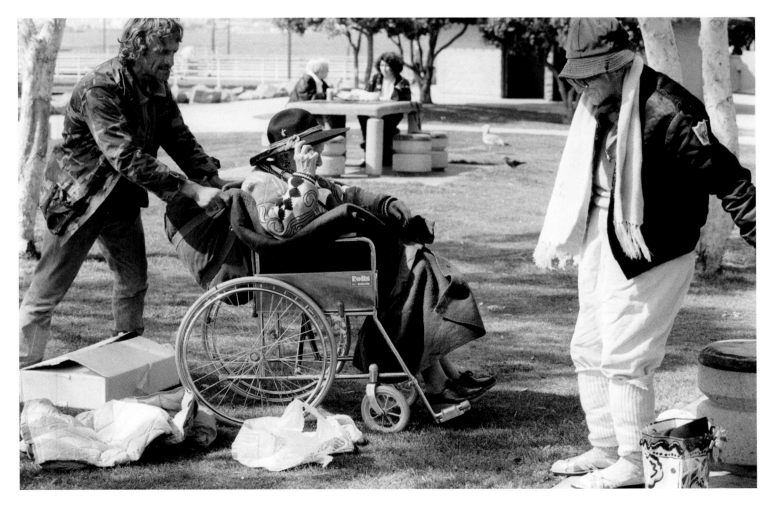

"Susie, I remember when I was 18, like Syd," Michael said. "I've thought about that kid. He needs some structure. He's OK, he just needs some tough male influence."

Michael had taken Syd to the Y to work out a couple of times, and they'd gone to a concert together.

"He doesn't have a dad, does he?" Michael went on. "Never talks about one. There's a lot that kid needs to experience for himself. He needs to get motivated about something, good or bad. Keep him off the pot. You know, just being at the concert, it's all over and in the air."

I'd been having trouble with Syd. I knew he was sneaking pot, and this kept him pretty passive. Oh, he was sweet about Dorie and about getting some things done at the ranch, but it didn't feel as though we'd ever strike a chord.

"I think he needs to go home," I said.

On April 12th, the meeting I'd been trying to set up with the police department finally came through. Captain Paul Ybarrando and Lieutenant Bill Skinner appeared for lunch at the loft and looked through some of the photos we'd gathered of individuals they recognized from the street and the park. I was delighted to have the captain and lieutenant wish to be a part of the project.

Michael and I also met with Bob Daren and Cathy Mathews, who worked with San Diego County Mental Health. We spread out photographs that day too, and discussed the mental health issues of some of the people I'd gotten to know on the street.

Daren: *You can classify people on the street into two categories— the homeless, and the street people. The street people, given the choice, will remain on the street. The homeless, I have to assume they'd prefer to be indoors, to have a place of their own rather than being outdoors 24 hours a day.*

Michael: *It's really not that bad. I remember Susie gave me the opportunity to move indoors, but I didn't. She said she'd pay me enough money to get a room, but I didn't want that.*

Daren: *Why?*

Michael: *Because I preferred to be on the street at the time.*

Susan: *Plus, he was heavily into drugs.*

Michael: *Yeah, drugs…what did I need to be inside for? It all depends on whether a person is ready or not.*

Susan: *What about someone who's not on drugs, supposedly, and maintains he really wants to be on the street? James maintains that he's much happier on the street with his dog than being indoors.*

Daren: *I'd wait for a rainy day and ask him. I'd say I've got a place for you that's warm, has blankets. I could put some money in your pocket, how about that? If he says no, then obviously he's a street person as opposed to homeless.*

Susan: *Mostly, your job is to help the mentally ill.*

Daren: *That's right. Although many times, as I get to know a person, I find out that part of their life has been in psychosis of their own choosing, by use of drugs and alcohol. The mentally ill on the street become really stuck on the street, either through mental illness or ambivalence about the rest of life. It's a crazy way of living. And it's a continuum; the people on the street are all mentally ill to some degree.*

My role is to get them off the street, and to refer them on to a program where people can help them. I look for the least restrictive environment where they feel content, and have their needs met. If they can't handle their own place, the next choice would be group living, a board-and-care home.

Susan: *Do you help them get medication?*

Daren: *For a lot of them, their biggest resistance is being involved with CMH and medication. I first deal with getting them a place to live, some food, and some money in their pocket. I get them access to a doctor at the psychiatric center. They want to live indoors, and not take medication, then we'll do that. They want to take medication and then consider living indoors, then we'll do it that way. If they just want food, we'll give them food for a while. We won't give them money on the street because that often does more harm than good.*

Susan: *Are they safe, and are the individuals around them safe? If they're vehemently opposed to medication?*

Daren: *Mentally ill are no more dangerous than the general population. And they become more violent and dangerous when they drink or use drugs, just like the general population gets more violent when they drink or use drugs.*

Susan: *Cathy, where do you fit into this picture?*

Cathy: They don't get as far as me without having a diagnosis. We lose people when they don't want to be diagnosed, don't want to be set up, don't want someone following them all the time. And that's after months and months of work that Bob may have done—they'll say, nope, that's it, I'd rather go back to the streets.

Daren: They might do okay for a while and then start showing up at our emergency psychiatric unit.

Susan: How do they get referred to the emergency psychiatric unit?

Daren: When they get psychotic, walk in front of traffic, start pulling down their pants, or things of that nature. And that happens every single night in San Diego.

Susan: Momma has been in the emergency psychiatric unit several times—the black woman who wears the turban.

Daren: Oh yeah, I know her. She has a social security income, but she doesn't have a payee to make sure her check is spent on food and a place to live. Instead, she's on the street and squanders her money within the first two or three days of every month.

Cathy: Most of the people who need our help have been identified. I can go up and down the street and see some of my clients, and they're still doing all that crazy stuff, but still I can't get them in.

Susan: What would have to happen to get Momma in?

Cathy: She'd have to do something dangerous. Then she'd have a psychiatric assessment, and we would determine whether or not she's "holdable." For every injunction there's a legal process. She'd be assigned an attorney and an advocate. She could say, "I don't want to take medication." And there would have to be a hearing. She could say, "I don't want to be here."

Susan: This is really costly, isn't it?

Cathy: Yes, it's very costly. And it's frustrating, because we can't keep anybody if they don't want to be there. Even if Bob gets them in the hospital, often the legal system works against us.

Daren: And of course there's continual prioritizing of patients in the hospital. You have people in there who are really, really very sick, but one of them has to be booted out if someone tremendously more sick is in the emergency room and needs to go in.

Susan: How many beds do you have now?

Daren: Sixty-nine.

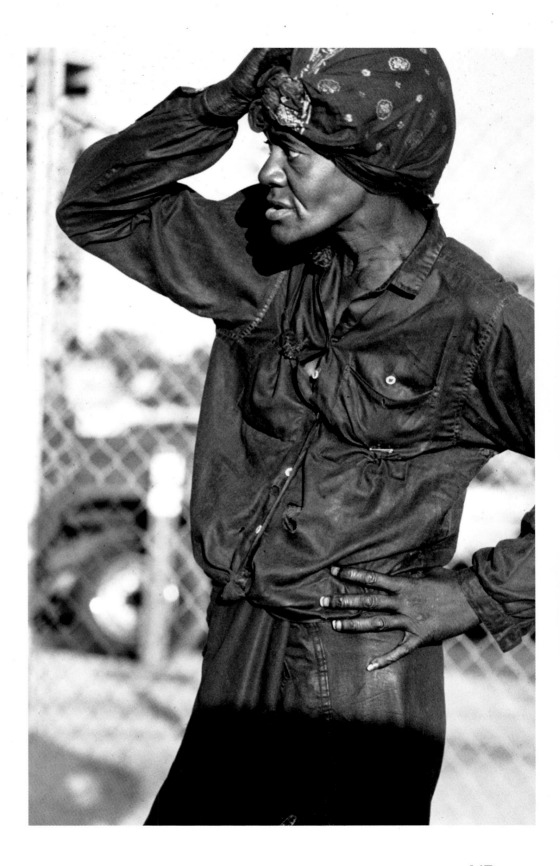

Susan: It went from 120 down to 69?

Daren: It's very limited. We have 14 acute beds, plus long-term, plus an elderly unit. I've lived and worked in other metropolitan cities, and I've never seen so little indigent care.

Cathy: We also have people in our caseload who live in our hotels. Or manage on the streets. One in particular is terribly crazy. Tall, with dreadlocks. He's just a mess. But he still comes in and sees the doctor, so I can't get him under a conservator.

Michael: The tall guy with dreadlocks down near the courthouse building? Blond dreadlocks? He doesn't use drugs.

Daren: No, he's just very mentally ill. His name is Terry. He hasn't had an indoor place in quite a few years. At first I didn't want to go near the guy, he's so nasty, then later I'm shaking his hand and saying how are you doing, are sure you don't want some food today. And he might even tell me about someone else who might need help. I get a lot of that—are you sure someone else doesn't need it more than me.

Susan: Is there hope in any of this?

Daren: Well, the more you expose the problem, the more people can't pretend it's not there. I don't think anyone wants to think of their grandmother or mother out on the street 24 hours a day, sleeping in Balboa Park in the sun, sitting on a park bench all night, existing on handouts and nothing more.

Susan: Is this one of those women?

Daren: Yes, that's Georgia! That woman was hospitalized in 1970, or 1972. She believed the Mafia—the Italian Mafia—was after her. While she was in the hospital, she got a conservator. They placed her in a board-and-care home, and she walked away. She's been on the streets ever since—more than 20 years now.

Susan: She usually tells me she's from Orange County, and just came down for the day. Then she goes and sleeps in the park every afternoon. Do you know where she sleeps at night?

Daren: She's on a bus bench on Washington Street. Occasionally she goes to the park just off Goldfinch, in Mission Hills. She used to hang out at the library there, use the library bathroom. She usually stays clean and well kept.

Susan: Do you know Chelsea? She may be off the street now. She's been in and out many times. She'd be 33 years old now. Ninety pounds, heavy into crack.

Daren: Usually when I hear that, I don't even get involved.

Susan: How about Bonnie? The first time I met her she told me, "My mind is in Mexico."

Daren: Oh yeah, I saw this picture in the regional task force. This woman is a real story—she's back with her husband in San Bernardino now. She used to tell us she worked for Cal Trans, and had money from workers' compensation.

Susan: Is she on medication now?

Daren: Her husband slips her medication into her breakfast every morning. The whole story is she was in Ocean Beach living in an alley, she was incontinent of feces, I believe she had lice. I talked a cop into 5150ing her—involuntary psychiatric hold. I got some history from her daughter and got hold of her ex-husband. He started coming down to visit her and took her for weekends. In December, she moved up there to live with him. They'd been sneaking the Haldol into her breakfast at the board-and-care home under a doctors' orders, and he just continued the same thing. That's one of the few success stories. They've been living very happily ever since.

Susan: How about the black woman who dresses well and spends her time in that church on Fourth?

Daren: Rosie. She won't accept going indoors. People have reported her and called the guy who runs the church. She defecates there and people see it from up top. They don't know what to do with her.

Susan: What is mental illness?

Daren: A disorder that affects a person's perception of reality—dissociative disorders, anxiety disorders, psychotic disorders. Or combinations like schizoaffect disorders, a combination of schizophrenia and manic depression.

Personality disorders get confused with severe mental illness. The prisons are full of personality disorders. They range from antisocial personality, to dependent personality, to borderline personality. Many people have both a personality disorder and mental illness. One complicates the other.

Cathy: We get them cleaned up from the psychosis, and then you have this personality disorder underneath that causes just as much of a problem, because they're so dysfunctional in society that they can't live with others. It never ends.

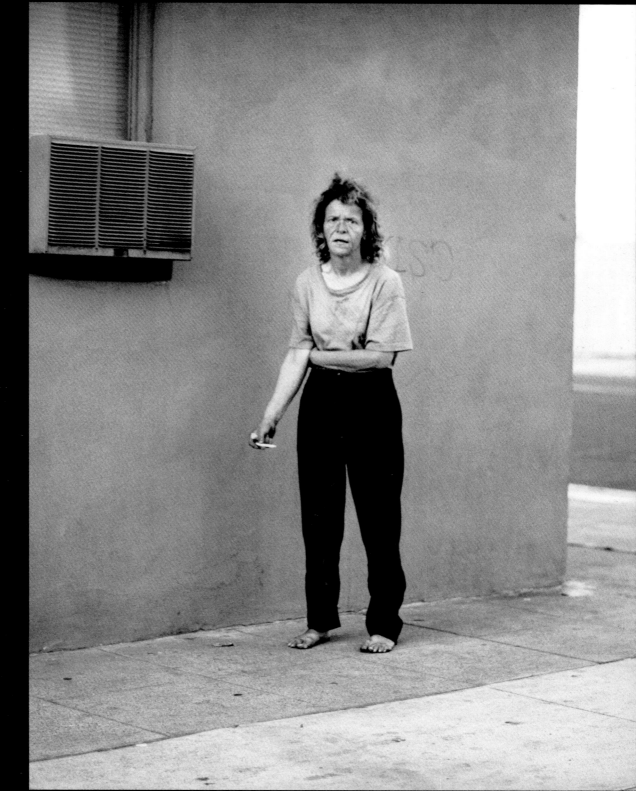

"*I was gang-raped several years ago in the park. I've been on the streets ever since.*"

–Charlotte

The parties were over. The interviews were done. Michael and I worked on the transcriptions and film organization. He studied the WordPerfect manual and came up with complicated, creative ways of employing Word-Perfect with PageMaker.

"At last I'm doing something for you!" Michael said. He took over Scott's area. Before long we had a roomful of manuscripts from my computer and the IBM typewriter. Michael laughed out loud at some of the material; he also remembered his days on the street. I was no longer interviewing and searching. Instead, the characters we'd met were a serious part of my life.

Stacey and I gathered up the computer, papers, and her schoolwork one evening in May and headed out the door. "Mom, look, the police are over there with Papa!"

Sure enough. Two cops were standing with Papa next to his cart. He saw me and pointed to me.

"That there's my daughter," he said. Stacey laughed. "Just ask her. Ask her!"

I asked the officers what the problem was with Papa. They were polite.

"Ma'am, you ever see one of these?" He held a tube, looked like an aluminum pea shooter with a test tube's black-rubber stopper on the end. "This is a crack pipe," the officer said. "And we found it in his back pocket."

Stacey was amazed.

"Papa, what are you doing with a pipe?" I said.

"Now, Susie, I wasn't using that! I picked it up. Yes, found it over there on the street where I stay. I can sell it, you know that."

I looked at the officers.

"Lady, if he had any cocaine on him, we'd have to take him in."

They drove off. Papa followed me and Stacey to the car. Three times a week, he'd been coming to the loft, asking me to look at his bad tooth.

"Look right in here, Baby," he said. Stacey and I both looked. I could see the vacant spot with a black silk suture holding it together.

"This damn thing hurts," Papa complained.

Stacey and I went looking for a prom dress that night, nylons, earrings, shoes. A sandwich and bowl of chili.

"Mom, Papa still smokes, doesn't he?"

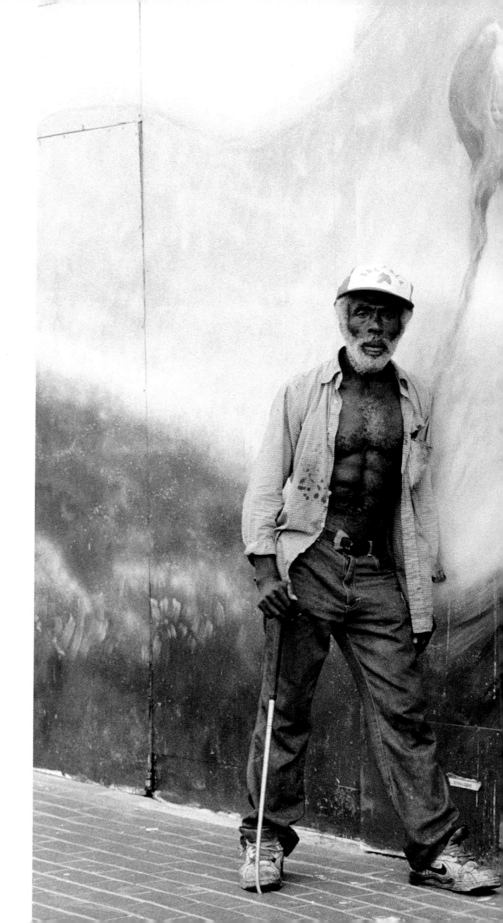

The next week, to my surprise, Papa started begging to move inside.

"What about the hotel down there?" he asked.

"That's a drug house. You know that, Smurf," Michael said.

"Papa, you want to get off the street, then let's just get this over with and you go to the Palms," I said.

"OK, Baby."

Again, I was surprised. "I'm talking about the rehabilitation program."

"I know that. I'll go. Let's go now."

"I have to call Richard White and see if there's room," I said. "Call me in the morning."

He hobbled off.

Michael shrugged his burly shoulders. Upstairs, he said, "Susie, he's smoking. He's not telling you the truth. I don't want to be a part of it."

"And what if he means it this time? I've never heard Papa so emphatic about getting off the street. And I've never seen him actually smoke."

"Did you ever see me?" Michael asked. "Did you ever see Jed?"

No, I hadn't.

I called Richard White. He said he could get Papa into the Palms early the next week, but wanted him to see a doctor, first.

Rob came to the loft before we shut down for the day. Michael asked him his opinion about Papa.

"I'm sure he's on drugs, from what you say," Rob said. Michael smiled. "But I thought you'd take care of this, so Susie isn't in the middle."

"What? I'm in this with Papa," I said.

"Honey, the guy called from jail last night at 10 and I told him you were asleep. I said look for her at the loft tomorrow."

Papa was getting too old for this. He'd seemed depressed lately, which was why I didn't think he was heavy into crack.

"I'm telling you, homeboy is smoking," Michael said.

Papa had shown me the Klonopin Dr. Johnson prescribed, an anticonvulsant, antianxiety drug. "Yeah, old Charlie, I been seeing him off and on for 20 years and he gave me this."

I wondered how a doctor could prescribe that medication if he knew the patient was a smoker and a drinker. Who paid for all this?

I got through to Dr. Johnson on Monday and told him what I knew about Papa. I explained that I'd known this man for over two years and hoped he'd get into rehab. "He showed me the Klonopin you prescribed."

"I haven't seen him in over four years, did he tell you that?"

"Yes. Your partner's been seeing him. He has an appointment with her tomorrow morning."

That afternoon, Michael and I went looking for Papa and found him over by the welfare office.

I pulled the car next to the fish market and Michael whistled his two-finger number past the back of my head.

Some homeboys along the curb were wondering who this white broad and black dude were, disturbing their hood. Then they recognized Michael. "Hey, Smurf," one of them yelled, "they want to see you. Over here."

"Hey, Baby," Papa said as he strutted unsteadily over to the car. "Baby, I tried to get you this morning. I'm ready to go."

"Tomorrow after the doctor's, Papa. You hear?" He looked terrible. He had a tie around his dirty neck all half cocked over the shoulder. "I talked to Johnson."

"You did? Good!" he said.

"He wants you to go into rehab, too. You're seeing the partner to-morrow at nine."

"I know. Dr. Wilson. I'll go to the Palms after that."

"Papa's beside himself," Michael said. "You better go down and see him."

I went downstairs and found Papa pacing in front of the electrical box. He turned and saw me and rushed up to me, crying,

"Doctor won't give me any more medication, 'cause he said Susie said I was on crack. Susie, how could you do that? Charlie Johnson's been my doctor for 20 years, Baby. You told him I was on crack!"

"I told him I'd never seen you use it but you lived on the street and I wanted his support encouraging you to move into rehab."

Papa's eyes became quiet. "I know, Baby. I'm ready to go. I'll go for you."

"Papa, the doctor said it has to be for you. Not for me."

"OK. I'm going for you and for me. I have to go and get my clothes first, up on 25th. I want to get a pack of cigarettes. Don't you even have some change for a hamburger?"

"No, Papa. You need to check in by three o'clock."

Richard White called at 4:10. "Susie, if he checks in before I leave, I'll have a bed for him, but he isn't here yet."

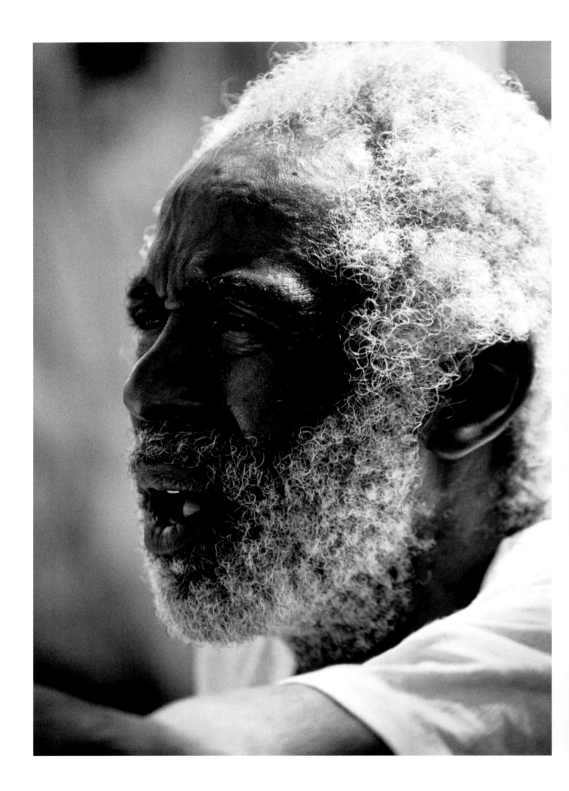

Chuck had called and urged me to come visit. I went to see him one night on the way home from the loft.

I got out of the old Beemer across from the gray two-story house converted into an SRO. Chuck stood waving his arms over his head with pride. I followed him inside and up the steep staircase.

"Getting kinda tough to manage these stairs. Seems like my health is failing now that I've moved inside."

At the top of the landing, three doors, all closed and in close proximity, reminded me of the old Omaha clinker-brick house I grew up in.

"Over here…this is mine. We all keep our doors shut. Don't exactly get along, if you know what I mean."

Inside the tiny room, Chuck had a dinette, a bed, and a small built-in kitchen station.

We talked over a decent cup of instant coffee.

Chuck: *Can't say I'm used to being locked up like this.*

Susan: *I thought there'd be some warmth and comfort inside, Chuck. Not true? Were you actually more comfortable under the streetlights at night?*

Chuck: *Yeah, I liked it. I'd run into lots of people. That little girl, the 16-year-old, the one who slept behind Ralph's. And that old woman, the one who smoked a lot and didn't talk to anyone. I used to stop and shoot the breeze with the guy in the Laundromat.*

Susan: *But your home was in the middle of the park, with gay prostitution and drugs all around you.*

Chuck: *A lot of times those kids used to come over. I had a lot of food left over and they'd come over and shoot the breeze. It's different, being inside. I'm trying but I'm floundering. Outside you don't worry about bills. You don't worry about getting attached to things. Sometimes when I woke up things would be gone off my cart, and I didn't really mind. But when you're inside, you start worrying about losing things.*

Susan: *Are you thinking of moving back outside?*

Chuck: *Nah. It's turned around. I really don't like it out there too much anymore. But I did go up to the park. I walked up to the park.*

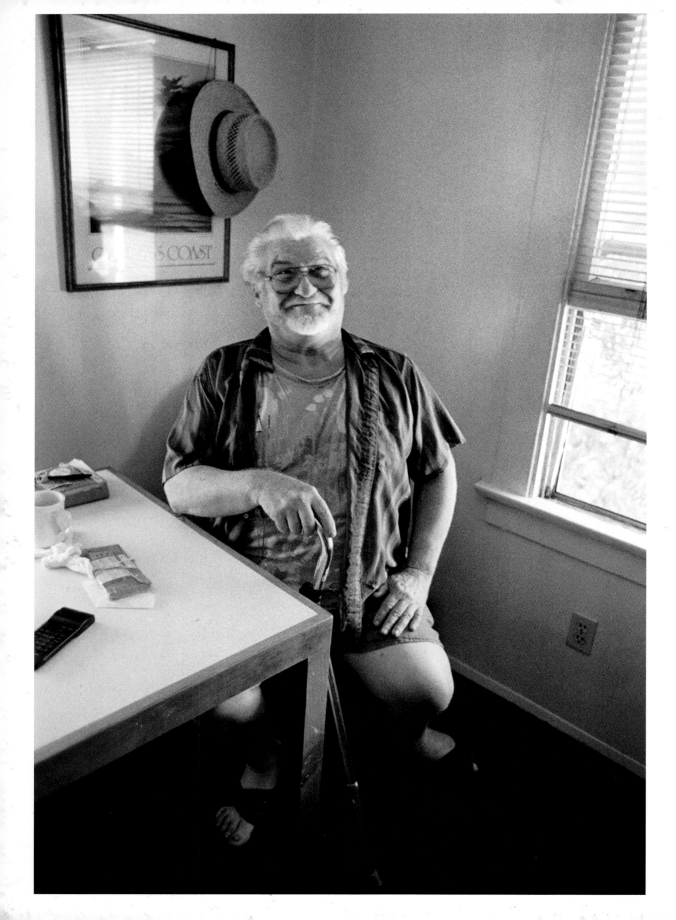

Susan: *And how was that?*

Chuck: *I found out a couple of people died. One was the little guy of the Mutt and Jeff duo. He had a cardiac arrest. And another friend died of tuberculosis. People are gone. There's a whole new group that are a lot younger.*

It ain't the same for nobody. They're locking up the dumpsters. The ampm used to stack hot dogs in the morning and put whole sandwiches out that they couldn't sell through the night. Now they're tearing everything up into little pieces so you can't eat it. People get the message real fast.

Susan: *Do you see any of the people you used to know, when you go out?*

Chuck: *Well, most every time I see one of 'em, the first thing they ask is "Can you buy me a cup of coffee? You gotta cigarette? You got any change, I can get a beer?" They don't come up and go, "Hey, how you doing?"*

It's funny. When you're out on the streets, you're like a brother or sister. When you move inside, there's always that little barrier. You're like a traitor. Inside, you can go crazy, too. You can get hooked up into a little room with a microwave, a TV, a refrigerator, some food, some coffee, drinks, cigarettes or whatever. You can forget that the outside is out there. So instead of just being a place to sleep and keep clean, you can become a total prisoner of it. It's safe. You become so safe it'll make you sick without you realizing it.

"When you're out on the streets, you're like a brother or sister. When you move inside, there's always that little barrier. You're like a traitor. Inside, you can go crazy, too. You can get hooked up into a little room with a microwave, a TV, a refrigerator, some food, some coffee, drinks, cigarettes or whatever. You can forget that the outside is out there. So instead of just being a place to sleep and keep clean, you can become a total prisoner of it. It's safe. You become so safe it'll make you sick without you realizing it."

–Chuck

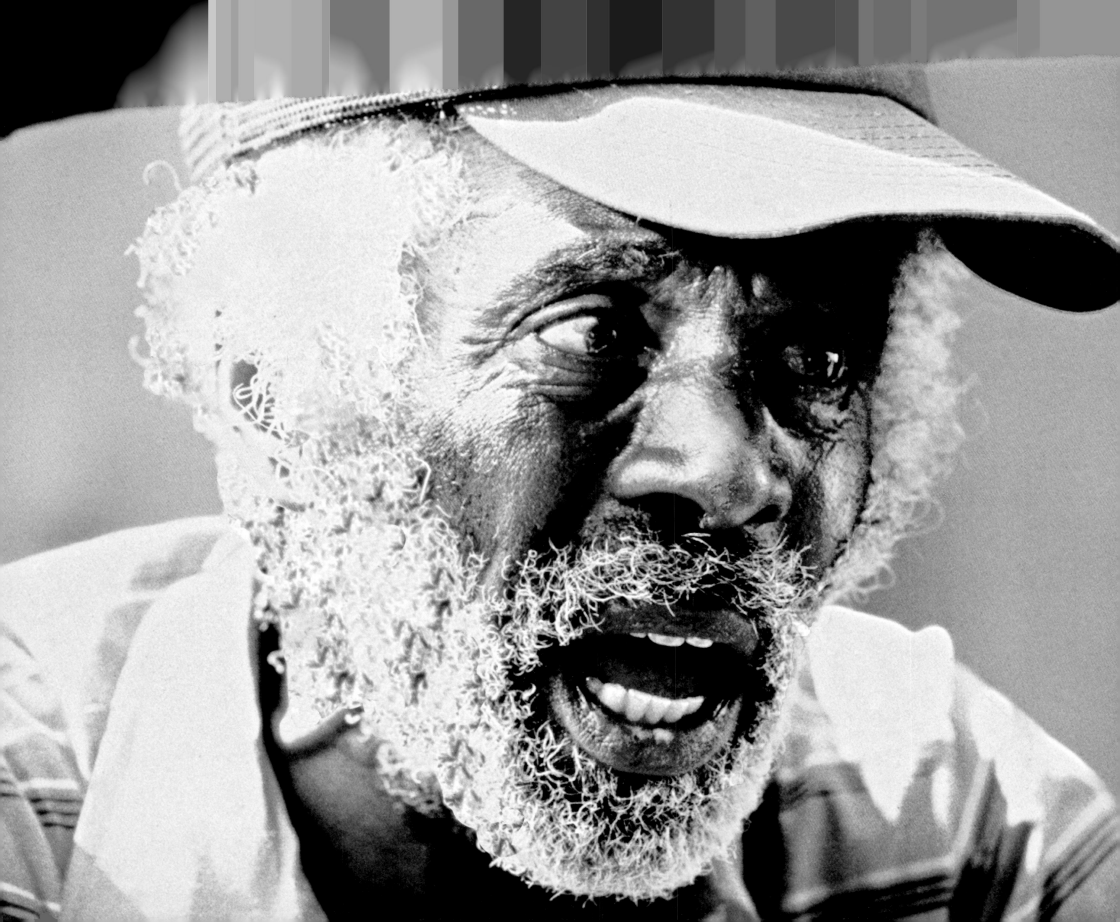

I saw Papa fairly often during the summer. We no longer talked about the Palms. He knew old Armond, a key maker whose shop was a converted caboose, located between Fourth and Fifth on F Street.

Papa liked to get a rise out of the hardworking craftsman. "Hey, old man," he'd say as he rounded the corner with his cart, "you got any change for a fellow vet?"

This made Armond furious. "Fool, I been making money on this street corner for 62 years and I don't mean to give you a lousy dime of it either! Go get a job."

The day I went to pick up my key, Armond was sitting on his stool in the doorway of the key shop. He waved and shouted, "Hi honey!"

He handed over his handiwork proudly. He'd made me a copy of the key to my bathroom, a wrought-iron decorative key from the 1920s. I always locked my kids' Christmas presents in there, and always worried about losing the key. Before meeting Armond, I assumed it wasn't possible to make a copy.

In his 87 years, Armond had seen a lot of change. He still ground keys with tools he'd used in 1918.

Across the street, maintenance crews were scrubbing foodstuffs and excrement off the brick sidewalks, creating a fine mist and amplifying the smell of urine on an 80-degree day.

I turned up Fourth Avenue, off Broadway, and heard a newscaster say that another cut had been made in mental-health aid.

Homeless scattered as police cars mounted Horton Plaza's curb.

Two and a half years had passed since I started photographing and talking to people who lived on the street. Their expressions as they shared their stories were etched in my mind, a part of my life.

I had friends who wouldn't go downtown because of the "homeless problem."

CHAPTER TEN: MRS. WALTON

IT WAS NOW AUGUST, 1993. In front of the work loft, Michael stood holding two coffees. I pulled over and he opened the car door. I was five minutes late and he could get nasty if I wasn't prompt.

"Morning. Here's your coffee. Spent my last dime."

I told him to hop in the car.

"Where we going?"

"To find Papa Smurf," I said.

"What you need with him?"

We drove down to Imperial, Michael muttering I was wasting my time. "You want Smurf? There he goes. Taking a hit by Todd's Market."

I slowed down.

"Don't stop now!" Michael shouted. "What's wrong with you? You missed getting into trouble as a kid?"

A few blacks gawked from a wall of graffiti at the corner of 25th and Imperial. Papa Smurf was one of them.

"Hey, Baby!" he yelled.

"The oldest fucking crackhead," Michael said, shaking his head.

Papa grabbed his cart and ran with a limp after the car. I watched him in the rearview mirror. His arthritic feet protruded out the sides of tennis shoes. Never slowing down, he shouted, "Baby! Baby! Papa needs to talk to you!"

"Sure he does, and you know why?" Michael looked ahead. "Hey! Watch out. Don't make another of those U-turns. There's a cop. You don't see shit!"

I turned left on 26th and pulled over. As I waited for Papa, I saw an old person huddled over a cart next to the alleyway, dressed in a black sweater and black pants.

"I'm going to make sure he's okay," I said, opening the door.

"You're crazy! That's not a man, that's a woman, and she knows what time of day it is. Get going! There're homeboys checking out this car.

They've got you pegged as the cops or a buyer."

I got out of the car.

"Shit!" he yelled at me from the passenger seat.

I crossed the street just as the old woman lifted her head and started to push the cart along the left side of the alleyway. I stayed close behind with my camera, in hopes of talking to her. Papa caught up to me, told me the woman had lived on a vacant lot for a couple years. He said, "Go on. Talk to her, Baby. She's OK. You'll learn a lot..."

I handed him two dollars for cigarettes and he moved away, whistling.

A brown, eight-foot, corrugated wall of sheet metal ran along the right side of the alley, covering the lower level of a pink stucco apartment building. Gang graffiti was painted on the barricade and two Mexican children looked down from a second-story window. The old woman stopped in front of a chain-link fence directly across from the kids. She bent over with the help of the cart and took a key out of her old Nike shoe. She unlocked the padlock, slowly pushed the cart through the opening, turned and closed the gate, locked the lock, and collapsed on a 1950s yellow-and-chrome dinette chair.

Michael came up to me. "Here're your keys!" He glanced back at Papa Smurf. "What the motherfucker tell you this time? How whites saved the South?"

By now we were close to the gate. The stench was inconceivable. Inside the gate, multiple grocery carts filled with street trash, a few broken chairs, and a tiny camper shell next to the cyclone fence separating the property from the next-door house. An oversized, unkempt palm tree provided the only source of shade.

The old woman pleated her pants with thin brown fingers and picked away lint. "Oh, hello. I didn't know I had company," she said, looking up and smiling. I was surprised to see such white teeth. Her body appeared older than her face...

"I just came in from sweeping my steps."

I could see the front of her lot from her back gate. The property was about one-eighth of an acre. On the west side was an old stucco church that appeared inactive. On the other side, next to her camper shell, was a '50s-style, rundown, yellow clapboard house.

"You live here?" Michael asked.

"Oh no," she said. "I just take a nap to cool off after cleaning my steps."

Michael looked around at the mess and coughed. The smell was suffocating. "She's crazy," he whispered to me. "There's plenty of those types around here, now come on!"

But I knew Michael was wrong. She was unique. Her cheerful smile was highlighted with lipstick and she'd even smudged some on her cheeks as rouge. She appeared peaceful amidst the filth.

"See the kitty cats?" she asked. Michael nodded, pulling at my arm.

"Those are yours?" I asked.

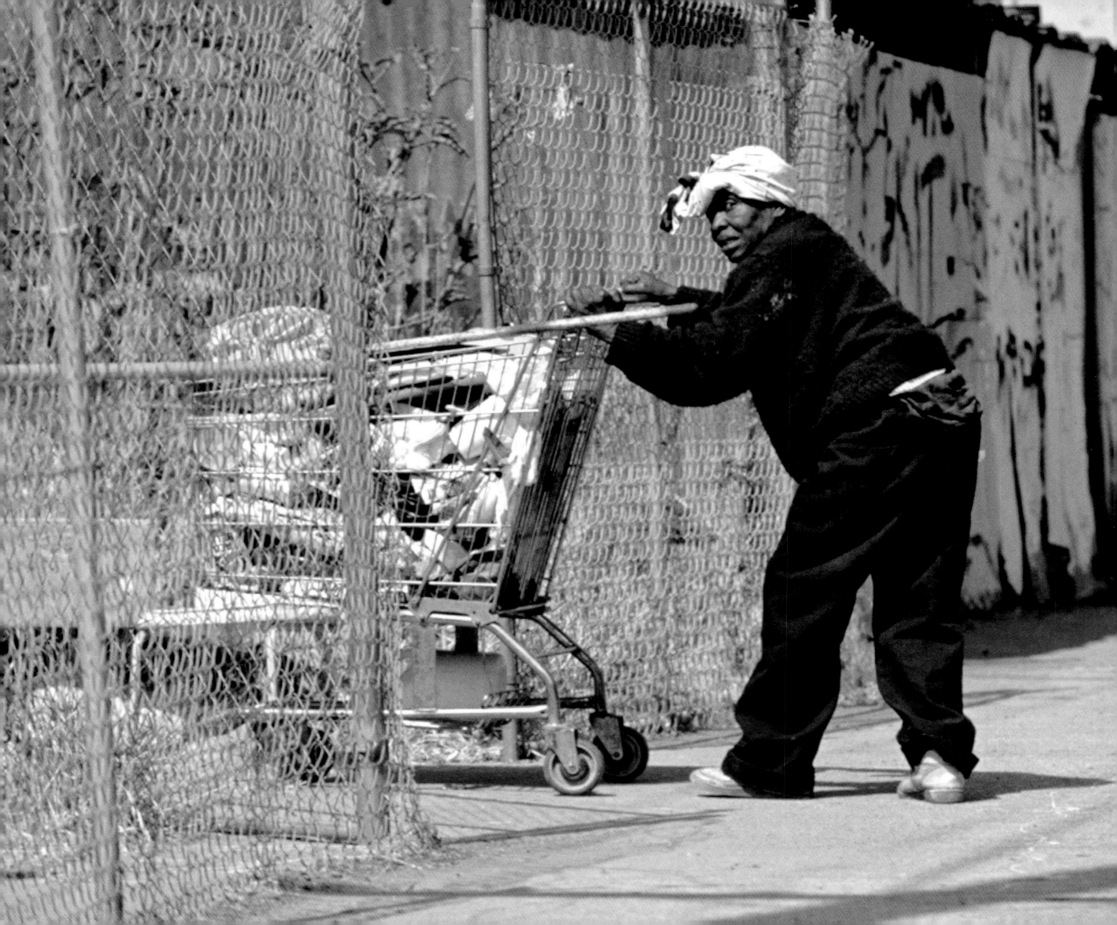

"Kitty cats live on the lot. The nicest young lady, Kristy, feeds them when she visits her boyfriend, next door."

Michael told me that was a drug house. He said there was no nice young lady within four square miles.

"They're bad kitty cats." She laughed. "They play and play, making a mess of things and sometimes I can't get a little nap."

Michael leaned down and said, "It's no nap she's talking about. She lives here, believe me."

There was a "No Trespassing" sign sticking out of the top of her cart, with an open can of sweet peas braced in the corner.

"You like peas?"

"I eat a can a day if I can't get some spinach. You know you can get a whole can of spinach for the same price as a bunch a fresh. Imagine that! Equal to three bunches! I find me spinach and put on vinegar. Uhmmm! You try that?"

Several homeboys meandered at the far end of her alleyway. She smiled, recognizing a man pushing his cart behind me. But she didn't offer "Good day" to a tough-looking woman sashaying down the center of the broken-up pavement.

I asked the old woman if I could bring her anything on my next trip out that way. She surprised me with, "A bra." I had to laugh. She laughed, too.

"Don't you think I could get me a nice man if I got these going the right way?" Her hands grabbed at her dirty black sweater. I couldn't take my eyes off her expressive, beautiful face to note if she had any breasts left. She was so small and frail.

Her name was Mrs. Walton. It wouldn't take much to help her out. Getting her a tent would be an improvement. I had warm clothes in the cellar I'd planned on taking to St. Vincent's.

That night, I shopped with my kids and found an inexpensive pink-satin bra at the Broadway.

The next noon, Michael and I drove into the alley and parked next to Mrs. Walton's fence. She was under the eave of the small fisherman's camper shell to avoid the hot sun, sitting inside an old tire. She waved and tried to get up. Her pants fell down and she toppled.

"This's sick!" Michael said. "We're in her damn bedroom."

I watched her, unable to help since the gate was locked.

With the aid of a matted broom she managed to stand and grab onto one of the carts to steady herself. She looked at us and beamed. "My friends. You came back, how lovely." She pushed the cart to the gate, unlocked it, and asked us to come in. "You just missed my granddaughter. She bought me some supplies. She be back."

She pushed the cart to a pile of trash under the palm tree, then poked around under nasty rags, torn shirts, newspapers, and wooden objects

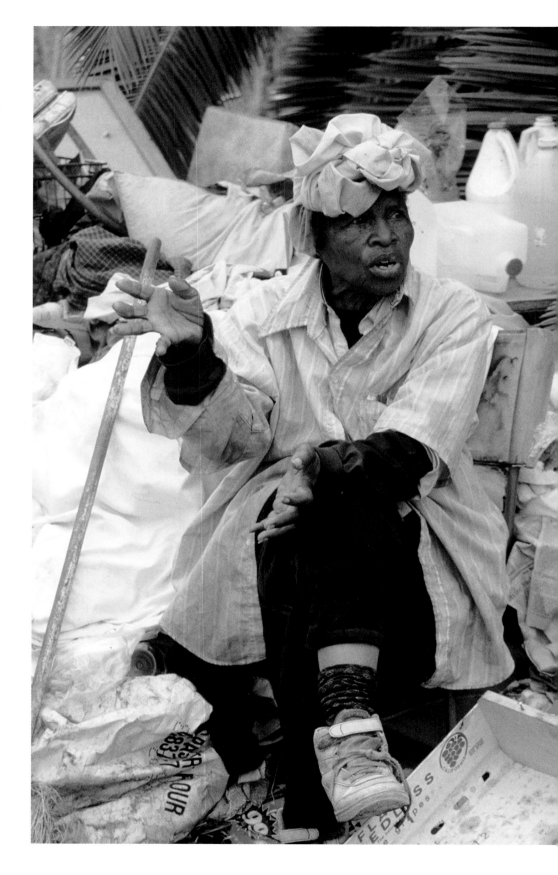

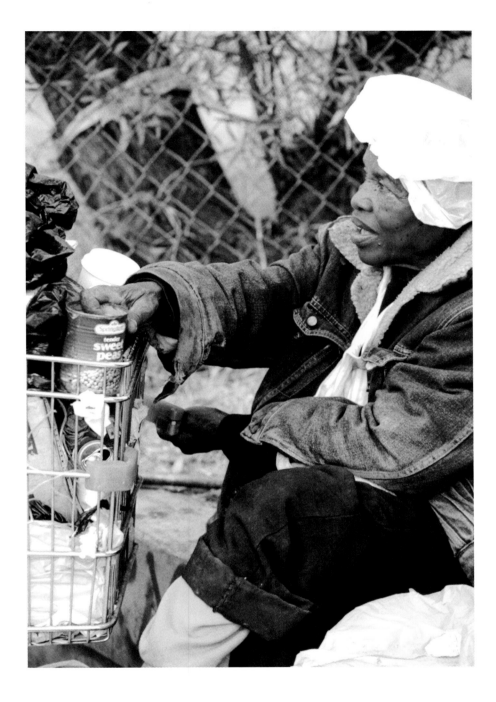

with no identity. "There it is! My special cane. I fall without it." She pulled out a eucalyptus limb. "My wino friend, over there on my steps...see him? He's made this for me so I won't fall."

She talked to Michael. I put my sleeve to my nose and headed over to the camper to look inside. I passed five carts lined up parallel to the side of the camper. I stepped over cat feces shaped like moguls and dusted with dirt and mold, a banana oozing onto the remains of an old blue shirt. Mrs. Walton had a sheet draped across the doorway of the little shelter. Empty plastic water bottles and old clothing created a mattress.

"How old are you, anyway?" Michael asked.

"I was born in 1910. How old's that?" She smiled at him.

"Damn," he said.

On Monday morning, Michael called Bob Daren at County Mental Health. "He'll get her help. That's his job. You can't do anything about this. He'll meet us day after tomorrow at one o'clock."

The next day, we went to tell Mrs. Walton about Bob. A dark woman dressed in clean bright leggings and an oversized shirt unlocked the gate for us. "I'm Tanner Pinkel," she said. She looked nervous and talked fast. "You see, Granny...well, she don't get along with my mother and...well, after the fire, my brother got Granny to sign a...what's that called, Granny?"

Mrs. Walton said, "Power of attorney?"

"That's it. Anyhow, he took both a her properties and he got her signature and then he took out a loan..."

"Wait a minute," Michael said. "Both of what properties?"

"Oh, see...well, Granny...she has another place on Webster. Only thing is, my mother lives there and they don't get along. She stayed there the night of the fire but she got up the next day and came back here...didn't you, Granny?"

"She's been here like this since when?"

"The fire! How long's that, Granny?"

"Two years this De-cem-ber the seventh...Pearl Harbor Day. I was coming from Arrows Market where I did sweeping the floor. I was walking up the alley when I see flames...oh my. I lost everything. I had pretty clothes I used to wear. I wore heels every day."

I asked her about her husband and she said, "Oh he's been dead a long time." She laughed and told us he never liked her wearing pretty clothes. "I never want another man. They tell you what to do all the time and where you can go!"

Michael stood in shock. "Let's back up. So what happened with the loan?"

"That's just it," Tanner said. "My brother...he's bad, real bad. He took out a $40,000 loan on something..."

She looked at Mrs. Walton. Mrs. Walton drew circles with her cane in the dirt.

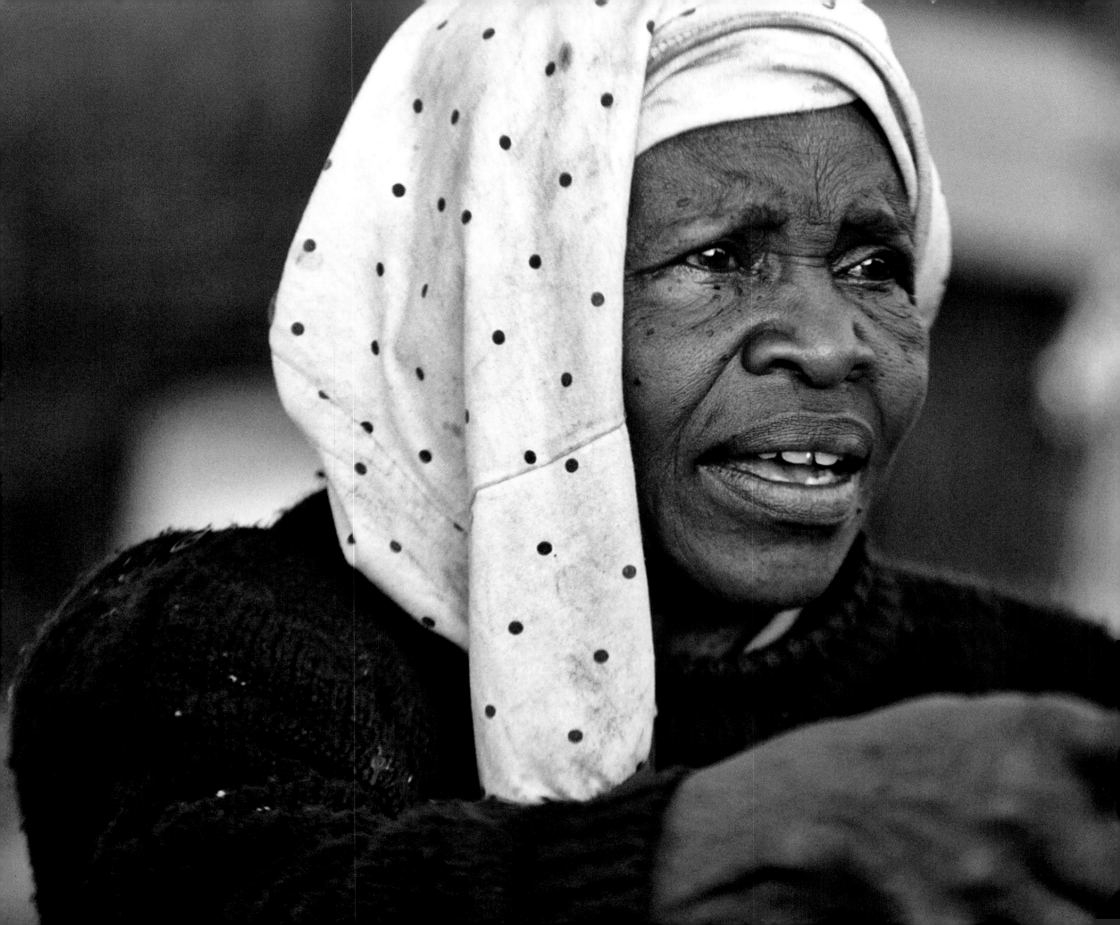

"So who owns the lots?" Michael asked.

"I don't know. Who is it, Granny?"

"Well, the church right here," Mrs. Walton said. "The woman who owns the church got this lot, somehow. I pay Mr. Thompson."

Michael scratched his head and started pacing. "For what?" he asked. "To be on an empty lot? This is sick. Why isn't she in her other house?"

Mrs. Walton said, "I had renters there, too. Had renters both places. This was a big place. Four big apartments! Nice people who paid me to stay here. Everything's gone. All my pretty things."

I took Tanner aside and asked her why Mrs. Walton wasn't staying with her. Tanner said she had three children and one was in jail. "He's my oldest and after Granny got the camper...some construction guys left it for her...my boy come back and steal from her!"

"I screamed!" Mrs. Walton said, hearing our conversation. "I screamed 'til the cops picked him up. He's in jail where he belongs!" I wondered if this meant Tanner's son had started the fire.

"Granny has a son, too," Tanner added. "That would be my uncle. Ain't no one seen him in a long time. He used to live on Granny's other property. Now he's gone. Just my younger sister, Lola. She's 27, ain't she Granny? And my mother."

Mrs. Walton looked up. "I spoiled Emerald, I guess. That's my daughter. I used to work and had my mother care for her. Worked 'til the fire. Always had a job... I worked at the San Diego Club. Worked for an old white woman 'til she died in her bed at 98. She was smart. Liked my mushroom soup, too. Ooohhh she liked my soup!"

Tanner stood in the debris wearing ballet shoes. She fanned away the flies from her greasy black hair.

Bob Daren met us at Mrs. Walton's lot the next day. He squatted down to talk to her and asked her when was the last time she ate a meal at a table. She said December, 1991. He stood and simply said she didn't qualify for mentally-ill housing. Michael was shocked. "She takes a shit under a bush, for god's sake. That's not mentally ill?"

Daren said Mrs. Walton could focus and probably this was a lifestyle choice, but suggested we contact Adult Protective Services and the Habitat. He drove off. Michael stood there shaking his head. "He was a lot of help," he said. "That's what our government does...finds excuses not to do anything."

Over the next few weeks, we tried to get help for Mrs. Walton, and to figure out what the situation was with her property. Michael did a lot of the work. He found out that Habitat only helped young married couples. When he contacted APS, Mrs. Walton was assigned a case worker, Diane Hampshire, who complained about the stack of cases on her desk and said she'd visit the old woman as soon as she could.

> "She can focus.
> Probably this
> is a lifestyle
> choice."
>
> –Bob Daren

Michael said, understandingly, "She doesn't want to be locked up. She's got some freedom. It's sick how she lives, but she didn't teach her kids to take care of her, so she won't expect anyone else to."

I never saw Mrs. Walton without her rouge. She washed herself with paper towels and bottled water. Her face, hands, and arms were always clean, but she was pleased when we offered to take her for a shower and some clean clothes at Rachel's, a daytime support center for women. Michael knew women from the street who went there to clean up.

Mrs. Walton grinned when we arrived at the modest one-story converted office building. "This's lovely. Just lovely." Several women yelled at Michael as he escorted her up the ramp. "No men allowed!"

Jessica, the manager at Rachel's, took Mrs. Walton by the arm and asked if she could stand in the shower. Mrs. Walton said, "Yes, if I have my canes."

I spoke with Jessica about Mrs. Walton's case, explaining that Diane Hampshire at APS still hadn't visited the old woman. Jessica said she knew Diane, and would give her a call. A few phone calls later, Diane had agreed to pick up Mrs. Walton at Rachel's and take her back to her lot.

We were making some progress.

I never saw Mrs. Walton without her rouge. She washed herself with paper towels and bottled water.

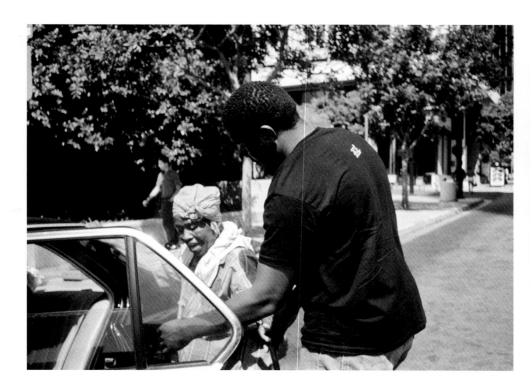

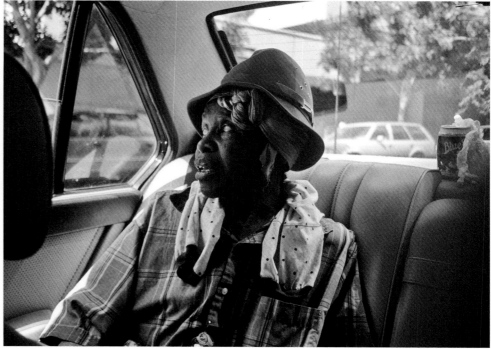

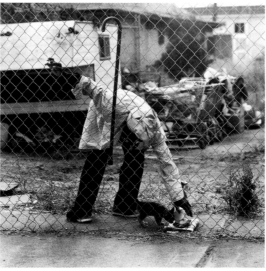
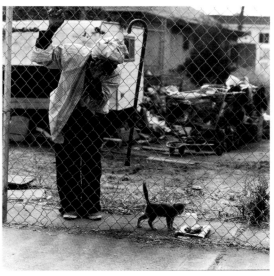
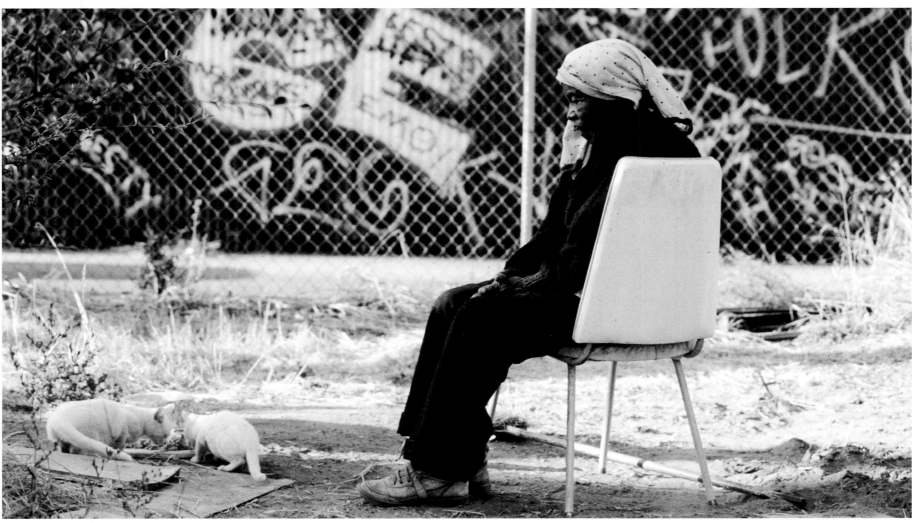

Mrs. Walton appeared to
still own the other lot,
on Webster.

Michael took it upon himself to contact the County Clerk and Recorder. He was gone for several hours, returned with a copy of the lot plot, threw it on the counter, and headed off to the computer, subdued and depressed. I asked him what was wrong and he said, "Everything's all fucked up."

A friend of my husband owned a title company. He did some further research and reported that the church had lost the vacant lot to a Mr. Azar. It wasn't clear how the church had acquired the lot in the first place, or who Mr. Thompson was. Mrs. Walton appeared to still own the other lot, on Webster.

The next time we visited Mrs. Walton, she didn't open the gate for us. She looked at Michael untrustingly and was cool toward me. I asked her if she wanted to move to her other property.

"That nice woman told me not to talk to anybody," she said. I assumed she meant Diane Hampshire.

I decided to let it go, at least for now. Michael creased a five-dollar bill and stuck it through the fencing. He told her to be careful. I told her to call when she wanted to see us.

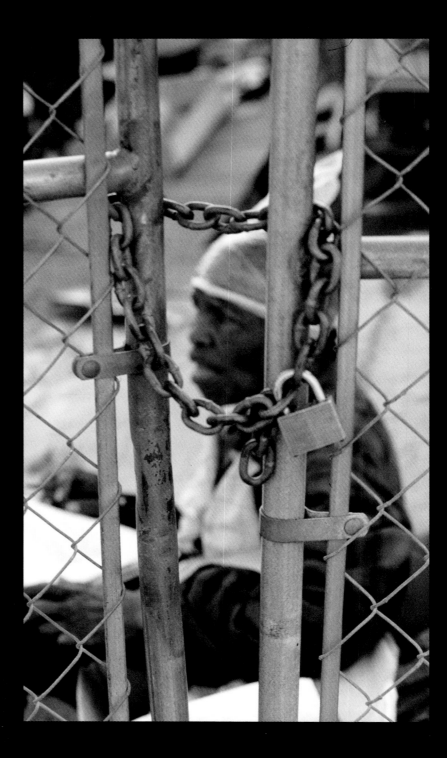

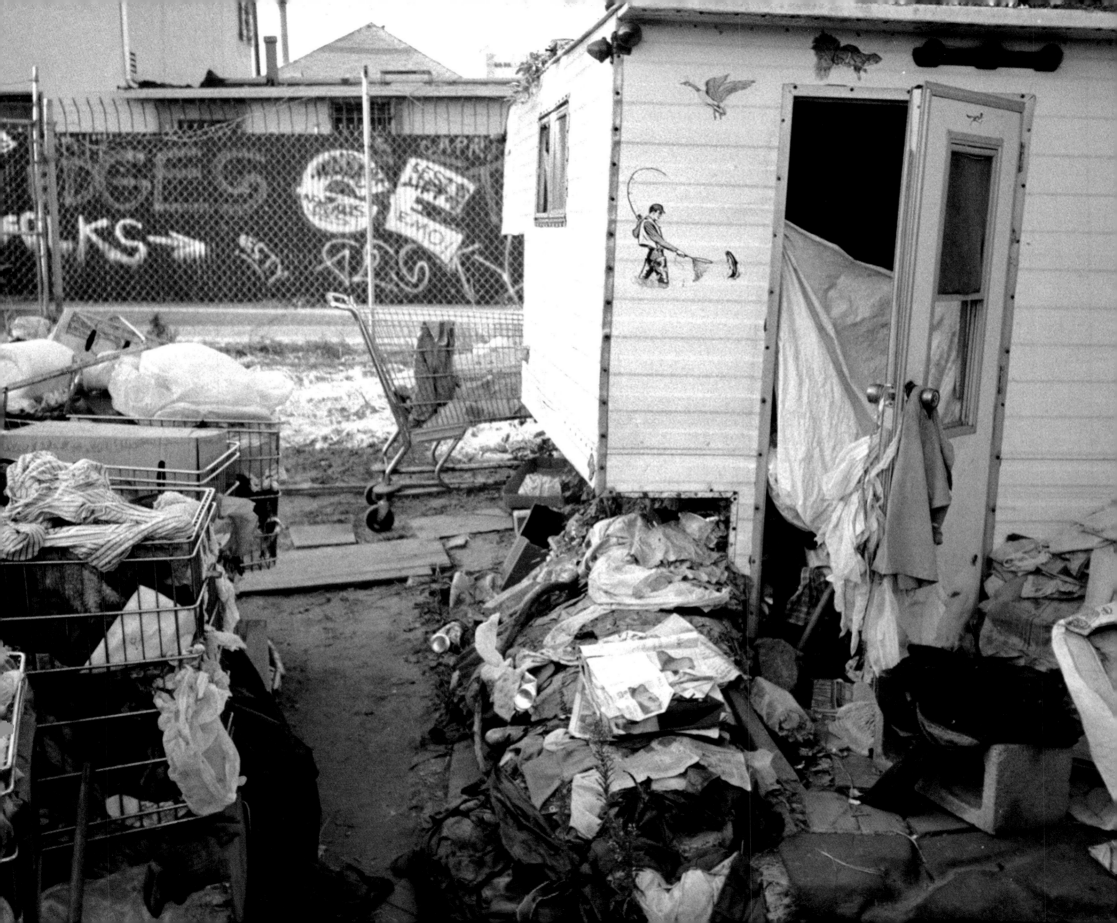

Michael, 2009

Not often, yet sometimes … I look back on the things I did … and man, I'm lucky to be alive. There's this bridge that goes over the train tracks … down near the convention center. It's the area that links downtown to Barrio Logan. Well, a number of times I jumped up on top of the bricks, the ones that are supposed to keep you from accidentally falling over … and walked over the bridge on the bricks. A fall would have been fatal … why did I do it? Bottom line, I was crazy. Malnourished, dehydrated, fatigued, with drugs and alcohol flowing through my veins and my brain. It sounds like the same ol' sad song … and it is. The real trip … the real fear factor … the real deal is that I'm only a "puff on a pipe" away from returning to where I left off … so keeping all of this fresh, green … right up front, not in the archives helps me a lot. It's easy to forget, because it's something so horrible I don't want to remember it … who would? But (I hate using that word … "but") I've got to remember. Otherwise, I'm doomed to relive it … and that's a fact, 'cause it happened to me before, when I forgot … and I remember.

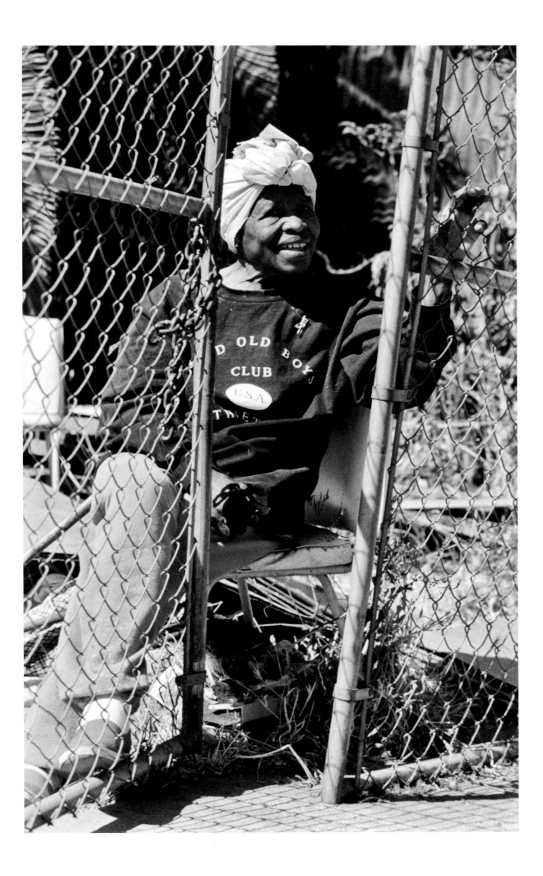

Michael had moved into his own place and wasn't working as diligently as before. He acted strange and came to the loft late, saying he'd worked out and lost track of time, totally unlike him. I brushed it off at the time.

One warm October night, Michael called me at my house, late. "Guess where I am?" he said.

"You're drunk!"

He laughed, "Can't you tell where I am?"

"I hear a horn."

"Good! What kinda horn? You're smart!"

"You're back getting high. Back where you hung out two years ago!" Michael had backslid into the drug world.

I went to see Mrs. Walton, alone, in mid-November. It was lonely going up Imperial without Michael.

She was sitting inside her gate. When she saw my car pull up, she smiled and called out, "My friend!"

She was still wearing Michael's hand-painted "Good Old Boys Club" T-shirt and the pink sweats and shoes she'd gotten at Rachel's. She had a fleece-lined jeans jacket over her shoulders and a pink polka-dotted shirt tied on her head.

"Where's that Michael?" she asked, though she acted as if she already knew. "It's that stuff, the crack, isn't it? There's something about that crack. It stays with them 'til they want to change theirself. Can't waste your time. He's just like the rest of them. See, I'm so old that I'm good at knowing things like that."

"Here, take your coffee. Want me to hand it over the top of the fence?"

"That Tanner was here and the silly, she took off with my key. I'm my own prisoner." She laughed, then started looking in her pockets and checking the little safety pins holding up her pants.

Two men walked behind me and she said, "Good Morning." They nodded, checking me out.

We talked about an hour. I sat on the pavement, outside her gate. Mrs. Walton talked about the old woman in La Jolla and how the woman loved her mushroom soup.

"From scratch? You cooked?"

"Why sure! I put a can of milk in a can of the mushroom soup. She loved it. That woman loved me for my soup."

She went on to tell me about growing up in Texas and how mean her father was. "Maybe my daughter got some of my father's blood."

When I asked her what was happening with the lot, all she said was, "It's a mess." She wasn't talking about the trash, she was talking about the things she couldn't control—businessmen, powerful people with educations, lawyers, her family and homeboys who knew how to take advantage of her when it was dark. She stayed inside when it was dark.

"When you coming back, now? I might just be at the other place. You know they say they're gonna move me."

"I'll see you with some Thanksgiving dinner."

"Be just lovely," she said. "But don't come 'til day after. You'll have plenty to do."

She was right. Not only was I planning a big holiday dinner at the house, I was scheduled to move to a cheaper loft the weekend after Thanksgiving. The studio was half packed. Photographs in large wooden crates, the equipment already protected from breakage. The Coca Cola fridge and oversized Cambo tripod required movers.

This year, Michael wouldn't be joining us for the holiday dinner.

Mrs. Walton waved as I drove up the alley. She seemed dazed in the strong sunlight. Someone had removed the bars at the end of her cart, and she perched there like a bird on a limb.

"Oh hello, my friend..." She got off the cart and leaned on it like a walker as she moved slowly toward the gate, limping. "Don't move so good. My ankles are swollen, I guess." She fell onto a piece of cardboard.

"Where's your chair?" I asked.

"I don't know. Missing lots of my things. Pretty things, you know, my clothes, too... Someone took lots of my things last night, I guess."

"Don't get back up. I'll hand the turkey over the fence when I leave," I said.

"Michael tell you I saw him?" she asked. "Asked me if I'd seen you! I said yes and what was he doing messing around with that stuff. He sure looks bad. You know, they had a sweep out here. Partly why it's so quiet. The po-lice, nice ones that talk to you, they come along and they take all the homeless to jail! Now they got that big, fine trailer, well pretty near a hotel, lined up by Todd's. Was thinking maybe I ought to go get drunk so I can stay inside that for awhile." She giggled, uncontrollably.

The first week of December, Michael called the house collect.

"Hey, what's up? You called the police on me, didn't you?" he said, laughing nervously. "Yeah, you did. I was outside your studio the day you moved. I was just out of jail and thought I'd say hi. Next thing I know, there's the cops...they're full of shit. It's all fucked up. Won't be talking to you again, either." His voice had gone hard.

"Hey, wait! You had a phone call from a guy wanting you to do some printing!"

"Fuck that shit," he said. "I'm out of here. I'm heading north."

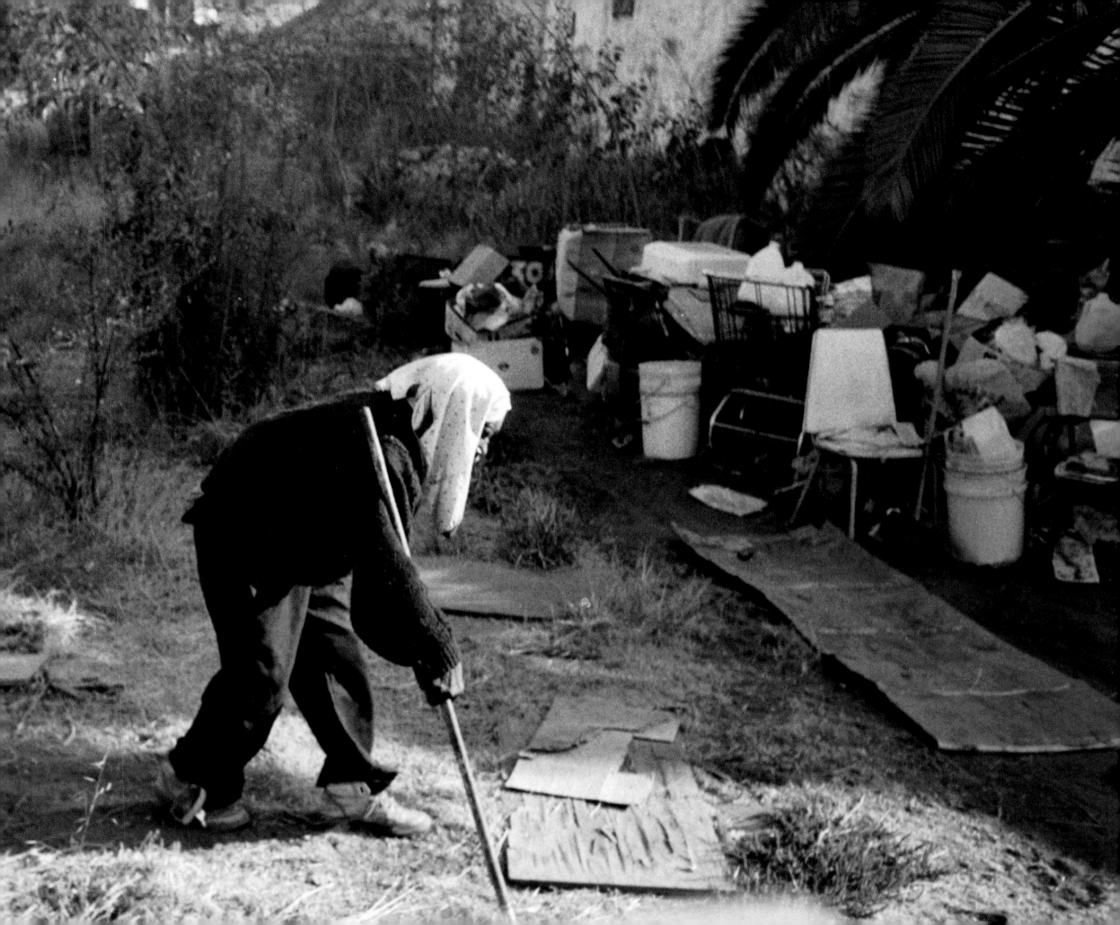

I drove out to see Mrs. Walton. She'd told me she wanted a wool robe for Christmas. I'd found one at Marshal's, plus a few other items.

I saw her pushing her cart past the lamppost on 26th. Flies swarmed around a fresh chicken sprawled on top of her cart. An unexpected Santa Ana had blown in early that day.

She saw my car and hurried back to her lot to meet me at the gate.

"My friend," she said, "have you seen that bad Michael?" She leaned over. "Keep my key right here now, in my shoe."

I asked her to leave the gate open so I could hand her the packages. She crooned and caressed the bows like prize awards then carefully started to open them.

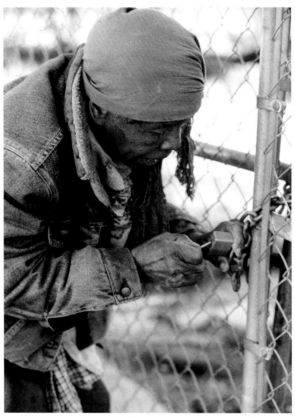

A thin but strong black woman, very dark, came out of nowhere and squatted down next to me, offering to fold the new jeans and sweat shirt. She fondled the robe. Mrs. Walton pulled it out of her hands and shouted at her ferociously, then stood and locked us out of the property, angrily. The intruder was dressed in clean pink corduroy pants and a pink sweater. She moved over to my car and eyed the packages in my back seat. "Let me have one of those."

"They're for my daughter," I told her, aghast at her nerve. "Leave!"

She joined a dirty, frail-looking woman and Mrs. Walton sat back down on her cardboard.

"Crackheads!" she shouted. Her voice mellowed with a bite of her turkey sandwich. "That's all they are."

Four black men stood at the other end of the alley.

"I've never seen those fellas before," Mrs. Walton whispered.

Two of the men approached, holding Darth Vader robots. "Buy this robot," one demanded. I told him it was a great gift for a boy, but I had girls. They moved on.

Mrs. Walton held onto her gate, distressed, as I checked the padlock.

"When will I see you next?" she asked. "You know, I might be at the new place. I don't want to go... My friends, I'd miss them. I'd miss my friends who come to the front steps, you know, the old sweet winos."

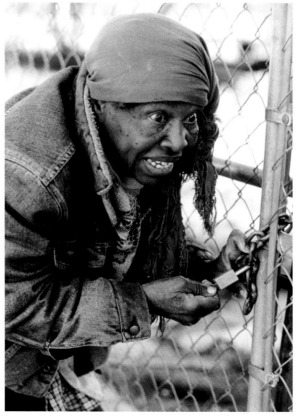

I drove up Imperial a couple weeks later, looking for Mrs. Walton. Before I got to her alley I heard that whistle—Michael's whistle. I looked in the rearview mirror and saw him in the middle of the street, down half a block, with his shirt open and all his muscle wasted away. I pulled over to the curb. Two black guys knocked on the passenger window, wanting to know if I wanted a pipe. Nice neighborhood.

Michael popped his head in my window, laughing, tickled with himself. I pressed myself against the seat back. He reeked of that familiar street smell, a

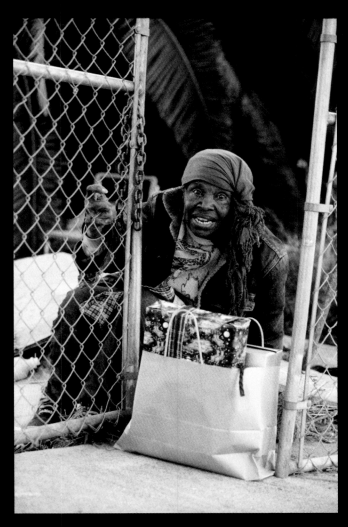
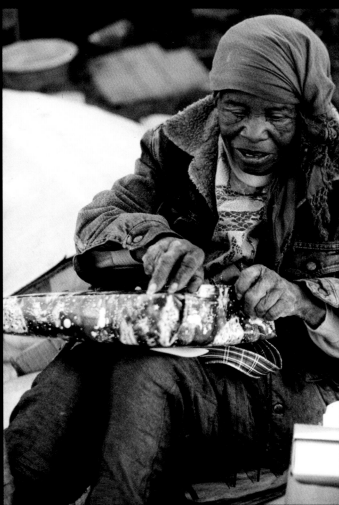
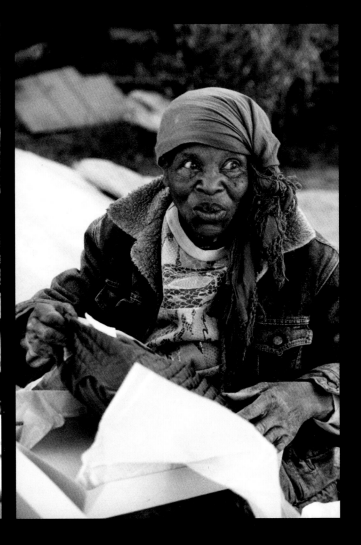

"My friend," she said, "have you seen that bad Michael?" She leaned over. "Keep my key right here now, in my shoe."

mixture of urine, soot, booze—decay. Then he stupidly started to unzip his jeans, trying to shock me, only to expose another pair of jeans underneath. All the homeboys watched him.

I asked if he'd seen Mrs. Walton.

"She moved," he told me.

He followed me to the lot by cutting through the backside of the alley. I got out of the car and Michael grabbed me, hugging me. "Don't do that," I said, pushing him away.

He'd lost at least 60 pounds, all the weight he gained after getting off the street. He tried to act proud of his body, still showing muscles.

No sign of Mrs. Walton. It occurred to me that Michael's birthday was coming up in a couple of weeks. I didn't want to think about how strong he'd been a year ago, or the portfolio case I'd given him for his drawings.

I got back in the car and headed toward the property where Emerald lived, remembering 29th and Webster. As I crossed Commercial, I remembered Mrs. Walton telling me how she'd walked along Commercial every day in her heels to go clean at the Arrows Market. I could visualize her petite body and her pretty shoes, proudly going to work.

In the next block I spotted the property. Two green cottages, a little yard, and a fenced-in area with a small blue trailer. A third cottage butted up to the side street where I parked.

I got out of the car. Mrs. Walton's cart was parked next to the trailer, the same cart with the same No Trespassing sign on top. She sat behind it in an antique chair. Three dogs came up to the low, friendly fence behind the two front houses. They were cute mutts. The property was like a carpeted room compared to 25th, but there was no one for her to watch and carry on with about the weather, crime, the fire, days of old.

I called out her name. She looked at me hard, then stood and moved toward me with her cart. "My things were stolen!" she shouted at me. "You left the gate unlocked!"

I jumped, my heart pounding in my chest. "Mrs. Walton, what are you talking about?"

"That crackhead. She came back and jumped my fence…took all my pretty things. If you had the gate locked…she'd never touched my presents."

A small-framed woman with a very large bust appeared at the screen door of the adjacent house.

"You must be Emerald," I said, moving toward her. "Tanner looks like you."

"That right?" She smiled a little.

"She flew over my fence like a bird!" Mrs. Walton went on. "She took

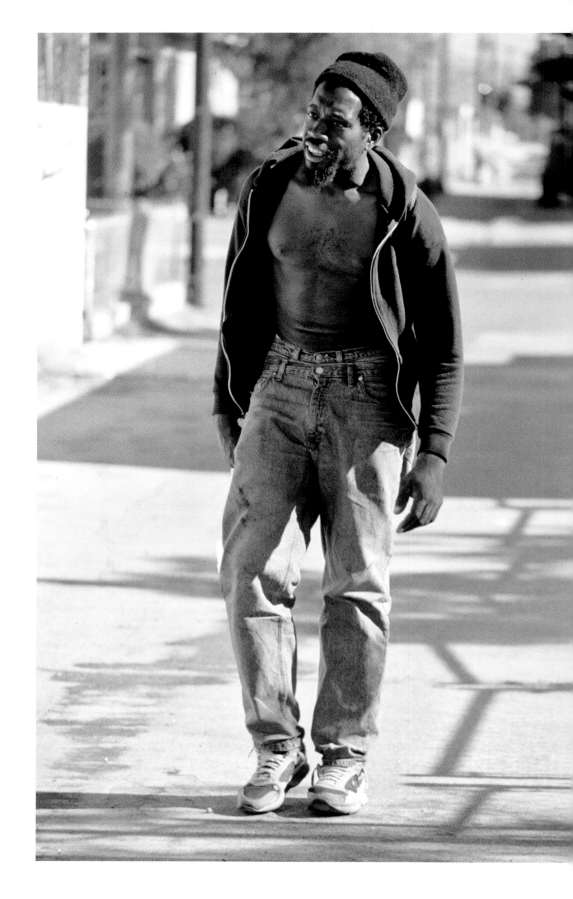

all my pretty clothes and left. I screamed and screamed. The po-lice came for me and said I wasn't safe there anymore. My camper, I want it 'cause it's made of tin."

"You're not having that camper over here!" Emerald said from the screen door.

The next time I visited Mrs. Walton, she welcomed me. She was sitting in a big yellow-gold overstuffed chair at the south end of her trailer, with a black umbrella perched to protect her from the west winds blowing off the street.

The umbrella dropped and she threw her hands up in the air. "Come in! Come in!" I went through the unlocked gate. "Sit down right here." She moved over in her chair. I sat on the arm. "I have to see you real good. Where you been! That Michael not back, yet?" She laughed.

Someone had folded blue plastic on the chair under her buttocks. Her cart was parked in front of her feet so she could reach her things.

"There's Lola, Tanner's sister. She's out feeding her animals."

Lola was very friendly and looked like a kid. "I'm 28 and have a nine- and 11-year-old," she told me.

"They live in the front house," Mrs. Walton said. Lola fed the goose, two ducks, and a couple roosters. She told me about her live-mouse-eating lizard in a cage under her bed.

"She has a baby iguana, too," Mrs. Walton added.

Emerald came out of her house. She wore two sweaters over a clean, printed frock that wouldn't close over her enormous breasts. She didn't say much, other than "Uh-huh."

Before I left, I got a glimpse of the inside of Mrs. Walton's trailer. Blankets, trash, rubble, and water bottles, like the old camper shell.

"I don't go anywhere," she told me. "I miss my friends." She was trapped on a property her family had taken over. She hadn't had a bath in months and still wore the clothes she'd put on in September, but she had the greatest smile and resisted anyone moving her inside.

"Come back soon!" she shouted as I headed to my car. "That'll be a special occasion, like today. You made my day."

I saw the old woman a dozen times in the course of the next year. Each time, she asked about Michael, and I was finally able to tell her he was off the street and back in rehab. She smiled and told me, "Let's hope he stays good."

I talked to Diane Hampshire about Mrs. Walton.

"She hoards things," she told me. "It's a lifestyle. She's collected things for a lifetime...a product of the Depression. She saves things for a special occasion, the way you or I would, only our occasion happens. Hers doesn't."

"Is she mentally ill?"

"No. She has a focus."

I asked her about the property, and why Mrs. Walton wasn't living inside. "She lived inside with Lola for two weeks, then moved back to the trailer," Diane told me. "The family wants to evict the man in the second green house, so Mrs. Walton can live there, but she'd rather have the rental income. She's worked hard all her life, so an income is more important to her. She's had a lifestyle of deprivation, but she's saving for the future, so there's hope."

Diane told me there was a whole society of women like this in southeast San Diego. Some of them had been helped, others refused to change. They stockpiled for the future and for a special day.

Diane was right. The old woman wasn't mentally ill. For Mrs. Walton, having a bathroom, eating at a table, taking a shower were not as important as the comfort of working toward a savings.

In the summer of 1995, my downtown work loft was robbed. Thousands of dollars' worth of equipment gone—cameras, lenses, computer equipment. The detective who came to look for fingerprints studied the dusty areas left under the computer and printer and said, "This was a professional job."

After the burglary, I moved my studio back to North County. I stayed in contact with Michael, but no longer followed Chelsea, Papa, Jed, or the others.

In early 1996, I wanted to know how Mrs. Walton was doing and went out for a visit.

Her great-granddaughter escorted me inside the dark green interior. She was friendly, yet subdued and respectful. We walked by aquariums of odd-looking large skinks and other reptiles under fluorescent lights. Not too much furniture in the room. Then into a tiny bedroom, the second door on the left side of the reptiles' living room. Dark hardwood floors and a single bed. No other furniture. No windows. A body lying in white, staring at the ceiling.

"Mrs. Walton," I said.

Nothing.

The girl shook her head.

Mrs. Walton's vibrant skin had turned gray. She was expressionless. I hadn't seen anything like this since autopsy class. I didn't know whether I should lean over and kiss her forehead or whether I should just leave the room. The woman was 85 years old. Still, something was going on that I had no notion of, nor was I able to comprehend.

I kissed her forehead, and left the room.

Michael, 2009

In '93, when I was looking for a place to stay, I ended up over on G Street above a restaurant. It was just a room, shared kitchen and bath … the bathroom situation was a nightmare. Susie's friend helped me fill out the application.

Yeah, I was "off crack," but probably for all the wrong reasons … not letting Susie down, wanting to please my parents, wanting to please everyone in the program … I still hadn't learned not to measure myself by outside influences. One of the first things I did on G Street was to celebrate … with beer, then weed, and finally crack. This all happened within the first week. I tried to keep up the image of being clean … I wore those Banana Republic green pants, white sweater, boats shoes day after day, but when on drugs … Well, I eventually fell all the way off, got kicked out the room … and found myself on the streets, right back at square one.

I ran into Mrs. Walton a couple times. She was pissed off … or more like disappointed. I'm sure she hoped Susie had rescued one brother off the street … but I needed to learn that my success or lack of it, my self worth or lack of it … it's all an inside job.

I got myself into Tradition One, over near National City. They offered three hots and a cot … and all the meetings, seminars, peer groups you wanted … I fit in pretty good, and excelled. Some of the friends I made there are friends to this day. What I learned, maybe from screwing up all the other times, was to get balance … physical, mental, spiritual, financial. I've been on a mission ever since to do just that … and it's been an interesting and rewarding trek.

Balance … that's the key word … balance.

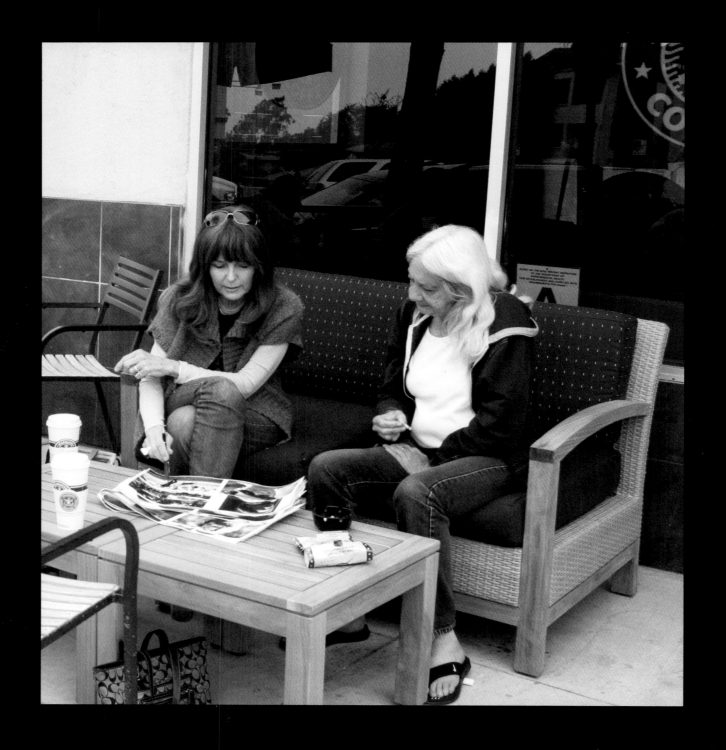

Epilogue

On December 13, 2008, I met up with Michael and my daughter, Polly, at a tiny Starbucks on 30th and B Streets. Michael brought his two dogs; he and Polly found a table on the patio while I purchased our coffees. When I joined them outside, Michael nodded toward a woman with shoulder-length white hair, rolling a cigarette near the entrance to the café.

"Remember her?" he said. "That's Sue Ann. You know… from the park?"

I laughed, wondering what in the world he was talking about. I didn't remember a Sue Ann.

"Remember the day Red and I played chess? She was hanging on him…"

I remembered. I approached the woman, taking a chance. "Are you Sue Ann?" I asked.

"Yeah. Who're you?"

Sue Ann sat with us. I bought her a coffee. She told me she'd lived in Balboa Park back in the '90s. She'd known the park Family well; they'd been her buddies.

"Sandy's dead. Died in the park—someone killed him. Janie—died in the park of AIDS, lying in a ravine."

I was shocked.

"Yeah," she said. "Sad."

She told us candidly that she had schizophrenia, and had lived in a mental institution for two years. "Now I live right over there," she said, pointing a half block north, "in a board and care. I take my meds…they make me feel weird. But I visit other board and cares…the one across the street from mine. I see them every day."

We set a time to meet again, the following week. Sue Ann wanted to see some of the photos of the Family.

"He's handsome," she said of Michael as she sat down. Michael guffawed, but he was interested in what Sue Ann had to say since he was so involved in the book.

"You said Sandy and Janie are dead," he said.

She nodded and leaned over the large contact sheets, smiling wistfully as she glanced at the faces of her old friends from the past.

"There's Red! I saw him a couple years ago. Wow. There's Sandy. Wow. Clive. Speedy. I haven't seen Speedy. There's Janelle. She's dead, too."

She grew quiet, sitting back and lighting one cigarette after another. Michael nodded at me, as if to say, "Yeah, it's OK. She's taken care of, don't worry."

We had to leave for work. Sue Ann asked when we could meet again. I gave her my cell phone and she called several times, just checking in, to hear someone's voice.

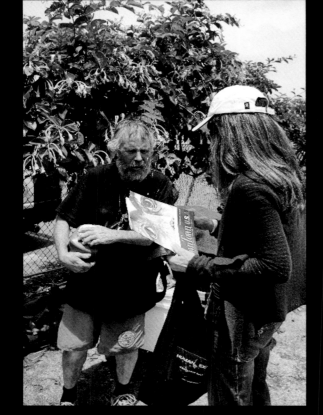
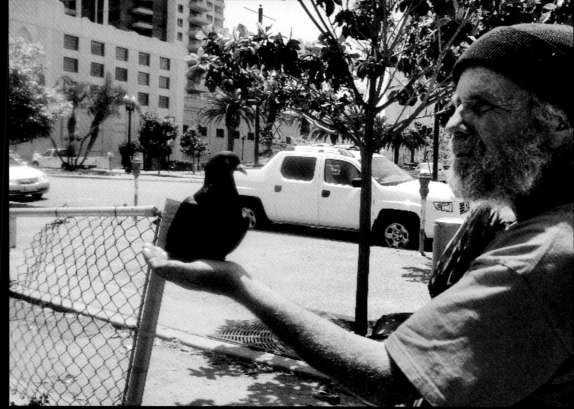

"People need to know that the way they treat the birds is what will happen to the people. We're not paying attention to nature! Nature speaks to us."

–Phil, 2009

Acknowledgments

The creation of *downTown U.S.A.* has taken many years—with detours to my related projects on incarcerated women and young people in juvenile hall—and I cannot begin to list all the people who have contributed to its completion. The acknowledgments that follow are heartfelt, but only a start.

I would like to thank the office of the City Manager for permitting me to rent the old Seaport Village jail, where the homeless of San Diego first found me and introduced me to their world. Over the next four years, I spoke to and photographed more than 60 homeless—some of whom preferred to be called "street people"—whose personalities ranged from intelligent and crafty, to addicted and limited, to gracious and kind.

The individuals you have met in these pages were eager to be included in a book about downtown San Diego, and to tell the story of the streets as they experienced them. I feel deep appreciation for each of them, and mourn the ones who are no longer alive.

Over the past 18 years, Michael Johnson and I have shared a complicated friendship, complete with ups and downs. A very special thanks to him for his willingness to speak in the book in "today's voice."

Barbara Jackson, my dear, dear friend and employee for 25 years, assisted me on several of my meetings with the homeless and felt moved to accompany me on my journey through the women's jail. Barbara also played a role in the review of material and initial layout of images for both *Maggots in My Sweet Potatoes* and *downTown U.S.A.* I am deeply grateful.

I wish to thank another close friend and colleague, Gene Nocon, for his extensive attention in readying images for gallery and museum exhibits. He, along with Hudson Printing in Carlsbad, prepped the many photo files to facilitate Hong Kong offset printing. Gene also made valuable contributions to the design of *downTown U.S.A.*

Through a literary publicist, I met Lydia Bird, an expert developmental editor. Lydia worked tirelessly on the structure and chronology of the material and helped me to let go of extraneous passages I found difficult to delete. Exacting editors are hard to find, and I'm fortunate to have worked with one who is not only talented but dedicated to this project.

Polly Lankford-Smith, an accomplished photographer and graphic designer, was the primary conductor as the project made its way from concept through design to finished book. Her ability to grasp my rough layout, incorporate text, and create stunning InDesign pages transformed the disorganized parts into a polished whole. Not only do I love her dearly, I'm fortunate to have such a remarkable business relationship with my daughter.

Finally, my heartfelt thanks to my family as a whole. All three of my daughters were young and impressionable when I first began working on this project. They inevitably met a number of the homeless, and—once they got past the ragged clothes and grime—showed interest in each of them, candidly asking them why they lived on the streets. My husband wasn't thrilled by my choice of endeavors early on, but he too found the relationships intriguing and learned more about this complicated issue. And, I suppose, about his wife. Their love and support made all the difference.